MUSEUMS, MEDIA AND CULTURAL THEORY

ISSUES in CULTURAL and MEDIA STUDIES

Series editor: Stuart Allan

Published titles

MUSEUMS, MEDIA AND CULTURAL THEORY

Michelle Henning

Open University Press

Open University Press
McGraw-Hill Education
McGraw-Hill House
Shoppenhangers Road
Maidenhead
Berkshire
England
SL6 2QL

email: enquiries@openup.co.uk
world wide web: www.openup.co.uk

and Two Penn Plaza, New York, NY 10121–2289, USA

First published 2006

A catalogue record of this book is available from the British Library

ISBN-10: 0 335 21419 3 (pb) 0 335 21420 7 (hb)
ISBN-13: 978 0335 21419 8 (pb) 978 0335 21420 4 (hb)

Library of Congress Cataloging-in-Publication Data
CIP data applied for

Typeset by RefineCatch Limited, Bungay, Suffolk
Printed in the UK by Bell & Bain Ltd, Glasgow

For John Parish and in memory of Syd and Kit

CONTENTS

SERIES EDITOR'S FOREWORD

The first public museum in Britain was the Ashmolean Museum in Oxford, which opened its doors in 1683. Almost two hundred years would pass, however, before the museum began to consolidate its modern form – an uneven process of development which owed much to the emergence of other kinds of institutions, not least the 'Great Exhibition' of 1851, but also the department store. In the United States, various world's fairs played a similar role as they sought to 'record the world's advancement' in terms of technological progress and public enlightenment. Ever so gradually, from one national context to the next, the features of the museum familiar to us today took root, yet not without sparking controversy at times. Then, as now, the challenges associated with putting certain aspects of social life 'on display' have posed acutely difficult – and fiercely contested – questions about the mediation of power. After all, no museum can escape entirely the accusation that its presentation of objects, regardless of how scrupulous its efforts, is political; nor that its carefully crafted decisions about inclusion are necessarily defined, in turn, by that which is excluded.

Michelle Henning's *Museums, Media and Cultural Theory* embarks on a fascinating investigation of the cultural significance of museums and exhibitions. Its purview spans from seventeenth-century innovations, the product of the first cabinets of 'natural curiosities' and 'rarities' gathered by merchants and explorers in the course of their great voyages of discovery, to the inflections of the 'virtual museums' engendered by the new media of today. Maintained throughout Henning's discussion is a desire to discern the basis for a materialist study of the museum as media-form. In the course of elaborating this fresh approach, she devotes particular attention to the communicative capacity of

the museum so as to rethink assumptions about the ways in which they act as 'sites for the classification and ordering of knowledge, the production of ideology, and the disciplining of the public.' For Henning, new questions need to be posed about the experiential and performative aspects of museums, that is, the ways they transform the manner in which people attend to things, the very sensuality of their practices of looking. At stake, as she shows, is the need not only to fashion strategies for applying theoretical frameworks to museums, but also to better enable museums to inform our ongoing efforts to rewrite cultural and media studies.

The *Issues in Cultural and Media Studies* series aims to facilitate a diverse range of critical investigations into pressing questions considered to be central to current thinking and research. In light of the remarkable speed at which the conceptual agendas of cultural and media studies are changing, the series is committed to contributing to what is an ongoing process of re-evaluation and critique. Each of the books is intended to provide a lively, innovative and comprehensive introduction to a specific topical issue from a unique perspective. The reader is offered a thorough grounding in the most salient debates indicative of the book's subject, as well as important insights into how new modes of enquiry may be established for future explorations. Taken as a whole, then, the series is designed to cover the core components of cultural and media studies courses in an imaginatively distinctive and engaging manner.

Stuart Allan

ACKNOWLEDGEMENTS

This book was produced thanks to research leave funding from the Arts and Humanities Research Council and the University of the West of England, Bristol. It was cooked up in the past two years, but has been marinating for nearly ten. My interest in museums has developed through my teaching in the School of Cultural Studies at the University of the West of England, in particular my teaching of a module called The Politics of Collecting and Display. I am indebted to the groups of students who took this class, for their observations and ideas have often remained with me and must have left their traces on this book too. I would like to thank all my colleagues in the school of Cultural Studies at the University of the West of England for their interest and support. I feel very privileged to work with them. In particular I am indebted to Ben Highmore, both as a good friend and as a colleague whose understanding of cultural studies and interest in exhibitions reassures me that my interests and passions are not peripheral to the field. In early 2005 we gave a paper at a symposium on world's fairs organized by the Royal College of Art and held at the Victoria and Albert Museum. Preparing that paper gave me a clearer sense of our mutual interest in experience and affect, and that, in turn, has shaped parts of this book.

I would also like to extend special thanks to Richard Hornsey, and Gillian Swanson, for inspiring conversations and for reading early drafts of chapter sections and to Adam Nieman for reading and commenting so helpfully on part of Chapter 3. I benefited enormously from a Masterclass in Museums and Heritage Agencies in Leiden, the Netherlands, in November 2004. This was organized by the International Institute for Asian Studies and the National Museum of Ethnology. I would like to thank Amaraswar Galla and all the

participants for such an enjoyable and informative experience. Many people have shaped my thinking, and helped me in the time I have been planning and researching this book, including curators and other staff in a number of museums, who talked to me and answered my questions regarding various exhibits. My apologies to those I have omitted to mention here. I would also like to express my gratitude to Sharon Macdonald and Tony Bennett for their help and support, and to the very patient series editor, Stuart Allan.

My little daughters Honor and Hopey Parish have tolerated my distractedness and become very resourceful in finding new ways to attract attention. Fortunately, they both love museums. John Parish has read passages for me, managing to appear interested as I rehearsed ideas and arguments with him, while also pursuing his own work. This book is dedicated to him with love and admiration. I am also grateful to our friends and relatives who have helped us out over the last two years, in Bristol and in Tucson. Finally, writing this has made me very appreciative of the early experience that my parents, Chrys and Mike Henning, gave me. The museums and exhibitions they took me to as a child are still vivid in my mind, and those memories have shaped this book.

ILLUSTRATIONS

1. The Akeley Hall of African Mammals at the American Museum of Natural History in New York. Photograph by the author with kind permission of the AMNH.
2. Detail of rhinoceros diorama, the Akeley Hall of African Mammals at the American Museum of Natural History in New York. Photograph by the author with kind permission of the AMNH.
3. El Lissitsky, design for the Soviet Pavilion at the International Exhibition of Newspaper and Book Publishing (or *Pressa*) in Cologne, 1928. Photo courtesy Rheinisches Bildarchiv Cologne.
4. The Gesellschafts-und Wirtschaftsmuseum (Museum of Society and Economy) Vienna, late 1920s. Courtesy of the Department of Typography and Graphic Communication, University of Reading.
5. Design for the kitchen of a cottage in a modern mining village by Miss Edna Mosely ARIBA, displayed at the *Britain Can Make It* Exhibition, 1946, in the Furnished Rooms Section. © Design Council and the Design Archives, University of Brighton.
6. Attendant seated in front of a cross-section display of a house showing the distribution of hot water and electrical services at the *Britain Can Make It* Exhibition, 1946. © Design Council and the Design Archives, University of Brighton.
7. André Malraux with the photographic plates for The Museum Without Walls, ca. 1950. Photo © Paris Match/Jarnoux.
8. The Hall of Biodiversity at the American Museum of Natural History in New York. Photograph by the author with kind permission of the AMNH.

INTRODUCTION

Museums and exhibitions have not been, until recently, amongst the usual objects of cultural studies. Nor are they commonly considered as media and studied as such. However, museums and exhibitions have been studied by people working in all sorts of disciplines, and neither the old discipline of museology, nor the younger one of museum studies, can claim a monopoly on them. I work within cultural studies, a very undisciplined discipline. In my view, cultural studies is best understood not in terms of its objects, but in terms of a certain critical and methodological disposition. This makes it possible for almost anything to become an object for cultural studies, but a related (and possibly worrying) phenomenon is that many other disciplines have started to look an awful lot like cultural studies. My interest is not so much in applying cultural studies approaches or theories to new objects, as in enabling those objects – in this case, museums – to rewrite cultural and media studies.

To approach museums from cultural and media studies is to approach them, not with an armoury of theoretical 'tools' but with a set of interests. Cultural studies is associated with those approaches that emphasize the museum's role in governance and its ideological character. In the 1990s, writers including Tony Bennett, Carol Duncan, Douglas Crimp and Eilean Hooper-Greenhill, amongst others, introduced European critical theory to Anglophone museum studies. They responded to the work of Michel Foucault, Antonio Gramsci, and Pierre Bourdieu amongst others. Through these critical perspectives, museums were identified as sites for the classification and ordering of knowledge, the production of ideology and the disciplining of a public. These new approaches challenged the liberal perception of museums as predominantly benevolent institutions and the complacency of an art history rooted in connoisseurship,

and they introduced a new complexity and a new theoretical language to discussions of museums. In my view, what was important about these studies was not simply the theories they used, but the questions they asked about the cultural significance of museums. However, they did not seem able to account for the material specificity of museums and exhibitions, for their experiential and affective appeal. For these we need to look elsewhere.

This book takes as its starting point a particular understanding of modernity which sees it as fundamentally, if unevenly, transformative. According to this theory, the social, economic and technical changes associated with modernity alter even those things we tend to view as permanent or eternal: the structure of memory, of the self, of experience. Practices of attention, ways of relating to the material world, change too. And while museums and exhibitions predate modernity, they take on a new, public form in the modern period which is connected to these larger changes in the subjective and objective world. In and through museums and exhibitions, subject and object are reinvented. Foucault, Bourdieu and Gramsci show us how this extends and reproduces social differen- tiation and regulation, subjecting everyday practices to forms of social man- agement. They allow us to observe how the cultural products of the world are turned into the material for narratives of progress, which make the present order of things seem both natural and inevitable. But the objects in museums are not amenable to being reduced to documents, texts or representations. The other side of modernity would seem to be the way that things exceed their designated roles, in which accumulations of 'stuff' resist the attempt to make of them coherent narratives or to marshal them for the purposes of moulding good citizens (much as the material interferences and 'noise' of media obstinately stand in the way of transparent communication).

If cultural and media studies can help explain the communicative capacity of museums, we can also find in these disciplines some models for thinking through their material or sensuous character. In this book I have tried to assemble a materialist study of the museum as media-form, mainly by piecing together theories, insights, historical accounts and observations from a wide range of texts. I try to account for the fact that museum objects are constituted by the museum and are, at the same time, material things. In the first chapter, I argue that museum content is not superimposed on things, but embedded in them, and discuss how things change when they enter the museum, how the museum transforms the ways people attend to things, how things address us and act in relation to us. I draw on various texts which attempt to theorize things to explore how, in the public museum, there emerge new relationships between people and things.

While the early public museum was rooted in a faith in 'object lessons', today many museums prioritize visitor experience over artefacts. The experiential and

performative aspects of museums have been written about in terms of the management of a public. Museums and exhibitions, through techniques of display and the organization of space and time, attempt to position or organize visitors, to choreograph them, or to direct and mould their attention. In many cases these attempts are connected with ideas about citizenship and subjectivity, but these ideas vary: from docile self-regulating citizens in the Victorian museum, to Marxist ideas of self-realization and agency in avant-garde exhibitions, to the construction of ideal consumers in exhibitions of design, and ideas of technological citizenship in new science centres. Yet we cannot assume that such intentions correspond with the actuality of the displays, nor that the sensory and emotive affect of a display will be complicit with the overt messages or content of the museum. Hence in science centres, the overt message of a world rationally comprehensible through science may be undercut by a perceptual experience which connects the exhibit with a magic show. Similarly, reconstructions of historical scenes may be intended to interest visitors in the past, but the experience of being able to 'step into the past' might feel like a particularly modern thrill.

Museums need to be understood in complex relation to the wider culture of which they are a part. Whilst the discourses of the museum may attempt to distance it from other more commercial and popular sites of display, the chief display techniques used in museums are shared across these other cultural sites. One of the virtues of critical-theoretical approaches to the museum has been the refusal to see it in isolation. Tony Bennett (1995) describes the museum as part of an 'exhibitionary complex' which emerged in the nineteenth century; William Leach (1989) writes of museums in the United States being part of an 'institutional circuit' through which ideas and technologies of display were exchanged and developed; Andrew Barry (2001) writes of the changes in the meaning and techniques of interactivity as the concept circulates between museums and across continents. The museum audience circulates too, arriving at the museum with expectations and modes of attention shaped by the broader culture, and finding in the museum material with which to negotiate that world.

I have used existing studies, both well-known and obscure, and from a number of academic fields, to construct an account which prioritizes the material character of the museum while recognizing its communicative and ideological role. Instead of summarizing existing arguments systematically and privileging the most influential books in the field, I have scavenged through texts for arguments and accounts which enable us to glimpse something of the significance of the thingliness of museums and exhibitions. The book is mostly based on existing academic texts, as well as some first-hand research in Britain, France, the Netherlands and the United States. Unfortunately, this has led to the book being more centred around examples from North America and Europe than

I would have liked, despite there being numerous writings on Australian museums and a growing body of writing on museums in the Americas, the Middle East, Africa, and the Far East. I have also had to leave out exhibitionary practices I would have liked to include, notably world's fairs, which are only mentioned in passing. Another reason for some of the notable absences in this book is my desire not to overlap too heavily with another book in this series, Bella Dicks' *Culture on Display*. Museums and exhibitions play an important role in Dicks' argument. Her interest is in the conditions which make places into attractions, making them 'visitable' and in the role of museums and other sites of display in the production of cultural identity and the representation of culture (Dicks 2003: 144–68)

This book is concerned with thinking about museums as a means of thinking about our experiential world. The topics, themes and historical moments discussed here are chosen because they seem to make vivid particular problems or contradictions which unsettle some of the certainties of text- and discourse-based cultural and media studies. I pay particular attention to recent develop-ments in museums and new media and the relationship between these and two significant historical moments: the interwar period (1920s and 30s) and the sixteenth to eighteenth-century culture of curiosity. I do not want to suggest that these are stepping stones in a developmental history of museums, but rather that they are moments which can be set in productive juxtaposition: when new display practices are invented, invested with the task of producing new forms of social identity; when experience, attention and knowledge seem to be in crisis for one reason or another; and when the world of things makes itself felt in particularly pressing ways.

OBJECT

1

Let me reward your patience by unlocking some of the cases and putting their contents into your hands. At once you realize that these treasures, recently so remote, so dead it seemed, come again to life.

<div align="right">(Stewart Culin, cited in Bronner 1989: 232)</div>

If the soul of the commodity which Marx occasionally mentions in jest existed, it would be the most empathetic ever encountered in the realm of souls, for it would have to see in everyone the buyer in whose hand and house it wants to nestle.

<div align="right">(Walter Benjamin 1983: 55)</div>

The life of things in the museum age

In the Grimm brothers' version of the Snow White story, after Snow White dies, poisoned by an apple, she is placed in a glass coffin by the seven dwarves. Inside the coffin her appearance does not change: she still looks as she did alive. A passing prince tries to buy her from the dwarves, who refuse to sell her but eventually give her to him. As the coffin is carried away, it is jolted, the poisoned apple becomes dislodged from her throat, and Snow White awakes.

The glass cases used in museums, called vitrines, have often been referred to as glass coffins. As the Snow White story suggests, this links the museum with death, and simultaneously with the possibility of awakening the dead. In the glass coffin fantasy, the body encased in the glass is not dead for eternity, but in suspended animation. The implication that museum objects are somehow alive is a peculiar one since the majority of museum objects have either never been alive or are things which were once alive and are now, very definitely, dead. The fantasy of awakening them from their enchanted sleep is at one level metaphoric: it means to make them more vivid and communicative for the audience, by removing the constraints placed on them by the museum. But there is a little more to it than this. It is also a fantasy of possession. The expectation is that

museum objects will be obedient and complicit, just as Snow White is when she awakes, and the prince announces his love for her and declares she shall become his wife. Yet why should the object, once 'brought to life', be passively feminine and obedient? The cultural theorist Bill Brown says,

> We begin to confront the thingness of objects when they stop working for us: when the drill breaks, when the car stalls, when the windows get filthy, when their flow within the circuits of production and distribution, consumption and exhibition, has been arrested, however momentarily.
>
> (2001: 4)

At their most thinglike, objects also somehow seem most alive – we curse them and hit them, think of them as truculent and obstinate. When things don't do what we want, they begin to 'stand out so much as objects that they seem like subjects' (Maleuvre 1999: 242).

Between the serried glass coffins of the late nineteenth-century museum and the elaborate and sometimes hi-tech displays of today are a whole series of attempts to jolt the poisoned apples and remove the museum objects from glass coffins, allowing them to flourish and live and breathe. Yet the removal of the glass case (and, in the case of paintings, the heavy gilt frame) may bridge the gulf between audience and things in one sense, but it does not necessarily mean a more intimate, comfortable and straightforward relationship between audience and displayed object. In fact, things can seem simultaneously alive and distant, unapproachable, recalcitrant. The notion that material things might turn on their owners and attack them is the basis for countless modern stories in which everyday objects become uncooperative, rebellious – and then malicious and dangerous. The fantasy of compliant femininity turns into the horror story of violent femininity; perhaps the most well-known example is the film *Christine*, directed by John Carpenter (1983) and based on the Stephen King novel, about a possessed and feminized car.

Another fictional account which deals with hostile, anthropomorphized objects is Dennis Potter's novel *Ticket to Ride* (1986). The central character, travelling in the buffet-car of a train, takes his gaze from the window to the carriage and discovers he no longer knows who he is, where he is going or who he is with. The plate of leftover food in front of him seems to scream at him, the arrangement of cutlery appears as a coded message, and the things on the table seemed to argue amongst themselves. For the amnesiac, inanimate things become animate and significant, though he is unable to read their significance. As this story reminds us, the object is framed not just by a material enclosure, or even (in the case of the painting) by its own composition, but by what the anthropologist Clifford Geertz calls (after Max Weber) 'webs of significance' (1993: 5). Our ability to interpret the things of this world is dependent

on acculturation. Culturally determined acts of interpretation enable us to distinguish the significant from the insignificant.

The museum aids interpretation by the arrangement and labelling of arte-facts, by its rules of access and the ways in which it frames objects. Lighting, fabric, plinths and even the plain white walls of the white cube art gallery, all serve the same framing and demarcation purpose as the glass case. Museum things, set free from their frames and cases, do not become indistinguishable from other kinds of things, because the museum environment becomes the frame which endows its contents with significance. In modern art or hands-on exhibitions, one frame goes, only for a larger one to take its place. One way of thinking about what museums do to things is to do with the distinctions between things and objects. Simply put, museums turn things into objects. According to 'thing theory', the distinction between things and objects is to do with their relationship to a human subject (Brown 2001: 4). We encounter a thing as a thing when we bump into it, or when it breaks down. Things are also unnameable, unintelligible, vaguely apprehended – 'that thing over there'. Objects, on the other hand, are interpretable, meaningful, things made into evidence, documents, and facts (Brown 2001: 5). Things exist as objects in relation to a society which values and interprets them. As the philosopher Hilde Hein sees it, 'objecthood, like textual meaning, results from multileveled acts of attention by individuals, social groups and institutions. Socially objectified things are imbued with meaning, layer upon layer, within sanctioned structures of reference' (2000: 64).

Another way of looking at this is that a thing becomes an object by being placed in a new network of relationships. Objecthood suppresses the rebellious and obdurate character of things, while the rational organization of the mod-ern museum militates against an anthropomorphic or animistic relationship with what it contains. It would seem that we only project human characteristics onto material things, or conceive of them as alive, at times of breakdown. Yet this isn't quite true. The recognition that animistic thinking was a central part of modern culture came in the nineteenth century. In the early part of the century, European anthropologists and philosophers described the religious practices of peoples on the west coast of Africa, as *animist* and *fetishist*. The use of ritual objects was seen as indicative of a 'primitive' animistic way of thinking which had been supplanted in Europe by a more 'rational' relationship with the material world.

Karl Marx's theory of commodity fetishism, which he outlined in 1867, effectively turned this theory on its head, finding the primitive in the heart of the modern, by applying the concept of fetishism to modern capitalism. He explained how the market in industrial society, and in a capitalist economic system, makes us experience material goods anthropomorphically. People

fetishize goods because of the kinds of social arrangements in which they encounter them. For Marx, *commodity fetishism* is the result of a system of exchange, mediated by money, which disguises social relationships between people as relationships between things, and a system of production in which workers become alienated from their own products. In this situation, commodities seem to have a value of their own, and even an ability to move by themselves. Marx's famous description of the transformation of a wooden table into a commodity emphasizes this aspect. The table, having become a commodity 'stands on its head, and evolves out of its wooden brain grotesque ideas far more wonderful than if it were to begin dancing of its own free will' (Marx 1976: 163–4). For Marx, the commodity is anthropomorphic in several respects: first, because the 'social characteristics of men's own labour' appear as its own natural qualities; second, in that it appears to its producer as an alien thing with a 'life of its own,' when the modern division of labour, factory production and deskilling estrange or alienate the worker from the product (Marx 1977: 61–74); third, as writers since Marx have shown, the commodity is further fetishized through product design, display and advertising which attribute human character to goods. Thus, for example, a dress, a chair or a car come to 'express' the personality of their owners and bring with them associations of status and lifestyle unrelated to their actual use, price or the material properties of the commodity itself (Sennett 1993: 144–7).

Commodity fetishism suggests an anthropomorphic relationship with material things, which we treat as valuable and meaningful in themselves, and capable of endowing us with certain desirable qualities. These relationships do not cease at the door of the museum; museums are not immune to the changed relationships between people and things brought about in capitalism. The ethnographic curator Stewart Culin saw the Victorian museum's dry display techniques as killing the objects, and so pressed for more sensual and aesthetic exhibits, department-store style (Bronner 1989: 232). An expert in ritual objects, including fetishes, Culin saw the potential of new and innovative display techniques to make objects come alive. Indeed the reinvention of the museum in the twentieth century is closely associated with developments in commodity display. Even the glass case itself was a display technique shared across the store and the museum. The glass case fetishizes objects by conferring an instant aura of preciousness. It places them in a space and time distinct from that which visitors occupy – protecting it from deterioration, pollutants, and changes in temperature. Like commodification, it disguises their relationship to the human beings who make and use them. In other words, the arrangements, techniques and acts of attention by which museums turn things into meaningful objects may even reaffirm the sense that things are somehow alive insofar as it fetishizes them.

Although commodity fetishism is pervasive, an excessive anthropomorphism, or an over-identification with objects, can actually undermine the orientation of the market toward accelerated exchange and consumption. This is cleverly illustrated in a recent advertisement by Spike Jonze in which viewers are encouraged to empathize with a discarded lamp, which lies out in the dark and rainy street while its owner installs a replacement. Viewers are then castigated: 'Many of you feel bad for this lamp. That is because you're crazy. It has no feelings! And the new one is much better'. The advertisement shows the ease with which people can be encouraged to feel for inanimate objects, invites viewers to laugh at themselves and their foolishness, and using the common-sense notion that anthropomorphic thinking is 'crazy' thinking, encourages accelerated obsolescence and increased consumption. Implicitly, the ad acknowledges that what stands in the way of increased turnover of goods is our sentimental attachment to things. One of the themes which will recur through-out this chapter, and later in the book, is the way in which a love of things both works in favour of, and against, an economic system premised on the trans-formation of things into commodities, and which, since the mid-1970s at least, is dependent on high levels of 'consumer spending'.

The social anthropologist Arjun Appadurai argues that a good dose of 'methodological fetishism' can unravel commodity fetishism. Objects can 'illuminate their human and social context' (Appadurai 1986: 5). If we treat objects as if they have 'social lives' and trace their movements and trajectories across societies, if we pay attention to how they are used and exchanged (not just to meanings, as cultural studies conventionally does), the mechanisms and pro-cesses which produce them *as* objects are revealed. To study the 'social lives' of museum objects is to study them in transition, with changing meanings and functions as well as material properties. This differs from the usual way of thinking about the 'provenance' of museum objects, their origin and histories of ownership, because it directs attention to the relation of artefacts to other objects, to people and cultural practices. In his book on modern art and museums, Philip Fisher has written about how museums participate in the social lives of things, as one of the 'many lives' a thing may have. He uses the example of a sword, showing how it passes from useful object to sacred, ritual object; to loot or treasure; and finally to museum object (Fisher 1991: 3–6). (These do not constitute the only possible life stages of an object, of course. It could pass from useful object to discarded or obsolete object, for instance, and never reach the museum at all). Though the material object itself may not change a great deal, at each stage it becomes a different kind of thing, with different meanings and uses. Each time, the object becomes what it is in relation to specific rules of access and as 'a member of a community of objects' (1991: 4).

Fisher states that the object's place in a set of objects not only gives it

meaning, it makes human activity possible. In this, he is close to the work of Bruno Latour. Latour's approach differs from the theory of commodity fetish-ism or the 'social lives of things', because he sees anthropomorphism not as a mystificatory thing nor as something we project onto objects, but as a property of objects themselves, when they are situated in a network of relationships. Objects, as Latour explains, act upon us and for us, affecting and even shaping our behaviour and our actions. Another way of putting this is that things have agency – the ability to act on and transform their world. Latour (1992) uses the example of an automatic door-closer (or 'groom'):

> The automatic groom is already anthropomorphic through and through. It is well known that the French like etymology; well, here is another one: *anqropoß* and *morpfoß* together mean either that which has human shape or that which gives shape to humans. Well the groom is indeed anthropo-morphic, and in three senses: first, it has been made by men, it is a con-struction; second it substitutes for the actions of people, and is a delegate that permanently occupies the position of a human; and third, it shapes human action by prescribing back what sort of people should pass through the door.

The groom prescribes how we move through the door – if it pulls the door closed smartly or violently we need to move nimbly. The eccentricities of a particular door-closer become what Latour calls a 'local cultural condition', so that people who use the door regularly learn the appropriate skills to move through it, while those who do not, get caught in the door or hurt by its violent movement. As Latour points out, it is not only faulty door-closers which dis-criminate in this way, even smooth-moving hydraulic door-closers discriminate against the young and the elderly, the disabled and anyone carrying heavy or bulky items (such as delivery people, furniture removers and so on). The important point here is that the groom is not representing a human actor – it does not look like a person or symbolize a person – but human activities and even human notions of social inequality are delegated to it. It, in turn, shapes human activities.

This approach is very different from those which consider cultural artefacts and technologies predominantly in terms of representation and meaning. The usual objects of cultural and media studies are not functional in the sense that the door-closer is, yet it is not difficult to see how they affect or prescribe human behaviour. For instance, the length of a television advertising break, or the timing of the television programme itself, has an impact on when and what people eat and drink, and this affects other technologies usually considered as outside the sphere of media studies. One (possibly apocryphal) example is how the timing of the popular soap opera *EastEnders* produces sudden peaks in the

consumption of electricity in Britain, as millions of viewers switch on their electric kettles at the end of an episode. Of course, the programme is deliberately scheduled to fit around the eating and drinking habits of the nation too. Television watching introduces us to new modes of attention, schools us in new habits, and works to socially differentiate us.

Museums, and the things in them, also prescribe certain kinds of behaviour. Fisher (1991) makes this argument, though he does not write of the object as an actor in the way that Latour does. Fisher shows how, at each stage in its life (or each life of its many lives), an object prescribes and sets limits on human activity. The museum's rules of access limit what people do within the walls of the museum, what they may touch, and even who may enter the museum. This aspect of the museum has been discussed in relation to it as a ritual space, in terms of the disciplining of audience behaviour and as performance (Duncan 1995; Bennett 1995). My emphasis here is on the role of the object (not just the visitor) as an actor, which performs in a given network or community. The forms of behaviour and activities enabled by the community of objects in the museum include how visitors conduct themselves and attend to the objects within the museum, and practices of curatorship. The place of the object in the community of objects affects how we approach it, where we stand or sit in relation to it, and how much time we spend in its company. It shapes not just how we interpret it but how we see it: making us blind to certain aspects and drawing attention to others. Fisher elaborates:

> When we think of an object as having a fixed set of traits we leave out the fact that only within social scripts are those traits, and not others, visible or even real. It is not only that in a museum we do not notice or even know about the balance of the sword. Once it is bolted down in a display and not swung in a certain way we cannot say that balance or imbalance is even a fact about it. Without a class of warriors, trained to fight in certain ways, even the permission to lift and swing the sword could tell us nothing . . . Our access assembles and disassembles what the object is.
>
> (1991: 18–9)

As Fisher says, the museum is more than a place. It is a network of relationships between objects and people. The museum is constituted in part by the activities of visitors and museum staff, which are themselves enabled by and enacted through the material objects that make up the museum collection. These objects make possible the various practices involved in museum visiting and curatorship. The museum object is shaped by and shaping of visitors' attention. At the same time, these objects are animated by the museum, its practices and procedures, its classifications and its display techniques.

In the rest of this chapter, we consider the historical circumstances in which

museum procedures and practices were introduced and in which they became sedimented. In the second section I provide a chronological account of the emergence of the modern public museum, told in terms of how it transforms things and the way we attend to them. The third section describes the relationship to things thus displaced, via the social history of the luxury trade and the curiosity cabinet. The final section looks at the relationships between museum objects and commodities, between the museum and the department store, and at aesthetic appreciation in the art museum in relation to commodity aesthetics. But at the basis of all of this is a concern with the role the museum plays in the historic transformation of the relationships between people and things.

The democratization of treasure

Museums as we now know them belong to a very particular historical era, appearing first in eighteenth-century Europe. Public museums participated in what Fisher refers to as the 'democratization of treasure' (1991: 7). Through different routes, the first public museums made private treasure and colonial loot available to a mass audience. For instance, two of the early public museums, the British Museum in London and the Louvre in Paris, made the possessions of the wealthy into the possessions of the nation, the first via the donation of a wealthy benefactor, the second through the dispossession of the aristocracy during and after the French Revolution. Before the eighteenth century, some royal and private collections were accessible to a public, usually for an entrance fee, but in them the objects remained firmly as treasure to be displayed to a restricted and privileged audience as an expression of power. It is only in the late eighteenth and early nineteenth century that museums presented their objects as the wealth of peoples and nations rather than of individuals.

The democratization of treasure transferred not only the possessions but also the leisure practices of the wealthy to the middle classes, and eventually the working classes too. When Sir Hans Sloane bequeathed his entire and rather idiosyncratic collection to the British nation in 1753, he participated in the democratization of not only the objects in his collection but also practices of collecting and forms of knowledge (Benedict 2001: 180–3). Virtuoso collectors, including Sloane, were usually the subjects of ridicule for their obsessive collecting, but the founding of the British Museum enabled collecting and viewing collections to be widely understood as purposeful and knowledge producing. The public museum made scientific knowledge accessible to people who did not have access to the universities. Collecting, especially natural history collecting, became a popular practice in Britain, participated in across the social classes

(Barber 1980: 27–40; see also Chapter 2, section 2). The democratization of treasure also meant the democratization of the aristocracy's social pastimes. Activities such as looking at art or curious objects from around the world, strolling in beautiful gardens, or looking at live animals in the menagerie, were transferred to new public institutions such as the museum, the public park, and the zoo (Fisher 1991: 7). In the museum, the public now gained access to once privately owned artefacts and to sights previously only available to those who had the means to travel abroad (Griffiths 1996). This change marks the beginning of what Germain Bazin named 'the museum age' (1967).

This process of democratization involved a redistribution of wealth and, importantly, of access to knowledge. It also involved the dissemination of the ideals of democracy. The 'treasure' which found its way into the public museums of Europe and the New World became a means of communicating democratic ideals. In France, the Louvre, which opened in 1793, was one of the means by which the ideals of post-Revolutionary democracy were constructed and disseminated (Hooper-Greenhill 1992: 171–3). The Louvre represented not only the new post-Revolutionary values of liberty, fraternity and equality, but also the French nation to itself. It contained French private, court and church art collections seized during the 1789 revolution, and art from other parts of Europe, including famous antiquities from Rome, ransacked by the Revolutionary armies. The Louvre came to aggrandize Napoleon himself, as the Revolutionary state became the Napoleonic Empire (Belting 2001: 29).

Many studies have analysed the role of museums in nation-building and in the construction of national identity (see for instance Kaplan 1994). This role was carried out not just through the ideological content of exhibits but also through the use of objects and displays to produce new habits and new patterns of behaviour. In his book *The Birth of the Museum*, Tony Bennett has written about how museums participate in governing people through the attempt to manage the conduct of visitors and through the social routines and perform- ances they elicit (1995: 46). He argues that in the nineteenth century the museum became a 'reformatory of manners,' that is, a means to 'civilize' the working classes. Thus the democratization of treasure was also about the trans- formation of a people into a democratic citizenry. This was both a response to the perceived threat of the working class as a dangerous, revolutionary force (1848 saw uprisings in Berlin, Vienna, Paris and London), and an attempt to reform drunken and dissolute behaviour amongst that class. Bennett shows how museums attempted to turn the working class into a manageable and civilized 'public' by encouraging self-regulation and self-monitoring (1995: 28). In later chapters we will look in more detail at questions of social class, and at the museum's educational role. Here, let us simply note that the democratization of treasure produced a demand for new habits and new kinds of attentiveness

from museum visitors. This was connected to the role of the museum in social reform, as Bennett argues, but we could also see it as connected to wider social anxieties regarding attention and inattentiveness which emerged in the nineteenth century, and consequent attempts to 'manage' attention (Crary 1999). New habits and new forms of attention also emerged as an unforeseen consequence of the new arrangements of objects in the museum.

The museum put objects to work in new ways. Artefacts were able to play their new roles in the management of attention only by being given a stable place in a community of objects, with specific rules of access. The public museum tore them from the previous contexts in which they made sense, and arranged them in sequences and groups, informed by new understandings of history and aesthetics. This is not a process peculiar to the museum itself, but characteristic of the wider nineteenth-century culture that nurtured the public museum. Using the conventional shorthand, I will refer to this as Victorian, though it reached far beyond the edges of Britain and of the British Empire.

Victorian society developed a new relationship to the past and to the rest of the world. European colonial relations enabled colonial powers to view their own culture as both universally valid and as the peak of civilization. Other cultures were discussed, sampled, represented in encyclopaedias, periodicals, and in popular displays as well as in the public museums. It is true that earlier European cultures had also collected, quoted and revived the artefacts and practices of other cultures, but usually only where they saw a similarity with their own, either in actuality or ambition. Victorian bourgeois culture assimilated contemporary and ancient cultures with very different worldviews. Indeed, the Victorian bourgeoisie was so assured of its own world dominance that the products of entirely different cultures were judged according to 'universal' criteria, such as the criteria of scientific and aesthetic value (see Chapter 4 for more on this). Museums enabled Victorian society to produce totalizing accounts of the world by acting as centres for the assembling and reordering of artefacts and specimens taken from all over the globe (Bennett 2002: 34–5). By the last decades of the nineteenth century, historical arrangements dominated many museums. Even museums with geographically organized collections, such as ethnographic museums, could represent world history. Some ethnologists believed that evolutionary theory applied to human cultures as well as to the development of species, and different cultures were thought to be at different stages in the social evolution toward civilization. This was not the case universally: the most renowned ethnographic museums were in Germany and, initially at least, placed an emphasis on comparative study rather than cultural hierarchy (Penny 2002; see also Chapter 4).

In historically organized collections and comparative ones, the object is subordinated to the sequence in which it is placed and gains its meaning from its

relationships within a community of objects. We can think of these relationships of equivalence as similar to those which make objects exchangeable as commodities in a market, insofar as they are based on socially established criteria or rules (Appadurai 1986: 14–5). The museum object is removed from commodity circulation, but by the late nineteenth century a museum artefact's value is partly determined by exchangeability – by its ability to be circulated between museum collections and substituted for other objects that belong to the same type. Tony Bennett says that at the end of the century, in most kinds of museum, relations of equivalence between objects were crucial for the construction of historical sequences (2002: 37). In this respect, an object's ability to stand in for other objects was often more important than its singularity. This is one of the things which distinguishes the Victorian museum from the private collections out of which it had been constructed. In the cabinets of curiosity of the sixteenth to eighteenth centuries, which we will look at more closely later, objects had been collected and displayed on the basis of their uniqueness, or their status as anomalies – even if in practice, these collections had certain staples, such as the obligatory crocodile hanging from the ceiling. In the last decades of the nineteenth century and the early years of the twentieth, the museum replaced this with an emphasis on the typical and with historicism (for more on Victorian historicism see Chapter 2, section 1).

We could say that the core difference between the late nineteenth-century museum and its predecessors was its privileging of the typical over the singular. Yet museums of the late eighteenth and early nineteenth century, saw not just the gradual replacement of the singular curiosity with the typical specimen, but the emergence of a new kind of singularity based in aesthetics. Not surprisingly, this is most explicit in the case of the art museum. Writing in the late 1940s, André Malraux credited the art museum with the development and popularisation of a new way of looking at art (1967: 9). It was new in two respects: first because it was determined by the art historical arrangement of the museum, and second because it was newly aestheticized. We have become used to the idea of the art museum as schooling us in art history. Thus, as Fisher argues, when we stroll rapidly through the museum we are not misusing it: our walk 'recapitulates . . . the motion of art history itself, its restlessness, its forward motion, its power to link' (1991: 9). However, if **encyclopaedism** and historicism dominated museum displays by the end of the nineteenth century, many of the objects that they marshalled into order were already enchanted objects: not dry material evidence or examples of a type, but objects deemed to be possessed of aesthetic qualities.

As the art and media historian Hans Belting (2001) narrates, during the early years of the Louvre there was a dispute about whether the museum should show only singular paintings – the 'masterpieces' – or other paintings considered

typical of a particular school or historical style. Before the Louvre opened in 1793, art was valued in collections for its rarity and uniqueness, and for the extent to which it adhered to the rules of classical beauty. Great art was art that successfully followed these rules and achieved near-perfection. Art was understood as an imitative practice, and the exemplary models were those paintings and sculptures which measured as most perfect according to the rules and which were known as masterpieces (Belting 2001: 27–33). On this basis, some argued that the museum should be a school of taste, and show only masterpieces, only, that is, works worthy of imitation. They imagined the museum as continuing to serve the purposes of an élite. Others advocated a chronological survey of art history, in which works typical or representative of different schools would be displayed, to educate a broadly conceived public in art history. Ultimately the Louvre, and the art museums that followed it, still reserved a special place for the masterpieces of antiquity and the Renaissance, but prioritized an art historical narrative arrangement.

In this new context of the art historical arrangement, Belting argues, masterpieces were stripped of their function as models for artistic imitation, disassociated from the rules of classical beauty which had measured their achievement, and removed from the hierarchy of genres which had established certain subjects as more worthy than others. The museum cut paintings and sculptures from their use twice over: first from their original or previous uses, as communicative, domestic or religious artefacts, and second, from their use in the imitative learning of the rules of classicism. Consequently, shorn of both kinds of use value, they re-emerge as the objects of new practices: the practice of experiencing art history as a journey through the museum, and the practice of a new kind of aesthetic contemplation (Belting 2001). The art historian Carol Duncan argues that these practices are secular rituals which replace religious practices as part of the wider secularization of European society and thought in the eighteenth century. Religious ritual can seem to suspend time, and provide distance from day-to-day concerns, enabling a certain kind of contemplative consciousness (Duncan 1995: 11). Participants emerge transformed and 'restored'. Duncan claims that the art museum is a secular ritual space, and in it, aesthetic experience becomes the secular counterpart to religious contemplation (1995: 14).

Belting (2001) also argues for a connection between aesthetic and religious contemplation, through the example of the Sistine Madonna. This altarpiece by Raphael had been taken straight from a Roman Catholic chapel in Piacenza, and installed in the Royal Gallery of Paintings in Dresden in 1753. The painting's subject matter is the Virgin Mary appearing as a miraculous vision to Saint Sixtus. After the museum abruptly deprived the painting of its religious function, the Sistine Madonna became – to its (mainly Protestant) eighteenth-century

audience – a 'miracle of art' (Belting 2001: 52 –4). This example shows the growing confusion between religion and art, as the painting's combination of classical perfection and religious subject matter became the basis of a new kind of art-worship. Contemplation of the individual work in isolation from those around it became almost religious in character. In the late eighteenth century, and through until the mid-nineteenth century, a miracle story circulated in which the image appeared in a dream to Raphael. Belting explains how this myth reinterpreted the Sistine Madonna as if it were itself a vision experienced by Raphael, so that a miracle becomes the origin of the painting as well as its content. As a miraculous object, the painting becomes imbued with religious significance, and the artist becomes a cult figure, the subject of myth and mystery (Belting 2001: 58).

The emergence of the cult of the artist accompanied the new cult value of the work of art. Masterpieces become objects of mystery, imbued with an inexplicable *aura*. This notion of auratic experience, derived from the work of the German critic Walter Benjamin, is discussed in later chapters. My point here is that works of art gained a new kind of singularity in the museum age. In 1857, Carl Gustav Carus wrote that Raphael's Sistine Madonna 'presented itself ever more radiantly and in its full significance to my soul' now that the painting had been reinstalled in its own chapel-like room in Dresden (Belting 2001: 61). Carus' way of describing his experience is a typically Romantic one. By the mid-nineteenth century, the Romantic notion of aesthetic experience had displaced old understandings of the contemplation of art advocated by eighteenth-century classicists. For the Romantic, paintings 'speak' to the soul. Their aesthetic qualities are not a matter of conforming to rules and notions of perfect form, but a mysterious communion between the viewer and the art object. This communion is akin to the ones that the Romantics were to find in nature, in the experience of the sublime and the picturesque landscape.

Writing on the museum as a rational instrument of governance has tended to draw our attention away from the impact of Romanticism on the museum. If we look at early nineteenth-century museums, and not just at art museums, we see a deliberate attempt to arrange displays aesthetically, under the influence of Romanticism. Museums were organized to produce evocative and unexpected juxtapositions, placing artefacts from different periods alongside one another for artistic effect. In 1882, the director of the Rouen Museum of Antiquities defended its displays (dating from 1831) against the current fashion for 'extravagant classification'. While he recognized the scholarly advantages of methodical classification, he argued, 'A picturesque installation speaks more to the soul than does a dry and cold display inspired by narrow pedantry. It is by means of the first system rather than by the second that true popularisation is achieved' (Jules Adeline cited in Watson 1999: 101).

In the nineteenth century, aesthetic experience was understood in terms of absorbing the aura of the object, immersing oneself in it, becoming transported by it. Aesthetic contemplation was encouraged by picturesque arrangements of collections or specially designed spaces, such as the chapel-like gallery of the Sistine Madonna. A more recent example is the Rothko room at the Tate Gallery (now Tate Britain) in London. But even chronologically arranged collections could not prevent the singularity of the object from piercing the narrative flow for a viewer open to the experience of aura. While chronological arrangement subordinates the individual object or artwork to the larger narrative of art historical progress, the newly auratic object resists this contextualization. From the late eighteenth and early nineteenth century, all sorts of objects (not just art) could become the focus of aesthetic attention. The fact that this kind of experience was to be had in even the most systematic and pedagogic arrangements is not in spite of the museum but because of it. That is, the very act of turning something into a museum object makes it available for aesthetic contemplation. The museum animates objects as the sources of knowledge, and simultaneously as aesthetic, auratic things.

Curious things

This new way of apprehending things is produced in and by the public museum. At the same time, these museums were based on the denigration (and in some cases forcible destruction) of older relationships to – and between – things. The private collections seized in post-Revolutionary France were used to construct a new fidelity to the Republic. This was only possible through the severing of the collections from their collectors and from those people's habits of consumption and material attachments. This happened both materially and discursively, that is, it involved actual material and economic changes and also changed ways of understanding consumption practices.

By the time of the French Revolution, the landed aristocracy were condemned for their idleness, for their extravagance, and for living off the labour of others. Their collecting practice was understood as part of this. In 1790 the English philosopher Edmund Burke attacked the Revolutionary policy of confiscating aristocratic property. He asked why the collecting practices of the French gentry, this 'laudable use of estates', should be viewed as less valid than the same collections placed in a museum. Burke recognized, in keeping with the general view of the day, that the collections of the aristocracy were the expenditures of the idle rich, but to justify that excessive expenditure he associated it with museums ('great permanent establishments') and contrasted them with other 'innumerable fopperies and follies' in which the opulent rich indulged. He

defended 'property and liberty' by evoking the most defensible kind of property: that which is knowledge-producing (Burke 1999: 268–9). Burke was writing in the wake of the great debates about luxury that had raged throughout the eighteenth century. It had now become possible to separate certain kinds of luxury consumption from others: and especially to value luxuries while deriding ostentation. The attachment of the landed aristocracy to certain kinds of things was defensible while their flamboyance was not.

The luxury debates had begun in the late seventeenth century and the first half of the eighteenth century. These were not philosophical debates conducted in high isolation but struggles at the foundation of the emergent economic system of capitalism, and related both to class, and to forms of governance. In Britain, excessive dress and conspicuous consumption became associated with monarchs who wanted to concentrate too much power in their own hands. After 1688 there were great anxieties about luxury producing 'moral and political decline'. Luxury was associated with France – the 'source of absolutism and luxury fabrics', and connected to speculative investments, which became particularly controversial after the 1720 stock market crash (the 'South Sea Bubble'; Kutcha 1996: 62). In France itself, the emergence of consumerism in the eighteenth century provoked fierce argument about luxury, and its effect on the social, economic and moral well-being of the nation (Kwass 2003; Saisselin 1992: 28). On both sides of the Channel, arguments about luxury were linked to the advocacy of different political and economic systems, and economic interests. They were also used to justify the exclusion of women from political power. British and French writers issued stern warnings about effeminacy and the dangerous influence of women: in 1787 Sénac de Meilhan specifically blamed women, especially the royal mistresses with their taste for novelty and fashion, for the bankruptcy of the state and the aristocracy (Saisselin 1992: 41). Opulence also became associated with economic ruin, and seen as a national failing of the French in particular. In her mid-eighteenth century novel, Madame de Graffigny wrote, 'The dominant vanity of the French is to appear opulent. Genius, the arts, perhaps even the sciences, are all related to this magnificence; everything works to the ruination of fortunes' (cited in Saisselin 1992: 29). Meanwhile the bourgeois class, with their high-interest loans, quietly benefited from this aristocratic predilection (Haug 1986).

The question of where to draw the line between necessity and luxury, and what counted as overconsumption, was crucial to the luxury debates. Advocates of luxury could argue that either luxury was everything that was not necessary for survival, in which case everyone except the almost destitute participated in luxury consumption, or there was no such thing as luxury at all (Saisselin 1992: 38). In the end, a defence of luxury was developed which allowed the luxury market to continue whilst dissociating it from excess, and specifically, from the

excesses of the aristocracy. George Marie Butel-Dumont's 1771 *Théorie de Luxe* drew consumer goods such as white bread into the category of luxury. By linking luxury with utility, he separated it from ostentatious display and excess. He advocated that material objects should be used as a sensual source of human happiness, but not for status purposes (Kwass 2003: 95). Dumont found a way to please the advocates of modesty and the interests of the luxury market, namely by making a sharp separation between individual pleasure and social appearances – between the public and the private. This was the justification needed by the bourgeoisie, who could live luxuriously and still condemn the ostentation of the aristocracy. While the aristocracy had first produced the critique of luxury, the bourgeoisie now adopted it. The association of ostentatious luxury with femininity became a means to question both the moral standing and the right to rule of aristocratic men. The *conspicuous consumption* of the aristocracy had become a liability.

Although Burke was keen to separate serious collecting practices from the accumulation of fripperies and trivia, in practice the separation was not so clear, nor had it been a recognized distinction until then. For one thing, the 'curiosities' amassed in private collections from the sixteenth to the eighteenth centuries were part of the luxury trade. In the seventeenth century, the word 'curiosity' began to be used to describe things admired for their beauty, their intricacy, their rarity or their marvellous and even mythical properties. Curiosities were therefore also luxury items – unusual, rare and 'extravagant'. Trade between Europeans and the inhabitants of places like the Indies and the Pacific brought valuable spices, exotic foodstuffs and other luxury goods that were eventually to transform the everyday lives of Europeans. But alongside this was another trade – in the carapaces of pangolins and alligators; in bird-skins stuffed with straw; in rare plants and seeds; in everyday and ritual artefacts, fetishes and magical objects; in living animals, monsters and 'freaks of nature'; in artefacts associated with folktales and with mythological and historical events. These were the curiosities destined for the collections of wealthy noblemen in Europe, to be housed in their curiosity cabinets (or *Wunderkammern*), their botanical gardens and their menageries.

These things were intended for conspicuous consumption. It is often said that the curiosity cabinets were highly private, yet it seems that the collecting of curiosities was an important part of the self-presentation of the aristocracy, along with flamboyant dress and graceful posture. By the beginning of the seventeenth century, connoisseurs and learned men travelled to see one another's collections. Illustrated catalogues and visitor guides were also circulated, cementing the reputation of princes and collectors in the minds of those who had never visited their collection (Daston and Park 1998: 265–7). At their peak in the mid-seventeenth century, both curiosity cabinets and the emotion of

curiosity were signifiers of intellect, power, privilege and property (Daston 1995: 402). This is not all that they were, however. Housed in specially designed cabinets or rooms, curiosity cabinets were understood to reflect a scholarly interest on the part of their owners in the potential of the anomalous and the marvellous to unlock 'nature's secrets'. Since knowledge was associated with power, curiosity cabinets became a necessary accompaniment to great wealth. Many were arranged on the basis of highly complex philosophical, religious and occult theories (Hooper–Greenhill 1992: 105–26; Benedict 2001: 53–4). Objects were chosen according to these ideas and to their rarity and curiosity value. These were not distinct: the very aspects of an object which designated it worthy of scientific or philosophical study also marked it out as a luxury (Daston 1995: 396).

In the age of curiosity, knowledge and ostentation are bound together. The eighteenth-century society which viewed the ostentation of the aristocracy with such suspicion had little sense of this connection. Burke could only defend such collections by listing them in categories already belonging to the museum age. He pointed the reader to the eighteenth-century private collections more in tune with new scientific and historical ways of ordering and classifying objects, and drew attention away from the status of these objects as curiosities, except in relation to science and scientific curiosity. By the time he was writing, curiosity had an ambivalent status, with associations both of scientific enquiry and of fickle consumption. In 1757, Burke himself had established the place of curiosity at the heart of the developing consumer society when he wrote critically of it as the desire for or pleasure in novelty:

> But as those things which engage us merely by their novelty, cannot attach us for any length of time, curiosity is the most superficial of all the affections; it changes its object perpetually; it has an appetite which is very sharp, but very easily satisfied; and it has always an appearance of giddiness, restlessness and anxiety.
>
> (Burke 1958: 31)

The appetite of curiosity was said to drive overconsumption because, by the mid-eighteenth century, it has come to represent a fickle attachment to novelties, although the early curiosity collectors had understood their collections in complex and erudite ways. Even in the late seventeenth century, the social uselessness of the propertied classes was associated with the low use-value of curiosities. Then, the attack on the virtuosos and curiosity collectors was also an attack on the legitimacy of science as embodied by the Royal Society (Benedict 2001: 46–52). Scientists and 'curious men' were suspicious on religious grounds, not only because of their interest in the 'unnatural' and strange, but also due to their indiscreet tendencies to probe and question what

should not be questioned. Curiosity collecting was associated with superficiality, effeminacy and deviant sexual practices (King 1994; see Chapter 4, section 4 for more on this). In Britain, curiosities were trivialized as 'knick-knacks', a term which linked them also with castration through the word 'knackered'. The fact that curiosity collections included the grotesque and the monstrous was used to justify the representation of their owners as equally grotesque and monstrous (King 1994; Daston and Park 1998).

The changing fortunes of the concept of curiosity were linked to the competing claims to legitimacy made by different social classes. The attacks and moral rebukes that curiosity and curiosities invited were part of the bourgeois challenge to the dominance of the landed aristocracy. However, curiosity and curious things were also a threat to the nascent modern society, with its emphasis on order and classification, and everything (and everyone) in their place. Curious things were always singular objects (notwithstanding the fashion which dictated that every cabinet ought to have certain highly-prized objects). As the catalogues of curiosity cabinets indicate, many of the most popular curiosities were hybrids, anomalies or 'freaks'. Collections included two-headed foetuses (animal and human), objects from miraculous events (such as rains of toads) and miniscule carvings on fruit stones.

The term 'curiosity' would regularly be used to designate objects that were otherwise indefinable. This would not necessarily be a judgmental designation. For instance, in the late eighteenth century, explorers in the south Pacific were still commonly using the word to describe local artefacts. Nicholas Thomas (1991), in his study of material culture and the south Pacific, suggests that the term enabled them to acknowledge how different something was, and express an interest in it, without passing judgement. Captain Cook could describe a Tongan coconut-fibre apron or a Marquesan head ornament as 'curious', and in this way draw attention to their significance without saying how they were significant. Thomas attributes this reluctance at least partly to the lack of 'established anthropological discourse' about material culture. While there was an interest in artefacts in the 1770s, there was 'no developed language' through which their relevance could be understood (Thomas 1991: 131). Another way of looking at this, and without necessarily disputing Thomas's diagnosis, is that in Cook's journeys, at the beginning of the museum age, we still can trace the pleasure in the curious as that which is 'outside intelligibility' (Swanson 2000: 32).

Indeed, curiosity collections may be understood as an attempt to manage the unintelligibility of the strange and exotic, and the emotions such things aroused. In his study of European responses to the New World, Stephen Greenblatt (1991a) discusses the belief that an encounter with radically different natural and cultural worlds would produce sensations of wonder that could 'dispossess'

Europeans of their secure sense of self. Wonder is paralysing, 'dissolving' the self and allowing an absorption in, and identification with, the exotic. Excessive wonder prevented the assimilation of the marvellous into a moral framework and placed one in danger of 'going native' – of overidentifying with that which one was supposed to be dominating (Greenblatt 1991a: 20, 135). The curiosity market grew out of the so-called 'Age of Exploration' beginning with the European arrival in the Americas at the end of the fifteenth century. My argument is that while wonder threatened the colonial project and the self-identity of Europeans, the curiosity market took the paralysis out of wonder by transforming it into acquisitiveness. The curiosity cabinet allowed the assimilation of the extraordinary into a framework in which it made sense, without taking away its extraordinary quality.

When Burke describes curiosity as restless and the curious appetite as insatiable, he pinpointed an aspect of curiosity that curiosity-collecting both addressed and contained. This restlessness of curiosity is to do with the singular pleasure it offers of unseating or unsettling one's self (Swanson 2000: 32–3). Once the curious object becomes familiar, it loses this pleasurable quality; one must consume again to repeat the experience. This pleasurable aspect of curiosity is something like the loss of self described above. The enjoyment that the wealthy curiosity collectors got from their collections may have included something of this. But by the late eighteenth century the pleasurable and profitable aspects of collecting had become more widely available. Nicholas Thomas cites Captain Cook's Journals on the way in which the people of Tonga parodied the sailors 'passion' for novelty:

> It was astonishing to see with what eagerness everyone [the sailors] catched at every thing they saw, it even went so far as to become the ridicule of the Natives by offering pieces of sticks stones and what not to exchange, one waggish Boy took a piece of human excrement on a stick and hild it out to every one of our people he met with.
>
> (Cook's Journals cited in Thomas 1991: 128)

Another explorer, Johann Reinhold Forster, complained,

> How difficult it must be for a Man like me, sent out on purpose by Government to collect Natural Curiosities, to get these things from the Natives in the Isles, as every Sailor whatsoever buys vast Quantities of Shells, birds, fish, etc. so that the things get dearer & scarcer than one would believe.
>
> (Forster, cited in Thomas 1991: 140)

Cook and Forster draw a sharp distinction between their own (legitimate) interest in curiosities and the indiscriminate, ignorant and commercially-driven

collecting of the sailors (Thomas 1991: 140). Thomas argues that the sailors also aroused the irritation of the scientist-explorers because they were seen as not being entitled to these potent signifiers. As scientific specimens and material evidence, curiosities were linked to the high value placed on empirical, firsthand knowledge. As such, they were expressive of the experience and social position of the gentlemen explorers and the scientists who had travelled on the voyages (Thomas 1991:143). The sailors recognized in them the means to become wealthy; indeed this was one of their prime motivations for undertaking such journeys. Already we see a split between the official and scientific acquisition of ethnographic objects for museum collections (supplied by the gentlemen explorers) and the curiosity market, which supplied private collectors and museums via the sailors.

By the mid-nineteenth century, scientific curiosity is differentiated from acquisitive or prurient curiosity (Oettermann 1997: 127). The latter becomes associated with new forms of popular entertainment and a sensation-seeking public. Curiosity's association with scientific learning was now viewed positively, but its longstanding association with ostentation and overconsumption, and its association with popular displays of scientific (and not so scientific) marvels also led it to be viewed very negatively. The once refined passion of the aristocracy had become an appetite for the spectacular associated with the ignorant rural poor, the urban working classes, and with children and women of all classes. It was courted by the commercial cousins of the public museum, such as the amusement park, circuses and fairs, as well as sensational popular museums such as P.T. Barnum's American Museum in New York and Bullock's Egyptian Hall in Piccadilly, London. Barnum described his museum as an 'encyclopaedic synopsis of everything worth seeing in this curious world'. His exhibits included hoaxes such as the feejee 'mermaid' (half-monkey, half-fish), and, notoriously, human 'oddities'. As well as exploiting the vulnerable people he showed, Barnum played on the ignorance and gullibility of the audience (Cook 1996). Bullock also exhibited people – one exhibit included Laplanders and reindeer in front of painted panoramas. An 1816 caricature by George Cruikshank satirizes the 'swarm' of curiosity seekers who came to see Napoleon's coach at the Egyptian Hall: while the audience, which includes everyone from peasants to fashionable gentlemen and a disconsolate Frenchman, clamber over the coach, a museum employee shows some fascinated women 'one of Napoleon's shirts' (Oetterman 1997: 127).

The popularization of curiosity was also the marginalization of the grotesque and the unclassifiable. Where curiosity had once been an indifferent term, it now became a reproach. A similar change occurred with the term 'non-descript', in the seventeenth and eighteenth centuries, a non-judgemental term for animals not yet described or labelled. By the early nineteenth century

however, 'nondescripts were apt rather to appeal to casual curiosity-seekers . . . They were increasingly likely to figure, not in learned zoological discussions . . . but in the posters and handbills advertising sideshows and menageries' (Ritvo 1997: 55). Like 'curiosity', 'nondescript' becomes a negatively valued term associated with a certain kind of trivial thrill-seeking. The prurient looker (who 'gawps' and 'gapes' instead of gazing) is viewed from a high culture perspective as easily duped or taken in.

The trustees, directors, and curators of the great museums of Europe, Australia and North America tended to see popular entertainments as encouraging improper attention, and appealing to a crude lust for entertainment that they associated with the working class. David Goodman (1990) refers to the anxiety they expressed regarding such forms of attention as 'fear of circuses'. Museum authorities also began to vocally distance the museum from the curiosity cabinets, which they castigated as chaotic, poorly preserved and unscientific. By the 1860s, the story of the museum was already being told as a story of the progress away from 'mere curiosity', chaotic display and poor preservation, toward science, ordered typology and new techniques in preservation. This teleological account, which is still rehearsed today, relies on reading certain cabinets (such as Olaus Worm's cabinet in Copenhagen) as intermediate stages, in that they begin to use a recognizable classification system (Goodman 1990). In this way, the curiosity cabinet was presented as the primitive ancestor of the modern museum. Its marvellous and anomalous objects could only find a place in the public museum if they could be transformed into typical or representative specimens. The display of anomalies, oddities and the atypical became the specialism of fairgrounds and circuses, freak shows and curio (or dime) museums. The nineteenth century natural history museums, for instance, had inherited vast numbers of preserved animals from the curiosity cabinets. Yet the stuffed 'freaks of nature' (two-headed lambs, Siamese-twin pigs and so on) which had been commonplace in the early collections, were now only to be found in popular curio museums. The public's interest in these things was seen as improper, prurient or salacious.

One of the important insights of Tony Bennett's (1995) work is that the museum should not be treated on its own, but rather as part of an 'exhibitionary complex' which took shape in the nineteenth century. This complex included the spectacular displays of popular curio museums, world's fairs and trade exhibitions, amusement parks, shopping arcades and department stores. While the old curiosity collections passed on their objects, voluntarily or reluctantly, to the public museums, they left a legacy of a different kind to the other sites of the exhibitionary complex. I believe what they bequeathed was curiosity itself. The public museum distanced itself from these other sites of exhibition and display partly because curiosity and curious things did not sit well with the

emphasis on systematic knowledge of the typical, or with aesthetic experience. Yet, the museum isolated itself only by careful management of both the visitors and the collections. It had to work hard to transform its inherited collections into museum objects. This process was necessitated by the unstable and unsettling potential of both the appetite of curiosity, and the material things designated as curiosities.

In the museum age, objects must be made sense of, classified and given their place in the hierarchy of things and cultures. When Captain Cook set out on his first journeys, Nicholas Thomas argues, the aesthetic qualities of a culture's artefacts were not necessarily linked to judgements about the culture as a whole (1991: 131–2). In later journeys, however, artefacts were used in the attempts to produce an evolutionary hierarchy of Pacific peoples, and even the most 'curious' object became the subject of anthropological classification. The objects from the curiosity cabinets, marshalled into the new public museums were produced as intelligible material culture. To make the artefacts of the old curiosity collections work as museum objects, the museum had to stabilize them, reduce their potential to unsettle and make them the legitimate objects of scientific, historical or aesthetic interest. In the first decades of the twentieth century, museum authorities regularly complained that visitors continued to treat museums as 'storehouses' of curiosities. In 1904 the influential League of Empire advised the 'orderly arrangement and transformation of mere curios into objects of scientific interest by appropriate classification' (cited in Coombes 1991: 194).

Meanwhile, curiosity became the province of the popular amusements already mentioned as well as of the cinema and the new emporiums of consumption, the department stores and shopping arcades. Here were offered the sensations of the unfamiliar and faraway within everyday cultural spaces (Swanson 2000: 28). Most importantly, these were public spaces frequented by women. Curiosity, far removed from the firm claims to objective knowledge of the public museum and of science, now belonged to the feminized world of popular consumption and mass-produced fantasies of luxury. Yet, at least in the United States, the museum did not stay distant from this world for long, and perhaps was never as distant as the statements which explicitly rejected curiosity might lead us to suppose. As H. Glenn Penny writes: 'scarcity – in the form of the rare, the odd, the old or the strange – maintained a prominent role in the selection of artefacts and the designation of their value' (2002: 80). The museum, like the market, was driven by the desire to possess, and objects gain value in proportion to the difficulty in acquiring them.

From the marketplace to the museum

In museums of natural history, ethnography, and archaeology, new and more scientific museum practices were developed by applying the principles of 'experimentation, observation and verification' to the study of artefacts (Bennett 2002: 37). Through the technical procedures involved in fieldwork, collection, classification and display, museums process objects, fixing their place in the community of objects and enabling them to do the work of museum objects. Using Latour's work, Bennett argues that museum objects are more than just bearers of meaning, they are actors performing given roles, and the institution itself plays the role of stabilizing their relations to non-human and human actors (2002: 36). The museum director Philip Rhys Jones has compared the museum to an 'impresario' who 'sets the scene, induces a receptive mood in the spectator, then bids the actors take the stage' (cited in Duncan 1995: 12–3).

Like the door-closer discussed above, museum objects become able to substitute and shape human activity. Through these processes and procedures the artefact comes to embody history, nature or a particular culture, rather than simply representing them (see also Watson 1999: 87). Furthermore, the human labour which turns this material thing into a museum object is concealed from the visitor, who is invited to perceive it as playing its role without direction (Bennett 2002: 39–40). The museum is like a theatre – enabling objects to 'perform', hiding what goes on 'backstage'. The properties an artefact gains through being processed by the museum come to seem its own properties. It is not difficult to spot a similarity with Marx's account of commodity fetishism. The labour that goes into making the object a museum object, is, to use Marx's term, 'congealed' in the object, which appears to us to 'come to life' in the museum.

In museums that contain once-useful objects (tools, say, or household arte-facts), the detaching of these objects from their use-value turns them into signi-fying things: representations of the category to which they are assigned. The museum processes them in such a way that the visitor, who might encounter similar things outside the museum and give them little regard, approaches them as objects of contemplation and instruction, as things which 'speak'. In the case of art, the transformation process is more complex, since art is already an object of contemplation rather than use. However, one of the earliest critiques of the public museum was based on the notion that art did have a use-value and that the removal of artworks from its original sites into the museum destroyed their authenticity (Maleuvre 1999: 17–8). Quatremère de Quincy, a writer and secretary of the Académie des Beaux Arts in Paris, opposed the establishment of the Louvre and the transformation of art into 'a practical course of instruction in modern chronology' (cited in Belting 2001: 40). For

Quatremère, the museum destroys the authentic living character of works of art by making them perform as history lesson. The objects he was concerned with were mostly antiquities – ancient Greek and Roman artefacts – that in his view had beauty, inspirational purpose and therefore a 'public function' in their original sites, which they lost through being removed and placed in museums (Belting 2001: 40). When the museum removed them from their life-contexts, where they had real social and moral purpose, it cut them adrift, turned them back into 'mere matter'. Quatremère saw the act of aesthetic contemplation in the museum as the 'sterile admiration' of dead things (cited in Maleuvre 1999: 16).

Quatremère saw art only existing as art when in its original context, and in relation to use. Yet there is a strong tradition in Western philosophy which defines art precisely by its uselessness: by its ability to stand for freedom by standing outside the drudgery of day-to-day existence. As the cultural theorist Didier Maleuvre argues, culture does not arise simply out of living, but by acts of meditation on living, it transcends 'embeddedness in being' by stepping out of the everyday and reflecting on it (Maleuvre 1999: 26–9). In this argument the very idea of art is connected to its detachment from living circumstance – the museum makes art, even whilst it also imprisons it and restricts its effects on the world outside. From this perspective, Quatremère's critique seems nostalgic because it evokes a time/place where art and life were more authentic because they were so closely interwoven. It also seems conservative because by reducing art to usefulness and social relevance it sees it as little more than 'society's self-congratulating vote of confidence'. As Maleuvre says, 'Insistence on art's entrenchment in immanence (to life, history, society) neutralizes it far more than any museum display' (1999: 33). Maleuvre argues that art is, by definition, already detached, reflective and critical of society.

These two perspectives raise questions about the relation between art and the commodity, and the museum and the marketplace. How does the 'sterile' admiration of 'mere matter' in the museum, which Quatremère described, differ from the admiration of beautiful goods on sale in the department store? If art is realized, rather than sterilized, by the museum, as Maleuvre suggests, does that mean that the aesthetic contemplation it invites is deeper, or more complex than the desirous looking invited by the commodity? And if things are constituted as objects through acts of attention on the part of visitors, as well as through the procedures and attentions of the museum, what happens when the museum visitor brings to the museum those modes of attention she applies in the marketplace? Does the museum, by its act of detachment, disallow this possibility?

The art historian Daniel J. Sherman reads Quatremère's critique of the Louvre as suggestive of how the museum actually invites the evaluative criteria

of the marketplace into the museum (Sherman 1994: 125). He discusses how the commission appointed to oversee the setting up of the Louvre as a national museum in the 1790s attempted to distance it from the market by refusing to have art dealers included in their number (Sherman 1994: 133). However, in Quatremère's view, the museum was already caught up in commerce because it replaced art's original value with its market value. The eighteenth-century art market established the exchange value of paintings and sculptures on the basis of highly specialized understandings of artistic form and technique. This system of value is associated with the emergence of a narrow, professionalized 'art world' disconnected from the broader public. Using Quatremère's writings, Sherman argues that the museum transferred this private system of exchange into the public sphere: by detaching the art object from its life-context, it makes the market's criteria of value into the main means of understanding the value of art in the museum. Criteria originally meant to establish the exchange-value of an antiquity (including age, authenticity, discriminations of technique and style) came to dominate the museum. Potential buyers understood the value of art objects in the art market because they were skilled at seeing those qualities which, according to the criteria, established each object as more or less valuable. When this market-oriented notion of aesthetic value passes over into the museum, all museum visitors are like potential buyers – more or less skilled in evaluating the objects presented to them. Notions of beauty proceed from these learnt evaluative techniques but they seem to emanate from the artwork itself. Just as exchange value passes for an innate quality of commodities, the value system which established the exchangeability of the art object comes to be seen as a property of that object. Like a wolf in a sheepskin coat, exchange value sneaks into the museum in the form of aesthetic value, and parades itself as transcendent and universal (Sherman 1994: 129).

This would seem to suggest that the market criteria of value and the aesthetic qualities which make something worth contemplating in the museum are identical. Therefore aesthetic contemplation in the museum is not too different from the contemplation of goods in the marketplace. Yet, as Maleuvre says, a work of art is more than just a sensuous thing; it is a reflective commentary on the world. In contrast, the sensuality of commodities tends to be seen as something harnessed to their economic function, a false appearance purely dedicated to inspiring desire in potential buyers. In this sense, the commodity is 'the antithesis of the aesthetic object' or 'a grisly caricature of the authentic artefact' (Eagleton 1990: 208–9). This is what the German Marxist philosopher Wolfgang Haug (1986) calls *commodity aesthetics*.

If, in theory, it is difficult to wholly disentangle the aesthetic experience to be had inside the art museum from its 'grisly' counterpart in commodity aesthetics, in practice they are entangled because of the way in which museums and stores

'stage' their respective objects. To enhance the sensual appeal of commodities, nineteenth-century commodity display evoked the privileged space of aesthetic contemplation. The **department stores** which first opened in the 1850s took inspiration from the museum in their interior décor. Museums were amongst the few places in which the majority of people could experience luxurious surroundings. The early stores wanted to create an impression of luxury, and the use of museum-like interiors helped them turn mass-produced goods into luxury items. Like museums, and like stately homes, they used mahogany, carpeting and chandeliers, heavy drapery, deep skirting boards and dramatic sweeping staircases. In this way they addressed women consumers, not just in recognition of middle-class women's increased purchasing power and of their role in styling the home, but also because of the feminization of luxury. While men's dress and demeanour had become less and less ostentatious through the nineteenth century, women's dress and the interior décor of the home had become central means by which signifiers of class were communicated (especially, though not exclusively, through the use of luxury fabrics). In its early days, the main lure of the department stores was related to women's recognition that social class was a matter not simply of wealth or heredity but of successfully styling oneself and one's home through consumption. The luxurious home was an object of fantasy for many women, associated with class aspiration, and the luxurious setting of the department store seemed to rub off on the things it offered for sale (Harris 1978: 150).

In art museums, especially, the luxurious setting was conceived of as providing the right setting for an aesthetic experience. But in the stores it was to give the impression that when one purchased a commodity from this luxurious setting, some of the luxury would come with it. If this was a one-way borrowing of display by stores from museums, it might be easier to argue that the two were still distinct, that the commodity simply dressed itself in the trappings of art. But the traffic in display design was two-way, and it involved not just art museums, but museums of all kinds. That is to say, not just museums concerned with aesthetic value, but those concerned with historical and scientific value as well. There is an argument that museums aestheticize all objects, turning them into objects of primarily 'visual interest' (Alpers 1991). This argument has been contested on the basis that there are many objects in museums that are not visually interesting at all, but that are made interesting by the contextual information given (Kirshenblatt-Gimblett 1998: 17). The argument that museums aestheticize may suggest, however, something of the effect of shared display techniques.

There are countless ways in which museums and department stores used one another's techniques or played on their similarities. The Magasin du Louvre, which opened in 1855 in Paris, took its name from the great museum.

Period rooms were first used in museums at the turn of the century, and in the 1920s and 1930s the department stores used them – at one point Macy's in New York had 65 such rooms (Harris 1978: 162). Window displays and museum dioramas both made use of wax mannequins, and new lighting technologies and techniques (such as 'boutique lighting') were shared between the stores and the museums. These similarities are not unintentional or coincidental. William Leach writes of 'a powerful institutional circuit through which merchandising ideas passed and were given aesthetic shape' in the United States (1989: 128). This circuit, as Leach says, included the museum. The newly wealthy impresarios who ran the department stores, such as Wanamaker and Blum, sat on the directorial boards of the major American museums in the mid- and late nineteenth century. They even founded museums – the Field Museum in Chicago was founded on the basis of a million dollar donation by Marshall Field (Conn 1998: 78). They supported the arts through their stores and, from the turn of the twentieth century, began to finance art exhibitions.

Several designers and curators operated in both the worlds of merchandising and museum display, influencing each with ideas derived from the other. For instance, Joseph Urban, an Austrian who designed 'some of the first modern museum interiors' as well as theatre sets, murals and hotel interiors, was commissioned in the 1910s and '20s to transform the interior décor of various large department stores in the United States (Leach 1989: 122–5). The curator Stewart Culin, known for his innovative displays and his campaigning against the dry and cluttered displays of the museums, had come from a mercantile background. He forged close connections between the museum displays and displays in department stores (Leach 1989: 130; Bronner 1989). The department stores created a new social élite in America, and the museums aggrandized them, gave them the appearance of magnanimity and immortalized them (Duncan 1995: 54, 83). They also provided new opportunities which shaped a generation of designers, display artists and architects. The museums became a resource for these designers, a place where inspiration for display themes and settings could be found (Leach 1989: 126).

Department stores helped produce a world of display organized around the desirability of goods. Displays work on the level of **affect**, they appeal to the body, the emotions and the senses. They turn objects into fetishes, not just in the Marxist sense, but also in the sense developed in the psychoanalytic theories of Sigmund Freud. *Fetishism* in Freudian terms is the transferral of (usually male) sexual desire onto a material thing (Freud 1953, 1961). Certain things lend themselves to fetishism more than others, for instance certain kinds of clothing and fabrics because of their role in concealing women's bodies. The nineteenth-century department stores played on the sensuality of materials such as silks and furs, enabling customers to touch and stroke them. Contradicting

Freud, they played on the eroticism that such materials held for women, not men. But the stores also held back the objects, placing them – as in the museum – behind glass to convey preciousness, and also to protect against the nimble fingers of shoplifters. Such displays work to heighten desire at the same time as they unavoidably distance the viewer from the thing. Historically the museum had rejected the appetites (such as curiosity) and put in their place a supposedly objective and neutral aesthetic value, but it reinstates desire through the use of store-like display techniques. The play of distance and closeness, absence and presence, which the glass-fronted display sets up, in both store and museum, is fundamental to the construction of material things as objects of *desire*.

Store window displays were designed to entice potential customers and encourage desirous looking. Window dressing first emerged in the late nineteenth century, and the early 'show windows' of North American department stores were astonishingly elaborate. Between the 1890s and the 1930s, show windows in these stores used live models, mannequins, brightly coloured textiles, artificial lighting, and animated mechanical displays. Whole scenarios were created, representing exotic and historical cultures, fairy tales and fantasies. The use of live female models in window displays of lingerie caused crowds to gather in the streets and even sparked riots (Leach 1989: 117). L. Frank Baum, the author of *The Wizard of Oz*, wrote a handbook for dry goods (i.e. textiles) window dressers which was published in 1900, the same year as the first Oz book. According to Baum, the shop windows ought to arouse curiosity, using all the 'humbug' and wizardry of the trade, to invest the commodity with magical properties, to animate it (often literally) and bring it to life – it is no coincidence that Baum's children's books are filled with mannequin-like characters come to life (Leach 1989: 107–8; Culver 1988).

Like all advertising, in other words, the role of the shop window display is to fetishize the commodity further. Trade publications emphasized the economic purpose of the window display, as the Chicago publication the *Dry Goods Reporter* advised in 1901: 'Goods should be so displayed as to force people to feel that they really wish to possess them' (Abelson 1989: 73). However window dressers also saw themselves as artists, the window not as a means simply to promote goods but also as a means to create a marvellous thing and to display their own virtuosity. Through a reading of Baum's window dressing book and of *The Wizard of Oz*, Stuart Culver argues that there is an implicit recognition that the ideal audience for a shop window display is someone who admires the display but does not want to take the goods home – who recognizes that the fantasy only stays intact if the display stays intact (1988: 112–3). The moment the commodity is removed from the display and taken home it is already beginning to lose its attraction. The act of consumption, though theoretically the ultimate purpose of the display, ends the fetishistic relationship, and kills

the commodity. The moment when the commodity actually comes to life is in the display. For the true window shopper, the shop window is like a museum display. When department store techniques are appropriated for the museum, the visitor in the museum may become like a window shopper. And the museum display technique which most resembles shop windows is the habitat **diorama** – a genre common to natural history museums in the United States and in Sweden and less used elsewhere. Both window displays and dioramas produce an oscillation between closeness and distance, between wanting to enter the scene and being placed outside it, something that is encouraged by their shared use of sheet glass, three dimensional models and lighting.

Natural history museums in the United States began to construct whole halls of dioramas in the 1920s. Possibly the first was the Hall of North American Mammals in the California Academy of Sciences, San Francisco. By 1929, the American Museum of Natural History in New York (AMNH) had five halls being planned. From the point of view of a visitor in the darkened hall, each backlit diorama appears like a shop window. Some halls, such as the Akeley Hall of African Mammals in the AMNH, have two tiers, making them reminiscent of shopping arcades and early malls. Cinema scholar Alison Griffiths argues that the hall of dioramas was a solution to a problem of attention in the

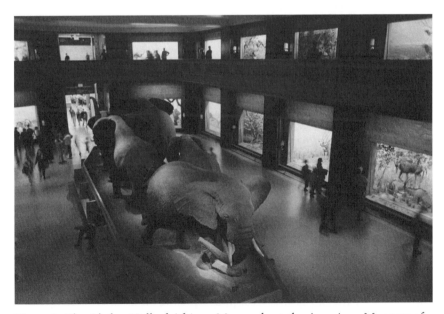

Figure 1 The Akeley Hall of African Mammals at the American Museum of Natural History in New York.
Source: Photograph by the author with kind permission of the AMNH.

museum (2002: 12–16). The cluttered appearance of natural history museums was found to be deleterious to visitors' attention. Visitors seemed distracted, their attention aimlessly drifting from one object to the next one that caught their eye. By moving the exhibits into the walls, the museum encouraged the visitor to be selective and focused, just as the store window was designed to arrest the drifting attention of the passer-by on the street. The hall of dioramas makes use of blank empty spaces and dramatic lighting (see Chapter 2 for more on the habitat diorama).

Interestingly, similar developments were happening in department stores in the same period. By the 1920s and '30s, department stores had been modernized, their interiors architecturally redesigned to maximize light and displays organized to minimize clutter and encourage the free flow of customers. According to Neil Harris, by the 1930s stores moved toward lighter interiors, selective and minimal displays, careful use of blank spaces and lighting, and they attempted 'to surround the shopper with a sense of adventure and to underline this by the continual display of new objects'. Harris sees the stores as being ahead of the museum in this, and as prompting a critique of the museum based on the new aesthetics of the department store (Harris 1978: 162–4). But in the hall of dioramas we can see a similar emphasis on discretion and selectivity, and on the careful organization of space to manage visitor attention. In the art gallery and the international expositions, free-flow displays were designed to open up vistas across the space, to organize the traffic patterns of visitors (Staniszewski 1998: 174).

Harris accounts for the changes in the department store on the grounds that class aspiration was now associated not with ostentation, but with modernism in architecture and interior décor. The association of the stark clean spaces of modernism with wealth is based in a changed concept of possession. The department stores of the interwar years in the US reflected the new association of modernist aesthetics with social superiority (Harris 1978: 161). But there was also an educational emphasis. While the hall of dioramas was intended to communicate an attitude to nature, the department stores were schooling popular taste. The impact of modernism on mass consumption was supposed to be to reform the taste of the people on the basis that consumption should be about discretion, not just accumulation. William Leach describes museums in the United States as participating in a wider training of the public in a new 'commercial aesthetic', an expression of the new commodity culture (1989).

Stephen Conn (1998) argues that the 1920s mark the end of the role of museum's primary role in American intellectual life. I discuss his argument in more detail in the following chapter, but I want to emphasize that the change in that country's museums in this period (and related changes in European museums a little later) was not a shift away from education as such but toward a

different kind of education. The modernist museum is highly educational. Like the modernist department stores, it schools the visitor in taste and discretion, in the values and the virtues of the 'sophisticated' consumer and the qualities most associated with wealth. Minimal amounts of objects, individual lighting, and large empty areas became more suggestive of wealth than accumulation and clutter, now associated with Victorian poor taste and even with poverty. The display of the permanent collection of a modern art museum connects aesthetics with commerce, both by recalling expensive modern homes or classy boutiques and by addressing visitors as discerning consumers. This effect is doubled since the modern art museum has become associated with objects with a high exchange value. By the 1950s, as New York replaced Paris as the centre of the world art market, modern art attracted popular interest in the United States partly because of the exorbitant amounts museums were paying for it. A number of highly publicized spectacular purchases created an interest in visiting the museum purely to see if the new acquisitions were worth the incredible price attached to them (Harris 1990: 91; Smith 2002). The American middle classes had been schooled in a new kind of aesthetic appreciation, tightly wedded to their skills as consumers, with discretion, good taste, and an eye for value.

This is not to say that the modern art museum simply addresses people as consumers, but that the development of taste and aesthetic value in the museum cannot be entirely separated from commodity aesthetics, which in turn cannot simply be reduced to false or illusory pleasures. The education of taste is clearly linked to the production of certain kinds of citizens and consumers and to class aspiration, and this is discussed further in Chapter 4. However, this is not the only way in which the modern art museum becomes entangled with the market. Modern art museums and exhibitions have become a means by which global economic status and political identities are established and maintained. This was recognized in the social histories of art written by Serge Guilbaut, Eva Cockcroft and David and Cecil Schapiro in the 1970s and early 80s. They described the manoeuvres which enabled New York to 'steal the idea of modern art' from Paris, and how in the 1950s the CIA with the Museum of Modern Art (MOMA) funded exhibitions of American abstract expressionist art. These exhibitions toured Latin America and constructed an identity for the United States as a centre of liberty and free expression (Guilbaut 1983; Cockcroft 1985; Schapiro and Schapiro 1985). More recently, critical attention has turned to the relationship between the promotion of the YBAs ('Young British Artists') in the 1990s and London's prominence in the financial services industry (Marshall cited in Rectanus 2005). Major public museums, not just art museums, are now characterized by increased corporate involvement. They use market indicators as a means of measuring the success of exhibitions and depend on satellite industries for the production of exhibitions (Rectanus 2002).

Exhibitions of design expose the tenuousness of the distinction between an 'authentic' aesthetic experience in the museum and commodity aesthetics. Since the 1940s, exhibitions of design and of everyday objects have been involved in schooling taste (some of these exhibitions are discussed in the final section of Chapter 2). More recently, museum staff have expressed concern at architecture and design companies which treat contemporary art museums as places to showcase their work and increase commissions (Rectanus 2005). In these circumstances, and particularly in an environment of increased privatization and dependence on corporate money, the line between museum and marketplace becomes ever more blurred. However, it is in the museum shop that the two come together most perfectly:

> The immediate gratification felt by the department store customer in the act of purchase, and the experience of handling objects and learning more about them, which was the joy of the fair-goer, are united in the museum store, and seal the museum-going experience for many visitors. Appropriately enough in our culture, it is a commercial setting which legitimises an aesthetic setting.
>
> (Harris 1978: 172)

The shop legitimizes the museum by inserting its objects into the world of taste and fashion, giving them a new life in reproduction, and returning them to the world of commodity circulation. This consolidates a longstanding relationship between the museum and the market. As I have suggested, the museum age is also a period of rapid growth in the circulation of commodities and of the development of new forms of attention. The museum in the modern period both emerges from, and produces, new relationships with things. The next chapter takes this argument further, examining modernist critiques of the acquisitive, overcrowded museum, and considering more closely some of the exhibition strategies which were devised to reinvent the museum.

Further reading

Fisher, P. (1991) *Making and Effacing Art: Modern American Art in a Culture of Museums*. Cambridge, MA: Harvard University Press.

Belting, H. (2001) *The Invisible Masterpiece*. London: Reaktion Books.

Hooper-Greenhill, E. (1992) *Museums and the Shaping of Knowledge*. London: Routledge.

DISPLAY

The Louvre is a morgue; you go there to identify your friends.

(Jean Cocteau)

We are not supposed to ask, as my children did when I took them to see the dioramas, 'did they have to kill the animals to bring them here?'

(Marianna Torgovnick 1990: 77)

The overcrowded cemetery

While the last chapter looked at how the museum turns things into museum objects, this chapter is concerned with the development of display techniques. I want to show how display both puts objects to work and *overcomes* them, establishing new kinds of relationships to museum visitors. In the second and third sections of the chapter we consider illusionistic genres of museum display that place museum objects in a naturalistic scenes, reconstructing the environment in which the museum object previously lived. Barbara Kirshenblatt-Gimblett refers to these as 'in situ' displays (1998: 19–20). Here I also address recent arguments about the modes of attention that nineteenth and early twentieth-century visitors brought to the museum, and about the educational role of such displays. In the final section, I discuss avant-garde exhibitions of the mid-twentieth century, which set up very different relationships to the audience, and in doing so, start to challenge the primacy of the object. These developments in display were partly provoked by concerns that the experiential and sensory impact of the museum was tainted or corrupted by its commitment to amassing vast collections and its emphasis on history. This found expression in a discourse which associated the museum with death, and that is the subject of this first section.

At the turn of the twentieth century the museum came under critical attack, as it had at the start of the nineteenth, but this time from modernists. Attacking the Victorian attachment to the past in the form of the museum

was characteristic of the early twentieth-century avant-garde. The Italian Futurist Filippo Tomaso Marinetti denounced museums as cemeteries in his 1909 'Founding and Manifesto of Futurism' (Marinetti 1973). The Soviet painter Kasimir Malevich compared the art of the past to corpses, while the Soviet critic N. Tarabukin described the art museum as a cemetery and art historians as grave robbers (Groys 1994: 148–50). In the late nineteenth century, the metaphor was used by critics of various political and aesthetic inclinations. In France the Romantic poet Alphonse Lamartine called the museum a 'cemetery of the arts', the nationalist politician and writer Maurice Barres referred to it as the place where 'the dead corrupt the living', and the writer Paul Valéry described it as a place where 'dead visions' compete for attention (Bazin 1967: 265; Valéry 1956). These attacks on the museum were informed by different politics, but they shared a vehement rejection of the Victorian obsession with the past, and especially, the art of the past.

The cemetery metaphor was also used by members of the museum world who were pressing for change. In 1888, George Brown Goode, the assistant secretary of the Smithsonian in Washington, argued that 'the museum of the past must be set aside, reconstructed, transformed from a cemetery of bric-a-brac into a nursery of living thoughts' (cited in Conn 1998: 20). By contrasting the cemetery with the nursery, Goode evoked the two poles of life and implied a distinction between the overcrowding of 'bric-a-brac' and the neatly planted seedlings of the nursery. He meant that museums need to change, become more systematic and organized to ensure that their objects become objects of knowledge.

The cemetery metaphor was quite differently employed by Marinetti. In the 'Founding and Manifesto of Futurism', he denounced museums as cemeteries, suggesting they only be visited as we might visit a grave, to annually place a wreath beneath the Mona Lisa. He announced:

> It is from Italy that we launch through the world this violently upsetting incendiary manifesto of ours. With it, today, we establish Futurism because we want to free this land from its smelly gangrene of professors, archaeologists, ciceroni and antiquarians. For too long has Italy been a dealer in second-hand clothes. We mean to free her from the numberless museums that cover her like so many graveyards.

> (Marinetti 1973)

Marinetti attacked the museum's orientation toward the past and toward 'dead' things, and scorned the encyclopaedic pretensions of the late Victorian museum. Like Goode, he described cemeteries as overcrowded spaces, but the effect of this overcrowding is not disorder (to which he was rather partial) but an intimacy between strangers, between bodies whose lives had been lived

in isolation from one another but which are now placed together in false connection:

> Museums: cemeteries! . . . Identical, surely, in the sinister promiscuity of so many bodies unknown to one another.
> Museums: public dormitories where one lies forever beside hated or unknown beings.
> Museums: absurd abattoirs of painters and sculptors ferociously slaughtering each other with colour-blows and line-blows, the length of the fought-over walls!
>
> (Marinetti 1973)

Marinetti's manifesto announced a contempt for history and historicism, which we find in other writings of the avant-garde, but unusually, Marinetti hitched anti-museum sentiment to nationalism (he later joined Mussolini's Fascists). The manifesto was published in the French newspaper *Le Figaro*, but he emphasized its source – 'from Italy' – at the same time as he rejected the museum culture of Italy, and by implication France too, in the effort to pronounce himself of the present and of the future. Marinetti associated museums with an obsession with the past which was corrupting and infecting the body of the nation.

Critical writing today tends to see museums as having been instrumental in the construction of concepts of nationhood, encouraging the patriotic feeling necessary to the projects of imperialism and colonialism (see Duncan 1995). That Marinetti could instead join nationalism with anti-historicism is perhaps due to the fact that he had lived in countries crawling with the 'professors, archaeologists, ciceroni and antiquarians' of foreign colonial powers. He had grown up in a wealthy Italian family in Alexandria, Egypt, which was at that time a fast-growing modernized city. But Egypt had been a source of antiquities for European museums since the Napoleonic invasions. After the British occupation of Egypt, which began in July 1882 with the bombardment of Alexandria, excavation became more intensive, as the Egypt Exploration Fund began to export antiquities to the British Museum. There, the Egyptian collections more than tripled in size between the late 1880s and the 1920s (British Museum, n.d.). Like Egypt, Italy had had many of its antiquities appropriated by the French in Napoleon's invasion. Through the museums, the historians and the antiquarians, both countries had gained an identity that was bound up entirely with their glorious past. Their loss of status was evidenced by the presence of their antiquities in the national collections of colonial powers such as France and Britain. For Marinetti, the past was stifling and enfeebling, associated with physical weakness and illness (rotting, poisoning, gangrene, the sickly). Against it he eulogized youthful strength and rebelliousness and

depicted himself as an iconoclastic collective, declaring, 'But we want no part of it, the past, we the young and strong Futurists!' New culture is to be made from 'violent spasms of action and creation', its sources are modern technology, its icons are racing cars.

Many of these themes – the anti-historicism, the cult of youth, the emphasis on action, and national identity – can be found in the writing of Friedrich Nietzsche who was an important influence on Marinetti. In his second 'Untimely Meditation', published in 1873 and titled 'On the Advantages and Disadvantages of History for Life', Nietzsche did not repudiate history and the past altogether but attacked the 'excess' of history with which he felt his own country, Germany, was burdened. He outlined different kinds of relationships with the past and with history, different ways in which history can 'serve life'. The history that Nietzsche categorically opposed was history as knowledge for its own sake, history as a science. Though he made little reference to museums, it was there that the encyclopaedic historical orientation of his era found public expression. In the discipline of history and in the sciences, the past is not understood as one's own roots ('antiquarian history') or as an inspirational model ('monumental history') but appears as an infinite overaccumulation of information:

> Now the demands of life alone no longer reign and exercise constraint on knowledge of the past; now all the frontiers have been torn down and all that has ever been rushes upon mankind. All perspectives have been shuffled back to the beginning of all becoming, back to infinity. Such an immense spectacle as the science of universal becoming, history, now displays as has never before been seen by any generation; though it displays it, to be sure, with the perilous daring of its motto: fiat veritas, pereat vita [let truth prevail though life perish].
>
> (Nietzsche 1997: 77)

The nineteenth-century discovery that the age of the earth was far greater than had been previously assumed had an immense impact both on the discipline of history and on the 'historical sciences' (including natural history, geology, archaeology) (Bennett 2002: 32). Nietzsche argued that nineteenth-century 'man' becomes burdened with historical knowledge entirely divorced from experience, and these 'indigestible stones of knowledge' are – like the artworks in Marinetti's cemeteries of art – at best strangers, and at worst, constantly fighting one another. Conflicting and irreconcilable pieces of knowledge – knowledge that does not add up and cannot be put to use in the business of living and transforming one's world – is internalized but not fully understood. Nietzsche connected too much history with a lack of vitality, with degeneracy and sickness. Yet whereas Marinetti opposes the sickly and the 'moribund' to

'we, the young and strong Futurists', the sickness of which Nietzsche wrote was weakness of 'nature' or of character, caused by an excess of historical knowledge and a consequent split between internal character and outward appearance, a split he saw as characteristically German (1997: 82).

The writer Paul Valéry also associated museums with overaccumulation. His essay entitled 'The Problem of Museums', published in *Le Gaulois* in 1923, echoes Marinetti in its description of the battles and conflicts between the paintings and sculptures in the art museum. Valéry called the museum a 'house of incoherence' and describes the sense of panic and feeling of offence induced by the placing of incompatible unique works alongside one another. He argued that 'modern man' is 'impoverished by an excess of riches'. Donations and legacies to the museum, the continual production of new works, new purchases and changes in taste and fashion which revive previously dismissed works, 'incessantly combine to produce an accumulation of excessive and therefore unusable capital' (Valéry 1956; see also Adorno 1967: 177). Just as over-accumulation produces 'dead' capital, so an encyclopaedic gathering together of artworks (for Valéry) or historical knowledge (for Nietzsche) makes those objects and that knowledge 'dead'. For both Valéry and Nietzsche, over-accumulation led to superficiality. Nietzsche wrote that the only way to deal with the onslaught of new historical knowledge was to embrace it as lightly as possible (1997: 79). Half a century later, Valéry saw the only options as becoming superficial or becoming erudite. For Valéry (1956), erudition is not a positive term when applied to art: 'It substitutes hypotheses for sensation' so that 'Venus becomes a document'. For Nietzsche too, the picture galleries represent a kind of education that has substituted itself for a real experiential understanding of art. Education becomes the learning of facts unrelated to experience. The encyclopaedic inclinations of the Victorian era, in Nietzsche's view, had the unfortunate effect that modern people, stuffed with 'the ages, customs, arts, philosophies, religions, discoveries of others', become 'walking encyclopaedias' (1997: 79).

A related argument about overaccumulation can be found in the work of the sociologist Georg Simmel. Writing at the turn of the twentieth century, Simmel saw modernity as bombarding the senses of the modern individual, who is unable to process the wealth of information, goods and sensations on offer. Consequently the individual either becomes prone to nervous disorders or confronts modern everyday life with detachment, and an insensitivity to the differences between things. For the jaded modern, everything is reduced to the same. In his essay on the Berlin Trade exhibition of 1896, Simmel stated:

Nowhere else is such a richness of different impressions brought together so that overall there seems to be an outward unity, whereas underneath a

vigorous interaction produces mutual contrasts, intensification and lack of relatedness.

(2002: 299)

The overabundance of things in the museum produced the problem of the confused, disoriented spectator (Griffiths 2002). One response to this is to enforce an illusory coherence. This is precisely what the great exhibitions of the nineteenth and twentieth centuries did. As Simmel commented, 'It is a particular attraction of world fairs that they form a momentary centre of world civilization, assembling the products of the entire world in a confined space as if in a single picture' (2002: 299). Nietzsche used the world exhibition as a metaphor for the way that too much historical knowledge led to a jaded relationship with reality. He argued, 'modern man who allows his artists in history to go on preparing a world exhibition for him . . . has become a strolling spectator and arrived at a condition in which even great wars and revolutions are able to influence him for hardly more than a moment' (Nietzsche 1997: 83). For Nietzsche the very concept of the world exhibition is associated with history as spectacle, and for Simmel the world's fairs produce a fragile illusion of wholeness out of what is in fact very disparate material. Yet a detailed look at the development of exhibition techniques suggests that it was at such international exhibitions and trade fairs that new exhibition techniques were developed which would eventually counter the impression of the museum as a site of amassed but 'dead' stuff. These techniques, discussed in the final section of this chapter, were first developed by the men and women of the Soviet avant-garde. Avant-garde artists, designers and architects reinvented the exhibition medium, but they also attacked the existing institution of the museum.

Like the writers already discussed, the Soviet avant-garde extolled 'life' as opposed to the dead past preserved in museums. After the Russian Revolution of 1917, the avant-garde argued for a new post-Revolutionary aesthetic, integrated with everyday life. Instead of having a special place for aesthetic experience, all life should be aesthetically transformed. The museum had become associated with the bourgeoisie and pre-Revolutionary art was seen as an expression of an overthrown bourgeois social order (Groys 1994: 145). The avant-garde believed that the new proletarian society would require an aesthetic of its own. This notion found justification in the writings of Marx, who argued that while earlier revolutions had needed to draw on the material of the past, a communist revolution would have to reject 'borrowed language' and forge its own 'poetry' (1968: 96–8).

The painter Malevich's essay 'On the Museum' presented the destruction of the museum and of all past art as a creative, life-affirming act. Malevich saw the preservation of the great monuments of past art as a hindrance to life and

to an art of the present day. The museum was a graveyard, the past associated with death, all past art and monuments merely corpses. To cultural conservatives, Marinetti had conceded a ritual in the form of annual visits to lay flowers before the Mona Lisa, but Malevich suggests a new kind of exhibition: 'In burning a corpse we obtain one gramme of powder: accordingly thousands of graveyards could be accumulated on a single chemist's shelf. We can make a concession to the conservatives by offering that they burn all past epochs, since they are dead, and set up one pharmacy' (cited in Groys 1994: 148). As the art historian Boris Groys says, Malevich sees the destruction of the past and of the museum as a kind of 'conceptualist act'. Art, for Malevich, is not something which can be preserved in museums, but produced through the processes of life itself, and so the artworks preserved in museums are just corpses – the empty husks of art (Groys 1994: 148–9). Nietzsche had described how the monuments of past art (the masterpieces) could become a weapon used against present art and action because of the overwhelming authority they gain as historical cult objects. For Nietzsche 'monumental history' could, in the right hands, act as a spur for life and for heroic action, but in the wrong hands (of the 'inartistic') it could be used to slay art itself (1997: 70–2). Similarly, Malevich viewed the art museums as a threat to both art and life, and especially to the bringing together of art and life.

Groys argues that the Soviet avant-garde regarded the museum from within terms set by the museum. He says that the distinction they drew between the art of the past and the art of the future is drawn along art museum lines, as differences in style and form. Ironically, the whole Soviet avant-gardist approach to making art, with its emphasis on the tangibility and 'thingness' of the artwork was, according to Groys, only possible once art had been isolated in the museums and torn from its representative and utilitarian role in social life (1994: 146–9). Groys argues that ultimately it was the Soviet state and the socialist realist art it sponsored (the arch-enemy of the modernist avant-garde) which destroyed existing conceptions of art and museums, by employing the museum as a didactic tool in the new totalitarian society. When the new socialist museum reorganized the collections seized after the Revolution, it gave all museum art a uniform significance: all was evidence of a progressive 'folk' culture, everything an expression of a dream for socialism and a critique of the class structure. In the 1930s, socialist realism made art into a utilitarian practice, as a vehicle for ideology, and museum art was indistinguishable from the visual propaganda saturating the society. Nineteenth-century historicism was replaced with an ahistorical uniformity, but overaccumulation continued, as the relationship between the museum and the artists' union resulted in a massive overproduction of artworks (Groys 1994: 155–61).

In the long term though, avant-garde exhibition practice did transform the museum by introducing to it an approach to display that interrogated the relationship between visitors and museum, and pressed visitors to question their received habits of attending to museum displays. The fourth section of this chapter considers this in detail. Before this though, we will look at the realist display techniques of the natural history diorama and the tableaux and immersive exhibits used in folk museums. These are more conservative in their conception than avant-garde exhibition design, but they too have been controversial, considered as concessions to populism which are detrimental to a deep or interrogative understanding of science or history. Like the great exhibitions in Simmel's account, they attempt to construct an illusion of coherence. They are explicitly inspirational, addressing the viewer as an individual and attempting to create an intense sense of being in the scene (in nature, or in the past). Each in their own way is a solution to the deadliness of the museum: both attempt to bring the subject of the museum 'to life' even while they deploy technologies heavily associated with death – taxidermy and the waxwork.

Dioramas as popular education

Natural history dioramas – sometimes described as habitat groups or habitat dioramas – are displays that use realist taxidermy set in illusionistic scenes. In the early twentieth century they were also a means of organizing the content of the natural history museum, addressing the problem of overaccumulation and the consequent distracted and drifting attention of visitors. The diorama hall, with its darkened centre, illuminated scenes, and overwhelming attention to detail, closes off distractions. To spectators accustomed to the bombardment of the senses that Simmel had diagnosed as characteristic of modern everyday life, the hall of dioramas offers an illusion of coherence. To the museum, it offered the possibility of regulating the unruly behaviour and distracted wanderings of visitors (Griffiths 2002: 15). By replacing cluttered displays, the dioramas changed the way in which the museum addressed its audience. I have already pointed to some resemblances between the hall of dioramas and shopping arcades and department stores (see Chapter 1). Here I will develop this argument further, and examine how dioramas connected museums to other sites in the 'exhibitionary complex'. The changed address to the audience is also to do with a shift in the educational purpose of the museum. This section considers the educational role of the dioramas in relation to commodification and consumption.

In a detailed study of dioramas, Karen Wonders links them with a commitment to popular education. In Sweden and the United States, the two countries

where the diorama first flourished, the foremost aim of the natural history museum was education, whilst elsewhere, she suggests, scientific research took precedence (Wonders 1993: 9–11). However, Stephen Conn (1998) argues that in the US at least, the dioramas were symptomatic of the shift of museums *away* from a commitment to popular education. Conn says that in the late nineteenth and early twentieth century the museum in the United States was conceived of as a site of the production of knowledge available to citizens from all social classes. He links the diorama with the forced retirement of the museum from involvement in cutting edge research, which by the 1920s had become the province of the universities. The diorama introduced popular spectacle to the museum, but as science it was in some respects already behind the times (Conn 1998: 66–71). Even while the first full halls of dioramas were in production, some museum staff and scientists were concerned that they were ineffective communicators of modern biology. Scientists were preoccupied with animal movement and behaviour, which the static dioramas could not adequately convey (Mitman 1999: 62–4). Also, the dioramas presented natural history as eminently visible, while biology explored that which cannot be seen with the naked eye. That the diorama had enormous popular appeal is not at issue. The question is whether the dioramas represent a shift away from addressing the museum public as active producers of knowledge, in favour of addressing them as the recipients of already formed ideas and knowledge.

To understand the popularity of the dioramas, we need to first consider the popularity of natural history itself. Today, natural history museums seem popular by museum standards, in that they have high visitor numbers, and appeal to visitors from less affluent backgrounds. However, this is a different kind of popularity to that of natural history as a practice during the nineteenth century. The journalist Lynn Barber (1980) has described the practice of natural history as extraordinarily classless compared to other Victorian pursuits. She claims that in Britain, it was participated in by men and some women from across social classes. Barber argues that working-class participation was enabled by several factors including the exclusion of natural history from university curricula, which meant that there was not a professional class of qualified naturalists. Added to this was the accepted view that it was an innocent amusement, even a religious one, since the publication in 1800 of William Paley's book *Natural Theology* which presented natural history as a means of studying 'God's design'. Working-class people were tolerated in natural history because the middle classes considered it a useful distraction from gambling and drinking, and political activism. Nor were the costs prohibitive; the equipment needed was simple and the study material readily available – branches such as entomology were especially popular since specimens were small and easily stored, and there was no need to own a gun. Furthermore, a speedy

postal system meant that naturalists from different classes could correspond and exchange specimens without coming face to face (Barber 1980: 31–9).

In Britain and North America, the popular passion for natural history supplied museums with an audience and with specimens, while larger animals were supplied by the hunter naturalists who killed big game in Britain's colonies and in the North American wilderness. As in Britain, early nineteenth-century natural history in the United States was relatively inclusive. Naturalists believed they were engaged in a devout and democratic pursuit. The members of the Philadelphia Academy of Natural Sciences, founded in 1812, included eminent scientists alongside working men and women (membership was predominantly male). Charles Willson Peale, who founded his private museum of 'natural curiosities' in the late eighteenth century, promoted his museum as being of use to a wide cross-section of society including farmers, merchants and mechanics (Conn 1998: 35–7).

The first major natural history museums saw themselves as places for research and study. Joseph Henry, the first secretary of the Smithsonian Institution (which opened in 1846), described the collections as 'the rough material from which science is to be evolved' (Henry cited in Wonders 1993: 108). The Philadelphia Society's museum, which opened in 1826, had object-based research as the primary purpose of its displays (Conn 1998: 38). Louis Agassiz, the founder of the Museum of Comparative Zoology at Harvard University saw the museum's purpose as furthering scientific education by facilitating the study of specimens (Wonders 1993: 108). These figures did not so much favour scientific research over education, as see research *as* education. This model was swiftly being overtaken by another, which viewed education as the dissemination of already-formed facts and ideas to as large a public as possible. In the 1870s, William Ruschenberger, president of the Philadelphia Academy of Natural Sciences, campaigned against efforts to market the museum in the same ways as department stores, and to emphasize entertainment and exhibition over research (Conn 1998: 40, 58). The increasing pressure to turn museums into sites of mass popular appeal was at the expense of the notion of the museum as a research institution for everyone.

The museum which most epitomized the new vision was the American Museum of Natural History in New York. Founded in 1868 as 'a democratic institution dedicated to popular education in the natural sciences', it was entirely financially dependent on its trustees. These were wealthy businessmen who favoured 'naked eye science' and supported the branches of natural history with the largest and most impressive specimens (Wonders 1993: 109). While some museum men held on to the importance of distancing the museum from popular entertainments, the AMNH wholeheartedly embraced popular techniques of display – most obviously in the form of the diorama. Frank M. Chapman,

creator of the bird dioramas at the AMNH, stated that the exhibits 'should appeal to sightseers as well as fact-seekers', in contrast to the view of Joseph Henry at the Smithsonian, who had declared in 1856 that the museum was not intended 'merely to attract the attention and gratify the curiosity of the casual visitor' (Wonders 1993: 127; Conn 1998: 40).

The dioramas could appeal to sightseers because of their association with popular spectacle. They were closely related to the panoramas of the eighteenth and early nineteenth centuries. These great paintings in the round were housed in specially constructed buildings with viewing platforms in the centre. They specialized in bird's-eye views of landscapes, townscapes and battle scenes, and developed from theatre sets which had become increasingly illusionistic and landscape-based (Schwartz 1998: 149–76; Wonders 1993). By the end of the nineteenth century, the period of the first natural history habitat groups, panoramas were addressing an increasingly broad audience. In Paris, for instance, lowered entry fees accompanied increased illusionism: using technical devices and three-dimensional objects, the aim was to envelope the spectator, giving them the sensation of being in the scene (Schwartz 1998: 149–52, 162). Unlike older popular entertainments, the new 'attractions' of the nineteenth century relied on stimulating sensations through illusionism, and in the process transforming the visitor from participant to spectator (Gunning 1989, 1990; Crary 2002: 11). Such attractions often included taxidermy, which was transformed from a set of individual isolated curiosities into a key component of illusionistic scenarios. In London, William Bullock's Egyptian Hall, which opened in 1812, incorporated animal specimens in panorama-like attractions. For instance, in the 1820s, Bullock constructed a Mexico-themed display, in which a large three-sided painting of a Mexican landscape formed the backdrop to a mixed display including taxidermy, casts of Aztec artefacts, and fake plants (Crary 2002: 10). In popular displays of taxidermy, it became commonplace to pose animals against painted backdrops in dramatic and spectacular ways, suggestive of ferocity and wildness.

At first, 'serious' museums steered clear of these kinds of displays, preferring simple poses and blank backgrounds for their taxidermy. Then, the year after it was founded, the AMNH bought 'Arab Courtier attacked by Lions' by Jules Verreaux, which had won a gold medal at the 1867 Paris Universal Exposition. This was a glass case with a flat painted scene at the back, a mannequin slumped on a camel and two taxidermied lions. In 1882 it bought William Hornaday's 'Fight in the Treetops', a tableau of fighting orang-utans (Wonders 1993: 114–5). The purchase of such tableaux marks out the AMNH as pursuing a particularly populist strategy. Museum staff and trustees saw the museum as a site of 'rational amusement' and 'a resort for popular entertainment' (Jesup and Boas cited in Griffiths 2002: 7, 5). In Sweden, the habitat diorama followed

the panorama format closely. Gustaf Kolthoff's Biological Museum, which opened in Stockholm in 1893, shows a continuous panoramic display of taxidermy animals against a curved painted backdrop, and viewers stand in a central tower reminiscent of Thomas Bentham's Panopticon prison (see Foucault 1979: 200–9).

In the United States, panoramas and natural history dioramas were linked by painting style and composition. American natural history museums commissioned painters with experience in the popular illusionistic techniques of the panorama (Wonders 1993: 187–91). These painters were also influenced by artists such as Thomas Moran, Frederic Church and Albert Bierstadt, who painted large-scale landscapes of the vast American wilderness in the 1850s and 60s, combining topographical study and Romantic composition. The diorama painters were well trained in illusionistic devices used to give impressions of realism, and three-dimensional depth. Techniques such as strong contrasts and sudden drops separating foreground and background heightened the illusion and helped to conceal the join between the three-dimensional models in the foreground, and the painting behind. American museums took the illusionism of the panoramas further by developing highly realistic taxidermy techniques. At the AMNH, Carl Akeley developed the technique of mounting the skin on a cast made from a sculptural model, which was based on precise measurements of the corpse and observations made of the living animal. The vivid and detailed musculature this technique produces can give the animals the appearance of being just about to move (this is most evident in the mountain lions and jaguars in the North American Mammals hall at the AMNH which opened in 1942). Akeley and his colleagues made an astonishing permanent representation of the tiniest transient details: we see perfectly lifelike plants which never wilt, the moisture of a rhinoceros's nostril and of the wet mud in which it wades.

The dioramas enter natural history at the point of the decline in popularity of natural history as a practice. This was connected to the increasing professionalization of field naturalism – the study of species in their habitats. In Britain, numbers practicing field naturalism declined even as the London Natural History Museum gained its own building, separated its study collections from its show collections, and attracted over 400,000 visitors a year. In the United States, however, field naturalism gained in status because of the dominance of the sportsmen, a moneyed male elite of hunter–naturalists and collectors. Sportsmen were important figures for most natural history museums in Europe and America, but at the AMNH they dominated the exhibitions policy. The men who initiated the first habitat dioramas were sportsmen and most dioramas were of species considered to be game (Wonders 1993: 149). The Boone and Crocket Club, a sportsman's society established in 1888, counted

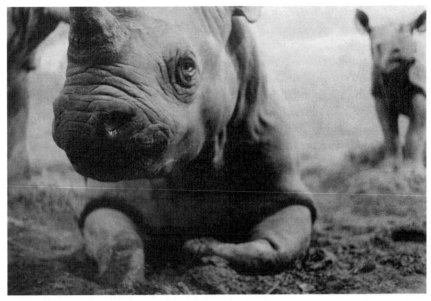

Figure 2 Detail of rhinoceros diorama, the Akeley Hall of African Mammals at the American Museum of Natural History in New York.
Source: Photograph by the author with kind permission of the AMNH.

Theodore Roosevelt and several of the trustees of the AMNH amongst its wealthy and influential members. These men viewed their passion for big game hunting as compatible with a belief in nature conservation and the Boone and Crocket club initiated some of the first conservation projects and legislation in the United States (Wonders 1993: 153).

The sportsmen's conservation efforts helped protect their access to recreational hunting as the spread of settlement closed the American frontier, and also helped preserve their socioeconomic position. The AMNH and the Boone and Crocket club were dominated by men whose inherited fortunes were heavily invested in the industrial exploitation of the wilderness, yet who campaigned for recreational nature reserves (Brechin 1996). As the feminist historian of science, Donna Haraway (1989) has pointed out, the same men were involved in the **eugenics** movement and the anti-immigration movement. Henry Fairfield Osborn, president of the AMNH from 1908 till 1933, and the inheritor of a shipping and railroad fortune, used his expertise in vertebrate palaeontology to justify scientific breeding, immigration restriction and anti-Semitism. Madison Grant, anthropologist, trustee of the museum, founder of the Bronx Zoo, and member of the Boone and Crocket club wrote the book Adolf Hitler described as his 'bible', *The Passing of the Great Race* (1916), in which scientific rhetoric

provides a veneer for assertions of white male superiority and the argument that miscegenation produced degeneracy (Brechin 1996). Haraway argues that Akeley's African Hall, with its emphasis on the perfect male specimen and conventional family groupings, encodes a masculinist and colonial view of the world, and uses nature as justification for eugenicist notions of the survival of the fittest. She shows how the dioramas express the anxieties and worldview of the men who 'largely authored' the museum (Haraway 1989: 41, 54–8).

Another view, from Tony Bennett (1995), would be that such anxieties translate not directly into the content of displays but into the increasing involvement of museums in the techniques of liberal government. This is not to suggest that men such as Osborn and Grant were politically liberal, but that they were part of a larger project which saw the museum as a means to enable people to regulate their own behaviour and exercise restraint. As Bennett acknowledges, this does not mean that the museum actually worked in this way, but that such ideas shaped its formation (1995: 11). The museum was thought to have a moral effect, countering 'the influence of the saloon and of the racetrack' (Boas cited in Griffiths 2002: 5). This notion, originating in Britain, was the basis of the 'modern Museum idea' propounded by George Brown Goode in 1895 (Bennett 1995: 20). In the natural history museum this idea combines with earlier views that studying nature in the field was morally beneficial. Nature itself was seen as playing a role in the control of the working classes, as Osborn wrote: 'Nature teaches law and order and respect for property. If these people cannot go to the country, then the Museum must bring nature to the city' (Osborn cited in Brechin 1996). However, for Osborn and others at the turn of the century AMNH, the lessons of nature and the civilizing effect of the museum were produced through acts of consumption, rather than (as earlier) through the active involvement of working-class people in the practice of natural history. The dioramas directed visitors toward a particular understanding of nature whilst, at the same time, positioning them as consumers. For the men who ran the museum, the dioramas offered to transform the museum visitor. But they were not simply the expression of certain social interests and anxieties; rather they spoke to existing popular tastes and beliefs. This was because they took shape out of well-established artistic traditions and much-used popular display techniques.

As with the Romantic and panoramic styles in painting, the dioramas invest nature with an apparently religious significance. Haraway perceptively highlights their quasi-religious character, describing the Akeley African Hall as both a 'cathedral' and a depiction of a lost garden of Eden, with each diorama appearing as an 'epiphany' or a 'revelation' (Haraway 1989: 29, 38). She links this religious quality with the white supremacist beliefs held by the trustees and hunter–naturalists. But the dioramas also reaffirmed a Romantic, theological

vision of nature, which was already popular, thanks to Paley's *Natural Theology* mentioned earlier. Romantic associations of sublime and picturesque scenery with religious feeling held great sway in the United States, where the lack of architectural monuments was compensated for by a monumental landscape. By the second half of the nineteenth century the North American landscape was a source of nationalistic pride, seen as evidence of America being blessed by God (Shaffer 2001: 364). In Sweden, natural history dioramas similarly expressed a connection between wilderness and national identity, providing a vision of nature appropriate to the sense of nationhood and deeply rooted in popular nineteenth-century concepts of natural history. The religious character of natural history, which should perhaps have never survived Darwinism, was given justification and permanent representation in the dioramas. The dioramas attribute religious significance to scenes of nature through the use of 'natural symbolism' derived from Romanticism. Romantic painting attributed spiritual meaning to the landscape by deploying a symbolism so broadly used that it appears to be natural (such as the association of light with transcendence), or by drawing on the meanings that seemed to emanate directly from the experience of nature (such as the feelings of anticipation and unrest associated with a gathering storm) (Rosen and Zerner 1984: 57–8). In the dioramas, the combination of Romantic symbolism and extreme illusionism works to produce a sense that the cultural meanings attached to nature are actually innate, and that these meanings are felt rather than read.

Romantic and panoramic painting also introduced visual devices which invite the spectator to immerse themselves in the scene by an act of imaginative identification. The most famous example of this is Caspar David Friedrich's painting *Traveller above the Sea of Clouds* (sometimes called *The Wanderer*) of 1818, in which the central human figure has his back turned to us, as he looks toward the landscape. In the Hall of North American Mammals, at the AMNH, the jaguar and the mountain lion dioramas use a similar technique. The animals look away from the viewer into the wilderness beyond, which is lit by the setting sun. In both cases, these figures are like the avatars in present day computer games – we imagine ourselves to be them, in the landscape. While we are enticed into the illusion, we are kept from it by the glass, effectively positioned outside nature, looking in. In the classic habitat diorama, there are no signs of human presence, the landscape appears untouched, unspoiled. Nature is thus presented as scenery, reachable only through sight. Visual consumption replaces the bodily experience of being in nature. Early visitors might have found that the dioramas both affirmed their belief in the divinity of nature, and their understanding of natural scenery as a feast for the eyes, and a trigger for fantasy and reverie. The dioramas position the visitor as a solitary spectator who is privileged to examine in detail a scene

that might have otherwise existed only momentarily, or possibly not at all for a human viewer.

Though, as I mentioned earlier, the static nature of the dioramas made them incapable of representing aspects of contemporary biology, it is possible to see them as peculiarly appropriate for addressing a modern spectator, precisely because of this frozen quality. Realist (post-Akeley) taxidermy freezes animal motion, much as a photograph does. Walter Benjamin associated this frozen-motion effect in photography with the development of an 'optical unconscious', allowing the eye to see what had previously been hidden from it, opening up reality for close examination (1979: 243). This is precisely the intention of the creators of the dioramas, and they addressed a mass audience that had become accustomed to finding fragments of reality far removed from their original spatial and temporal context.

Another aspect of the diorama which is characteristically modern is the way it deploys 'reality effects'. This phrase was coined by Roland Barthes (1989) to describe the use of descriptive detail in nineteenth-century realist novels. Reality effects are all those extraneous descriptions which don't serve to progress the narrative, but which work to underwrite the realism of the text. The Berlin 'media archaeologist' Friedrich Kittler (1999) suggests that such reality effects first become apparent in new analogue media technologies in the nineteenth century (such as photography, film and phonography) which record everything, regardless of its significance. In photography and phonography, reality could be recorded without being translated into symbolic code first, which allowed for the presence of meaningless noise, utterances, and imagery which the conversion of data into symbols would usually filter out (Kittler 1999: 16, 23). Older understandings of what constituted a real or 'true' representation are replaced with a 'forensic' notion of realism, in which reality is found in traces, in background noise and in irrelevant detail. Late nineteenth and early twentieth-century representations in a wide range of media mimic or reproduce such extraneous detail to underwrite their own realism. And so the Akeley-style natural history habitat diorama painstakingly reconstructs the traces and details that are indifferently recorded by machines such as the camera (photography was heavily used in the design and construction of the dioramas). The diorama marshals these technologically produced effects of the real into a coherent composition. In doing so, it manages to be simultaneously modern and popular, addressing a visitor reconfigured as a consumer, and carrying an (apparently) morally uplifting conservationist message, mixing scientific veracity with popular illusionism.

Attention and mimesis

Illusionistic exhibits address visitors who have formed new habits of attention in response to rapid changes in social life, new popular entertainments and forms of transport and communication. From the mid-nineteenth century, rapid but globally uneven modernization (concentrated not just in western Europe and the Americas, but in pockets across the continents) allowed new – or newly dominant – practices of attention to emerge. The characteristically modern form of spectatorship has been termed 'panoramic perception', a mobile, impressionistic and distracted way of looking, shaped by the experience of the railway train, the department stores and early cinema (Schivelbusch 1986). Late nineteenth-century museum designers were faced with the challenge of capturing and holding the attention of visitors accustomed to the fleeting impressions and spectacular displays of modernity. Visitors were bringing to the museum 'composite viewing habits' and expectations formed in response to other modern experiences and attractions (Sandberg 1995: 321–2). These were not well-received by the museum. There was concern that visitors either moved casually and inattentively through the museum galleries, or seemed to become intoxicated by the array of stuff in the museum and would gawp at it in wonder, failing to absorb the pedagogic messages of the institution. Though some curators recognized that it was possible to learn through experience, without necessarily becoming intellectually engaged, and whilst museums appropriated popular spectacle in the form of life groups, tableaux and habitat groups, the mindless intoxication associated with popular spectacle continued to be negatively valued (Griffiths 2002: 11–6). Exhibit designers worked to produce certain modes of spectatorship. This can be understood as an attempt to manage the attention of visitors. Jonathan Crary (1999) has written of how attention is produced as an object of scientific study from the late nineteenth century, in response to anxieties about the effects of modernity on people, especially populations viewed as particularly susceptible. His concept of the 'management of attention' describes how cultural forms and technologies are used, not just to prevent and prohibit, but also to incite and produce certain kinds of attention. In the case of museums what was required were docile spectators – engaged and complicit – rather than passive gawpers or distracted drifters.

Before discussing the ways in which visitor attention is managed through illusionistic exhibits, I want to say a little about the kind of rapt attention which was, and is, perceived as undesirable. I want to suggest that the low value attached to gawping (also called 'gawking' or 'gaping') is linked to notions of social inferiority and the threat it poses to class distinctions. Gawping has long been associated with peasant and working-class behaviour, the behaviour of children and with idiocy, ignorance and credulity, while composed silent

contemplation is associated with middle-class aesthetic appreciation and self-possession. The dictionary definition of a gape as 'a gaze of wonder or curiosity' reveals the modern association of curiosity and wonder with passive spectatorship. This kind of looking is the antithesis of the gaze – which connects looking to power, and possession. In cultural theory the gaze describes an abstracted act of looking, characteristically disembodied, distanced and assured. The gape, by contrast, is bodily; as the gawker's eyes widen, and his or her mouth drops open ('gapes') or yawns ('gawps'). As the adjective 'gawky' suggests, this kind of looking involves a dropping of composure, and a bodily awkwardness.

Since gawping is not simply an internal and invisible disposition but a highly visible form of public behaviour, it is available to be policed. As Tony Bennett has argued, in the nineteenth century the public museums begin to function as 'instruments for the reform of public manners' through a process of self-surveillance (1995: 90). Gawping is both ill-mannered and unselfconscious. In the 1930s, Walter Benjamin wrote of the *badaud* (gawper or gawker) intoxicated by the city sights, completely losing herself or himself in spectacle. When the *badaud*'s shifting, drifting attention does alight upon an object it fixes *excessively* – he or she becomes totally absorbed in the object, unable to take a critical distance, self-oblivious. Unable to classify or make sense of the world, the *badaud* confronts it 'with a wild and vacant stare' (Benjamin 1983: 69; Gunning 1997: 27–8 and Edgar Allan Poe cited in Gunning 1997: 32). Anyone can become a *badaud* if they let their guard slip. By the 1840s class distinction had become increasingly a matter of miniscule coded differences in dress and comportment, especially amongst men (Sennett 1993: 164–8). The mingling of social classes in public spaces such as the museum and on city streets gave a new importance to questions of visible social distinction. Young women were advised to police their own looking, and to be careful not to treat high-cultural objects as 'gape-seed'. Policing gawping is about policing class distinctions, and the distinction of the (bourgeois) self from the mass. To become a *badaud* is to join the masses: 'Under the influence of the spectacle which presents itself to him, the *badaud* becomes an impersonal creature; he is no longer a human being, he is part of the public, part of the crowd' (Fournel cited in Benjamin 1983: 69).

The introduction of immersive, mimetic and environmental displays, such as the diorama and the historical reconstruction, was an attempt to counter distraction and produce rapt attention. Barbara Kirshenblatt-Gimblett uses the term *in situ* to describe these kinds of displays, which 'at their most fully realized . . . recreate a virtual world into which the visitor enters' (1998: 3–4). Ironically such exhibits have become the ones most often associated with gawping, accused of producing passive and uncritical spectators who lose themselves in the illusion. In the 1990s, the historian Raphael Samuel castigated British

academics and journalists for disliking 'living history' and simulation-based heritage displays, and for associating such displays with mindless gawping because of their popular appeal (Samuel 1994: 268). It is interesting that the same exhibits are understood by their advocates as producing transformative experiences closely related to aesthetic experience – it seems that how audience attention is read depends on notions of class and the value attached to *mimesis* (see also Chapter 4, section 2).

The museum seeks to manage attention because all attempts at classifying and organizing its objects into a coherent narrative founder without the properly directed attention of the visitor. Given the wrong type of attention, the collection could collapse again into a 'mere' collection of curiosities. The anxieties expressed by museum directors and staff regarding visitor attention are linked to the recognition that they cannot entirely control it. *In situ* displays seem to offer more control over visitor experience than the orderly collection of objects. They often require tight control of visitor movement (in some cases only working if visitors take a particular route through the exhibit or stand in a specific place). Exhibit designers give great consideration to visitors' engagement by organizing and controlling viewpoints and pathways through the exhibits, and by careful arrangement of space within the exhibit. Yet, the viewing pleasures visitors experience may still conflict with the explicit ideological content of the displays.

The possible discrepancies between the stated intentions of museum directors and the experiential possibilities of exhibits are suggested by Mark Sandberg's (1995) study of folk museums. He distinguishes between the 'eventual social function' of the folk museum and its 'neoromantic' origins. Like the habitat diorama, the folk museum flourished first in Scandinavia, where the industrial revolution came relatively late, and the imperative which shapes both kind of display is in many ways anti-modern, harking back to a more organic and stable existence prior to industrialization. The Scandinavian folk museum used immersive displays to bring folk culture closer, but the ways these displays positioned and addressed the visitors often ended up confirming and reproducing modern, panoramic and voyeuristic ways of seeing (Sandberg 1995: 321–5).

Sandberg argues that the pleasures that visitors got (and still get) from these kinds of displays were peculiarly modern pleasures related to mobility. Visitors reported enjoying the ability to dip into the past and re-emerge from it, together with the sense of themselves (and the past) being both present and absent (Sandberg 1995: 349). Artefacts heavy with historical resonance were placed in scenes, brought to 'life' by narrative (through the scene and the accompanying text), and the presence of wax mannequins in period costume. The construction of such narrativized space allowed spectators to take up the position of voyeurs. Sandberg describes the mannequins as 'in-between' figures which enabled visitor

identification because they appeared both alive and dead, present and absent. This 'in-betweenness' helped visitors to imaginatively substitute themselves for the mannequin (Sandberg 1995: 331–7; Metz 1982: 42–57). In this sense the mannequins work like the figure in Friedrich's *Traveller above the Sea of Clouds* mentioned on page 51.

Voyeuristic looking was encouraged by the fact that the tableaux of the early folk museums were arranged for an observer looking at the scene from one side, as if looking into a house through an invisible fourth wall. As with the dioramas, their composition was frequently based on painting: Sandberg claims that at the Philadelphia exposition of 1876, about half the Swedish folk-life tableaux were based on well-known genre paintings (Sandberg 1995: 335). In these ways, the tableaux, along with the panorama and the diorama continue to prioritize visual experience, separating visitors from the scene they behold, which they can only enter imaginatively. This voyeuristic positioning frustrated folk museum curators who saw it as perpetuating a detached relationship 'too reminiscent of the social distance between folk culture and modernity, insertion fantasies not withstanding' (Sandberg 1995). They developed immersive displays in which visitors wandered through actual rooms populated by mannequins and nothing 'except perhaps social decorum' prevented them from touching or interacting with the waxworks. Artur Hazelius's open-air museum at Skansen deliberately confused real people and mannequins, posing living guides in apparent interaction with the effigies in order to surprise his visitors. Sandberg sees this playful approach as part of the transition to the new forms of immersive display, schooling visitors in how to negotiate the space, before mannequins were dispensed of altogether (Sandberg 1995: 339–44).

The transition to immersive space marks a significant break in the way in which visitors are invited to engage with museum displays. While the simulation remains within the constraints of a visual spectacle, addressing a spectator positioned outside it, the space of the display is only experienced imaginatively. Immersive exhibits engage visitors on a more sensual level, inviting them into the space. They promise a greater degree of immediacy by allowing the material of the display to have a physical effect on the spectators. This was noted in 1967 by Molly Harrison, the curator of the Geffrye museum in London, as she argued for the educational importance of reproduction and dramatic techniques within the museum:

> A girl who walks among eighteenth-century furniture dressed in a good reproduction of the costume of the period feels something of what life was like 200 years ago, more deeply than could result from mere seeing, or even handling the furniture. Her classmates, too, will notice that she walks differently in the long dress, that the tilt of her head is altered by the weight

of the wig and that her gestures become almost elegant. They will sense the past more vividly for seeing her walk, even though the costume she wears was made only yesterday.

(Harrison 1967: 2)

The child's composure and behaviour is materially determined. The ability to really feel and inhabit the past, is for Harrison, a means of engaging the child pedagogically when 'the pace and noise and complexity of modern life makes concentrated looking difficult' (1967: 6). Harrison's educational projects in the period rooms of the Geffrye Museum owe much to the history of hands-on displays and progressive educational theory. But she sees in simulation a means to manage attention through experience. Mimesis and theatre can evoke the absent world from which the artefacts in the collection have been extracted. They complement an educational emphasis on sensory experience, as well as on environment and process. They allow the museum to reproduce that which cannot be collected – which is immaterial, intangible, or ephemeral (Kirshenblatt-Gimblett 1998: 20, 28).

The folk museum founders saw the capacity of objects to evoke what is absent from the display and make it seem present. In the immersive exhibits, mannequins were replaced by guides in period costume but also by traces of human presence: clothes, shoes and possessions placed as if someone had just been touching or wearing them and had only recently left the room, intending to return. However, these touches, combined with the fact that what was on display were private domestic spaces, meant that visitors could still feel themselves to be in a rather illicit position, now as trespassers rather than voyeurs (Sandberg 1995: 345–7). While the museum founders were looking for immediacy, a sense of unmediated contact with the past, many visitors seemed to enjoy the simulation *as* simulation, finding pleasure in the to-and-fro between deception and recognition. Instead of desiring an older and lost (or rapidly disappearing) reality, a good number of visitors took pleasure in that in-betweenness, a pleasure that was only possible through modern spectator positions, and that dispensed with the priority of the original over the copy, reality over the representation. By the 1910s, Sandberg suggests, many visitors no longer felt any nostalgic attachment to the reality the folk museum represented. Instead, they were attached to the representation itself, which allowed them to enjoy the advantages of modern spectating. Indeed, it is possible that 'the compensatory social functions of narrative helped make modernity attractive, turning a sense of "displacement" into "mobility" and a feeling of "rootlessness" into "liberation" ' (Sandberg 1995: 352–3).

Sandberg's study of the folk museum and visitor's responses to it suggests a gap between the explicit pedagogy of the exhibit and the pleasures visitors

found in it. Even though these reconstructed spaces may seem the most controlling of the visitor experience, offering a ready-made and already narrative experience, the ways in which visitors attend to them, shaped by a host of modern experiences outside the exhibitionary space, may be in direct conflict with the intended lesson of the exhibit. A similar conflict exists in present day immersive exhibits. The most dramatic examples can perhaps be found not in museums but in zoos. Present day immersive zoo design situates visitors in highly illusionistic reconstructions of the Amazon rainforest, Congo jungle and so on, complete with fake rocks and waterfalls, or even fake weather conditions such as a sudden snowfall or mountain mists. The explicit pedagogy of such exhibits is about environmentalism, about inspiring visitors toward a greater commitment to the environment, and about the new zoo project of protecting biodiversity and endangered ecologies and species. Yet the pleasures visitors get from such technically complex simulations may be quite antithetical to the project of getting them to care about the reality to which such representations refer. As with the folk museum, visitors may even prefer the simulation, and the display may compensate for 'late' or 'post' modernity in much the same way as the folk museum 'helped make modernity attractive' for some.

Film theorist Tom Gunning (1989, 1990) has challenged the old view that credulous early film spectators were duped by the cinematic illusion (ducking below the seats, or running out of the cinema to avoid an oncoming train). The pleasures of cinema were related to the tension between the knowledge that it is an illusion, and the physical, habitual reactions that the sights and sounds stimulated. As Gunning argues, astonished, speechless, gawping spectators did not mistake the film for real, but were responding to the marvellous, magical illusion. The assumption that spectators were duped is related to the association of gawping with incredulity and naivety. But gawping is also misdirected attention – it focuses on the 'wrong' object: instead of looking through the illusion, the gawper is besotted with its perfection, the details of how it is constructed and so on. At the AMNH, Franz Boas cautioned against extreme verisimilitude in ethnographic life groups, on the grounds that the static plaster figures would seem 'uncanny' or 'ghastly' if they were too real, but also because high illusionism would distract visitors away from the intended content of the display and toward the illusion itself (Griffiths 1996, 2002). The museum director Michael Ames gives the example of an ethnographic life group in a Canadian museum intended to demonstrate local fishing techniques, where according to one curator, 'the most frequently asked question by the public does not concern the Indians or the fish, but how the designers were able to construct such a realistic scene' (1992: 23).

In this case illusionism becomes a demonstration of technological superiority. Illusionistic exhibits necessarily set out to deceive the visitor – indeed, they

are often playful with the visitors' assumptions about what is and is not real. However, high illusionism can parade itself as technical know-how. The ability to reproduce something can become associated with mastery of it. What matters is not that authenticity is threatened but rather that the transformation of a piece of culture, or nature, into an object to be exhibited is marked by a violence that then erases itself. The everyday life theorist Michel de Certeau has written about the transformation of popular or folk culture into an object of academic study in the nineteenth century. He argues that popular culture 'had to be censored' before being studied, and that it only became an object of study once 'its danger had been eliminated' (1986: 119). Censorship tames the threat of the popular, but the direct and uncensored use of popular culture is possible once that threat is gone (Certeau 1986: 120). The collecting of the culture of the 'folk' or peasantry was linked to its destruction, and to the subjugation of that population. In folk and popular culture studies, there is an emphasis on authenticity, on finding the 'true' popular. The irony is that this lost origin is identical with the origin of such studies; they come out of the suppression of the very thing they chase (Certeau 1986: 128). Very diverse beliefs and politics may inform the interest in the popular, but what matters is the operation by which the search for a lost original conceals the violence on which it is founded. As Certeau says, 'We cannot reproach a literature for grafting itself upon a prior violence (for that is always the case) but we can reproach it for not admitting it' (1986: 134).

Similarly, we can see that practices of collecting and display are often violent in origin, and exhibitions often commemorate a loss or death which nevertheless is the precondition for their existence (see Conn 1998: 68–73 and Luke 2002: 100–23 for the connections between extinction and natural history). The very act of collecting is a transformative act, a surgical operation of excision which violates that which it leaves behind. Barbara Kirshenblatt-Gimblett, in her discussion of exhibits of 'exotic' cultures and peoples, mentions examples of the restaging of historical events occurring as part of the celebration of a victory, so that exhibition is directly linked to erasure and subjugation (1998: 160). Certain exhibits, including zoo exhibits, justify themselves on the grounds that what they are representing is 'disappearing' or endangered. In the attempt to preserve vanishing worlds, they turn to reconstruction. The copy becomes a means to bring the original closer. We can see this in Carl Akeley's Africa Hall as well as in the Swedish habitat group, the Scandinavian folk museums and immersive zoo exhibits of endangered species and threatened environments. We find it in the open-air industrial museums and 'living history' displays which opened in 1970s Britain as British industry went into rapid decline. The world's fairs of the nineteenth century, which included displays of real indigenous people practicing traditional crafts or going about their everyday

business, required that they perform an everyday life unchanged by the reality of colonization or by the new context in which they found themselves (Kirshenblatt-Gimblett 1998: 47–51).

In both human and animal exhibits, display techniques are used to conceal or distract from the possible cruelties of exhibition. An example is the immersive zoo exhibit which gives visitors the optical illusion of greater space in the animal exhibits, while keeping the enclosures small enough to ensure optimum viewing opportunities. Though visitors would commonly recognize that the habitat before them is constructed – that you cannot really have an intact piece of the Congo in the middle of the Bronx, and so on – the impression of larger and more 'natural' enclosures is also intended to assuage any concerns they have about looking at captive animals. Some writers also argue that such simulated exhibits may also make the reality they reproduce pale by comparison: the political analyst Timothy Luke makes this argument about the Arizona–Sonora Desert Museum, near Tucson, Arizona. He also suggests that this attraction inadvertently contributes to the destruction of the surrounding desert through its insertion into the political economies of tourism and urban expansion (Luke 2002: 146–64)

It is commonplace nowadays to criticize simulation-based and mimetic displays for their association with popular entertainment and commerce (as terms such as 'edutainment' and 'Disneyfication' suggest). In my view, what is significant is not necessarily the use of illusionism and popular spectacle, so much as the way these attractions occupy a position 'between voyeurism and pedagogy' (Certeau 1986: 125). The most impeccably well-researched and historically accurate exhibits can be deceptive; this depends not on the use of illusion, but on their refusal to admit their own place in relation to the erasure of what they commemorate. What matters, Certeau seems to suggest, is not the extent to which the exhibit is 'educational' or 'entertaining', but the 'operation' it performs in relation to its subject-matter.

The art of exhibition

In the final section of this chapter we will begin to examine exhibition techniques which set out to counter the museum's accumulation of 'dead' knowledge. What we can loosely label 'avant-garde' exhibition design emerged in the 1920s and 1930s. Like children's museums and science centres, which I discuss in the next chapter, these exhibitions have a hands-on or interactive element (though I am applying both these terms anachronistically, since neither was in currency at the time). Hands-on exhibits are very different from mimetic ones in the relation they establish with their visitor. Mimetic exhibits situate the visitor

as an invisible or illicit observer (the trespasser or voyeur). Hands-on exhibits acknowledge the visitor's presence and even require it to activate them. Yet we should not make too firm a distinction; the history of the two techniques also shows plenty of crossover, from the origins of the diorama and panorama in theatre sets, to the involvement of the modernist avant-garde in designing department store window displays.

In the 1920s through to the 1940s, avant-garde exhibition, like hands-on exhibits later, recognized the importance of tactility, of space and of engaging the audience actively, but they emphasized these at the expense of the object – especially the unique art object. Though these days the historical avant-garde takes its place in the museum as a set of unique and highly valuable objects, its aim, as mentioned earlier in this chapter, was to restore a social relevance to art, which meant the destruction of art as a distinct category, and its merging with everyday life. Whilst they may have seen existing museums as cemeteries for art, artists, designers and architects saw the exhibition as a new and exciting form of mass media. The exhibition promised to establish an unprecedented inter-active relationship between media and audience (and, in the case of the great international exhibitions, could reach huge audiences). In an era of rapidly developing mass media, the fact that the world of exhibit design was not yet professionalized gave great scope for experiment. Members of the European avant-garde movements, especially the Dada, de Stijl, Bauhaus and Constructiv-ist groups, devised new and innovative exhibitions. These are sometimes termed 'ideological' exhibitions as opposed to 'theatrical' exhibitions (such as the hall of dioramas) (Barry 1996: 310; Kachur 2001: 4–6). However, this distinction is a bit misleading, since all exhibitions are ideological in the usual sense of the word, and since theatre itself is reinvented in this period. Exhibition designers often doubled as set designers for the theatre, and avant-garde theatre trans-formed the relationship between audience and performers, disposing of the proscenium arch which separates actors from audience and using a range of techniques to disrupt the flow of the narrative and break the theatrical illusion.

Interwar avant-garde exhibition design was also distinctive in its foreground-ing of the installation itself, and the explicit incorporation of the viewer into the exhibit. Exhibition designers, including Herbert Bayer, El Lissitzky, László Moholy-Nagy and Frederick Kiesler, attempted to integrate the dramatic organization of space in the theatre with graphic and typographic visual elem-ents. They reconfigured the exhibition space to enable visitors to interact with the display, using a number of different strategies. One was to make the exhibit change with the visitor's point of view. For instance, El Lissitzky's 1927–8 'Abstract Cabinet', commissioned by museum director Alexander Dorner for the Landesmuseum in Hanover, used vertical thin metal slats placed at an angle to the wall. These were white on one side and black on the other, so that they

seemed to change shade as the visitor moved through the space (Lissitzky 1984: 151). As the art historian Benjamin Buchloh has argued, this exhibition strategy discouraged traditional practices of aesthetic contemplation and demanded a new kind of behaviour in the presence of the work of art (1988: 86).

A closely linked strategy was to make the exhibit dependent on manipulation by the visitor. In the Hanover cabinet, El Lissitzky placed artwork on sliding panels and rotating drums. Also in Dorner's museum, Moholy-Nagy's 'Room of Our Time', begun in 1930, contained the *Licht-Raum Modulator* or light machine, which projected abstract patterns of light onto walls and ceiling when visitors pressed a button. Kiesler's adaptable 'L and T system' (*Leger und Träger*), first used at the International Exhibition of New Theatre Technique in Vienna in 1924, placed images on display racks that visitors could adjust to view. The exhibition designs Kiesler created for Peggy Guggenheim's Art of This Century gallery (New York) in 1942 allowed visitors to swivel or raise and lower paintings by hand.

These art exhibitions often abandoned the traditional arrangement of art on the wall and in frames. The release of the picture from its frame is connected with the development of abstraction and the rejection of older artistic conventions (such as perspective) which had made each picture a self-contained space (O'Doherty 1999: 13–34). With his 'L and T system' Kiesler removed two-dimensional art into the middle of the display space itself, while the walls of the building were left bare. The Dadaists, particularly Marcel Duchamp (who worked with both Dadaists and Surrealists), had already experimented with the disruption of the traditional salon style of hanging pictures. The First International Dada Fair in Berlin in 1920 included slogans interspersed with the pictures, and a model of a Prussian officer with a pig's head suspended from the ceiling. Duchamp hung coal bags from the gallery ceiling at the 1938 International Exposition of Surrealism, and wove a mile of string across the exhibition space at the 1942 First Papers of Surrealism exhibition (see O'Doherty 1999: 67–76 for more on these). His approach was far more confrontational than Kiesler's, not least because his exhibits were seemingly hostile toward the viewers and the other works in the exhibition.

Another device Kiesler and Duchamp both used was the peephole. On Duchamp's instructions, Kiesler installed a peephole at the 1947 International Exposition of Surrealism in Paris. Through it, visitors could view Duchamp's *Le Rayon Vert* (The Green Ray). In Kiesler's 'Kinetic Gallery' at Art of This Century, visitors could use a lever to reveal Breton's 'poem object', while Duchamp's *La Bôite-en-Valise* could be viewed by peering into a hole and simultaneously turning a very large wooden spiral. Herbert Bayer also used a peephole in the *Bauhaus 1919–1928* exhibition at the Museum of Modern Art, New York in 1938–9 (Kachur 2001: 201; Huhtamo 2002: 8). In these examples,

the peephole recalls popular Victorian optical devices such as the kinetoscope and the zoetrope. Peepholes also link the history of hands-on exhibits with theatrical techniques. Kiesler had used a peephole as early as 1922 in his stage design for Karel Capek's *R.U.R.* at the Theater am Kurfürstendamm in Berlin. In that show, the peephole mimicked a large camera shutter. In 1939 he used a similar device in the 'Screen-O-Scope' which replaced the theatre curtain in the Guild Hall Cinema, New York (Huhtamo 2002: 9). But it is in Duchamp's final work that the peephole device is used to its full potential. *Étant Donnés* (1946–66) is a scene of a splayed female body in front of an illuminated landscape and viewed through two peepholes in an old wooden door. Produced in New York in a period when art was dominated by American abstract expressionism, it rejects the emphasis on the picture plane in favour of a diorama-like scene – the woman's body is made of leather stretched over a metal armature, the landscape painted on glass and backlit – and it recalls the layered illusion of space in classical perspective painting, yet it is also disturbingly pornographic, implicating viewers in the scene before them.

Kiesler's elaborate peephole devices could be seen as subordinating the artefact to the display device, as science centres would do later. The art historian Lewis Kachur has commented that the peephole regiments the spectatorial experience (2001: 201). Certainly it offers the thrill of an individualized experience, otherwise unavailable unless one was alone in the exhibit, but it also forces a certain self-reflexive attitude on the spectator. It directs the visitors' attention whilst making the act of direction explicit. Stepping up to the peephole and laboriously turning a wheel, or pulling a lever, visitors cannot forget the act of viewing and their own voyeuristic positioning and simply imaginatively immerse themselves in the illusion, as they might looking through the invisible fourth wall into the tableau or diorama, or through the proscenium arch of the theatre. In this sense it is related to other devices that wrote the visitors' presence into the space, such as the cut-out footprints used by Bayer at the Bauhaus exhibition and the pointing hand device which directed visitors through the display. In these devices, which Bayer used repeatedly, the imagined viewer's body is inscribed into the space in the form of pictorial representations of hands, eyes and footprints.

American journalists responded to European exhibition designers' use of popular culture vocabulary with disdain. They commented unfavourably on the peepholes in Kiesler's Guggenheim gallery ('a kind of artistic Coney Island') and on the use of cut-out footsteps on the floor (a 'cheap sidewalk device') in Bayer's Bauhaus exhibition at MoMA (cited in Kachur 2001: 201 and Staniszewski 1998:145). It is possible that these criticisms derive from the different histories and expectations of the art museum in Europe and the United States. The European avant-garde attempted to overcome the separation

between art and the everyday, and worked across both, producing gallery art but also designing department store displays and utilitarian domestic objects. They quoted from popular culture, lifting clichés from one space into another space which they conceived of as quite separate. Footsteps and peepholes were not clichés in exhibition design but pieces of popular vernacular. To journalists reviewing the Bauhaus show, however, the museums were in a continuum with the department stores – historically linked to them, they were places one went to educate one's taste, to learn about the latest thing. To encounter there examples of the lowest forms of popular culture (that one was supposed to be educating oneself away from) merely indicated a poor exhibition design decision.

Differences between North American and European understandings of the purposes of exhibition design are perhaps less significant than differences within the design approaches that I have loosely classified as 'avant-garde'. I would like to begin to draw finer distinctions between them, specifically between the ways in which the exhibitions staged their relationship to the visitors. The most explicitly politicized and radical conception of the active audience can be found in the work of the Soviet avant-garde of the late 1920s and 30s. A number of Soviet artists attempted to reinvent the role of art in society to enable it to address a mass audience without sacrificing the advances made by modernism in its rejection of an older, bourgeois conception of art. The artist and exhibition designer El Lissitzky is very influential in this respect. He wrote,

> Large international art shows resemble a zoo where the visitors are subjected to the roar of thousands of assorted beasts. My space will be designed in such a way that the objects will not assault the visitor all at once. While passing along the picture-studded walls of the conventional art exhibition setup, the viewer is lulled into a numb state of passivity. It is our intention to make man active by means of design. This is the purpose of space.
>
> (Lissitzky 1984: 149)

Earlier, in 1923, Lissitzky had written that his organization of space involved 'destroying the wall as the resting place for . . . pictures' (1984: 140). Space was not about the construction of representations, but about responding to human requirements. Lissitzky's notion of the 'active' visitor is informed by a Marxist concept of self-realization. In 1930 he explained the purpose of Soviet workers' clubs:

> That in the club the masses should provide for themselves, that they should not throng there from the outside merely to seek amusement, but that they

should arrive at a realization of their own potentialities by their own efforts. The club's role is to become a University of Culture.

(Lissitzky 1984: 44)

Lissitzky's approach to space, whether the architectural space of the club or the space of his 'demonstration rooms', was informed by a rejection of pictorial, perspectival space (including the voyeuristically viewed space of the diorama or tableau) in favour of a concept of space as something to be lived in (1984: 138–9). As the first section of this chapter suggested, amongst the avant-garde in this period the notion of 'life' and 'living' was closely tied with notions of presence and agency – the ability to act on the world and change it. The museum – and especially the art museum – represented its antithesis. Lissitzky declared, 'We *reject space as a painted coffin for our living bodies*' (1984: 140, his emphasis). Along with other members of the Soviet avant-garde, he shifted priority away from the unique art object and the practice of aesthetic contemplation, both of which were central to the art museum, and neither of which seemed to have continuing relevance for a mass, proletarian society. In the process he reinvented the exhibition and by implication, the museum as a space for action.

Lissitzky's most well-known, and most influential, exhibition design was one he collaboratively produced (with 38 designers, the majority of them graphic designers) for the International Exhibition of Newspaper and Book Publishing (or *Pressa*) in Cologne in 1928. The Soviet Pavilion at Pressa was very different from his 'demonstration rooms' insofar as it was crammed full with pictures – iconic photographs rather than abstract compositions. The space of the exhibition became theatrical or even cinematic, using blown-up photographs and typography and centred around a huge 'photofresco' which juxtaposed images in a way reminiscent of Soviet film montage techniques. The reproductive technologies and materials out of which the Pressa pavilion was constructed were also the exhibited objects, and in this respect as well as in terms of its appearance, it became a paradigm for avant-garde exhibition design (Staniszewski 1998: 47). The Pressa pavilion condensed the artefact and the display support into one. It marked the beginning of a disappearance of the artefact, which becomes itself the walls and ceiling of the space. This was one reason why the exhibit resembled a stage set. Lissitzky was disappointed that the exhibition had ended up looking like a 'theatre decoration' (Lissitzky cited in Buchloh 1988: 102–3). Yet this aspect of the design, along with the innovative use of materials and scale, was to become very influential.

By the 1930s, under the restrictive conditions of Stalinism, Lissitzky's montage techniques, intended for educating and consciousness-raising, had become a resource for exhibitions and designs 'prescribing the silence of conformity and

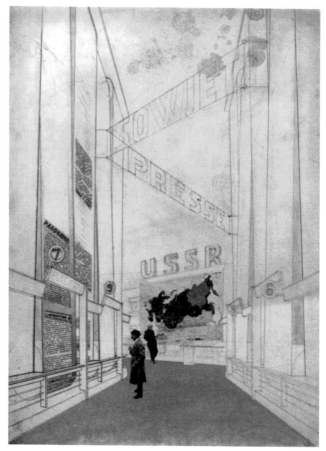

Figure 3 El Lissitsky, design for the Soviet Pavilion at the International Exhibition of Newspaper and Book Publishing (or *Pressa*) in Cologne, 1928. *Source*: Photo courtesy Rheinisches Bildarchiv Cologne.

obedience' (Buchloh 1988: 103). Buchloh shows how these techniques are disseminated and put to use in various ways – in the totalitarian Soviet Union, for Fascist exhibits in Germany and Italy, and in the United States in the service of an ever-accelerating capitalism. This is not to say that the formal and material characteristics of avant-garde exhibition design could be used for these purposes without adaptation. Buchloh discusses the way in which Fascist exhibitions replace the photomontages of Lissitzky's exhibition design with the 'awe-inspiring monumentality of the gigantic single-image panorama', as exemplified in the German Werkbund Exhibition of 1933, *The Camera*

(Buchloh 1988: 108). In this and Lissitzky's own exhibits, the iconic photograph works as an effective propaganda tool, albeit in different ways. Yet more formal, abstract approaches can also lend themselves to political uses, as the work of Ludwig Mies van de Rohe and Lilly Reich demonstrates. Mies and Reich produced impressive and seductive exhibitions that made great use of expensive and sumptuous materials, lush colour, dramatic scale, solid forms and curved surfaces. In 1934 they both worked on the Nazi Party's *German People/German Work* exhibition. At the time, commentators pointed to the connections between the scale and richness of their designs and the developing monumental and classical aesthetic of Fascism (Staniszewski 1998: 39). The National Socialist and Fascist states used monumental classicism to assert the power of technology, the state and industry, even while the overt political message was about the power of the 'German people'.

The form and materials of an exhibition have a politics and a content of their own, which are distinct from and may even contradict, the overt content of the exhibition, and which are addressed to the body of the spectator (Highmore 2003). The American designer Philip Johnson, who supported Fascism early in his career, was influenced by the designs of Mies and Reich. His 1934 *Machine Art* exhibition at MOMA looked seamless, using rich textures and materials and hidden lighting to aestheticise the shiny machine parts and machine-made objects on display (Staniszewski 1998: 153). However Johnson's show did not have the monumentalism of the *German People/German Work* exhibition. In *Machine Art*, visitors seem to have experienced not so much the awe-inspiring power of industry as their own power as North American consumers – the objects, all products of US industry, were displayed in a manner reminiscent of store displays. Reportedly visitors behaved as if they were shopping (Staniszewski 1998: 159). *Machine Art* could be seen to address an active visitor, but a visitor who is conceived as an actively discriminating consumer. Four years later, Bayer's *Bauhaus 1919–1928*, at the same museum, placed more emphasis on inviting the viewer to reflect on their own role in the interpretive process. Yet Bayer also conceived of his work in relation to consumption, as an art of persuasion similar to advertising (Phillips 1988: 273). Indeed, Bayer was one of a number of European émigrés who oversaw the political transformation of the aesthetic techniques of modernism. Lissitzky's initial Soviet aesthetic, committed to the education and 'realization' of the people, was adapted to suit the demands of Fascism (the subjugation of people to the State and to technology) and then the demands of accelerated capitalism (the people as consumers) (Buchloh 1988; Phillips 1988: 273).

Frederick Kiesler was another émigré exhibition designer who was instrumental in shaping the techniques of the avant-garde for the purposes of the consumer society. Kiesler worked as a window designer for Saks Fifth Avenue

from 1928 to 1930 and published a book *Contemporary Art Applied to the Store and Its Display* in 1930 (Otwell 1997). He viewed the opportunities for display in America (in the store window as well as the exhibition) as a way of introducing contemporary art to a mass audience, thereby educating people as consumers of 'good design' (Kiesler 1930). His was a very different approach to Lissitzky's, since for Lissitzky existing notions of taste and aesthetics had to be overturned in response to the demands of a new collective society. The work of Bayer, Kiesler and Johnson encourages the viewer to reflect on their own position, and to inhabit the space. Yet, though they reinvented the exhibition space along modernist lines, they held onto a belief in aesthetic value and a fetishistic attachment to objects that was rooted in older notions of aesthetics and in the world of goods (see Chapter 1, section 4). One of the reasons Johnson's *Machine Art* exhibition may have been well received by critics was that it reinforced 'an ahistorical understanding of culture', finding a 'timeless essence' in the objects of industrial mass production (Staniszewski 1998: 158).

The exhibition design animates the object, like the show window, it brings objects 'to life'. If anything bridged Kiesler's practice as an exhibition designer for MoMA and Guggenheim, and his work on show windows for Saks Fifth Avenue, it was the theatre. Stage sets provide the environment in which the drama happens; they stage the encounter between actors (objects) and audience (visitors). Oddly enough, in the art gallery this leads to the self-effacement of exhibition design itself – the end of avant-garde exhibition design in art. In 1961, Kiesler wrote:

> The traditional art object, be it a painting, a sculpture, or a piece of architecture, is no longer seen as an isolated entity but must be considered within the context of this expanding environment. The environment becomes equally as important as the object, if not more so, because the object breathes into the surrounding and also inhales the realities of the environment no matter in what space, close or wide apart, open air or indoor.
>
> (cited in Staniszewski 1998: 8)

This anthropomorphic account of the 'breathing' art object is consistent with the view in the 1950s and 60s that art needed space to 'breathe'. In the 1970s Brian O'Doherty argued that the blank whiteness and obligatory minimalism of the 'white cube' art gallery was intended to liberate the art: 'The art is free, as the saying used to go, to 'take on its own life' (O'Doherty 1999: 15). Modernist art gallery spaces are designed to distance the museum experience from other kinds of experience outside, to heighten aesthetic contemplation of the individual artwork by suppressing context. The white wall, is not – as it may seem – the absence of display support but, as Mark Wigley has argued in his

study of the use of white in modern architecture, a 'dressing up' of the space. According to Wigley's reading of Le Corbusier's *The Decorative Art of Today* (1925), whitewash facilitates the subordination of the sensual: 'The discretely clothed object makes pure thought possible by bracketing materiality away' (Wigley 1995: 20). The modernist building and the white gallery space channels 'our attention only to those things worthy of it' (Le Corbusier cited in Wigley 1995: 25). All distractions are removed. Though the white wall is supposed to be neutral, allowing the art to dominate, O'Doherty argues 'it stands for a community with common ideas and assumptions' (1999: 79). Though austere, the Modernist space heightens the fetishism inherent in the aesthetic experience through subtle signifiers of luxury and class. The classic modernist art gallery appears to many people as an exclusive space and the isolation of objects makes them like 'valuable scarce goods . . . esthetics are turned into commerce – the gallery space is *expensive*' (O'Doherty 1999: 76). The white cube is the ultimate framing device, managing attention and assuring the (cult) value of the unique art object.

Modernist exhibition strategies can be seen to have two contrary outcomes. One was demonstrated very early on by Marcel Duchamp with his 'Ready-Mades'. That is, the framing power of the museum is such that even the most mundane, mass-reproduced, or ephemeral of things can be transformed into a museum object. The second outcome was the abandonment of the unique individual object, and its replacement with reproductions or models, series and multiples. At the beginning of this chapter I mentioned that I was interested in the way in which display 'overcomes' the object. There, I was alluding to the way in which the display support ends up displacing the object altogether. Modernist exhibition design anticipates the eventual demise of the artefact, and the advent of the 'mediatic' museum. It is now seen as the forerunner of the 'virtual museum' as well as post-1970s installation art (see Huhtamo 2002; Staniszewski 1998; also Chapter 5 in this book). This notion of the exhibition as a media form is the subject of the next chapter.

Further Reading

Conn, S. (1998) *Museums and American Intellectual Life 1876–1926*. Chicago, IL: University of Chicago Press.

Haraway, D. (1989) Teddy bear patriarchy, in *Primate Visions: Gender, Race and Nature in the World of Modern Science*. London: Routledge.

Staniszewski, M. A. (1998) *The Power of Display: A History of Exhibition Installations at the Museum of Modern Art*. Cambridge, MA: MIT Press.

3 | MEDIA

Exhibition design has evolved as a new discipline, as an apex of all media and powers of communication and of collective efforts and effects.

(Herbert Bayer cited in Staniszewski 1998:3)

In a world of transnational media and global communications networks new models of the museum are necessary, that are appropriate for an age of networks, of decentered and diffused distribution of knowledge, and of access and reciprocal communication.

(Charlie Gere 1997)

Materialist media theory

This chapter is about museums as media, and how recent media theory can be used to theorize museums. In this first section, I consider what the materialist tradition in media studies offers for an analysis of museums as media, not just in relation to display, but also in relation to their research, archiving and preservation aspects. In the second section, I look at developments toward increasingly 'mediatic' museums. This is followed by a discussion of the development of the interactive science centre. In the final section of the chapter, I examine educational notions of learning through things and through experience in relation to the museum's move away from an emphasis on 'object lessons' toward an emphasis on experience.

Existing studies of museums as media tend to focus on the exhibition, emphasizing museums' roles as communicators of messages and visitors as the recipients of those messages. They have made use of theories familiar within cultural and media studies, such as semiotic approaches, viewing visitors as active decoders of museum messages, or treating objects as 'utterances' – instances of 'speech' organized into a 'grammar' through practices of collection and display (Hooper-Greenhill 1995: 5–8; Pearce 1995). Semiotics derives from structuralist linguistics, in which utterances are subordinate to the abstract

system of language. So while semiotic approaches are useful for interpreting the ideology of the museum, and revealing how meaning is constructed through exhibits, they tend to play down the materiality of museum collections, treating material objects as simply concrete instances of an abstract schema. Some studies have considered museums and exhibitions in terms of the ways in which they manage visitor attention, choreographing them, and organizing their experience of space and time (see also Chapter 4). For instance, Roger Silverstone (1992) uses the concepts of 'orienting' and 'clocking' (derived from family therapy literature) to describe the ways in which both television schedul-ing and exhibition design work to organize time for spectators. The exhibition orients them toward past, present or future, regulating the time spent in differ-ent parts of a gallery, and the sequence in which visitors experience events in the exhibition space ('clocking') (Silverstone 1992: 38–9). This approach begins to acknowledge that how the exhibit is experienced bodily by visitors, through the activities and sensations it engages, is as important as the more explicit messages of the exhibition, and that this is something it has in common with other media.

Yet the material aspect of museums seems to distinguish them from other media. Modern media are characterized by their ability to detach objects, scenes and people, from their fixed place in time and space, and to allow them – or their forensic traces – to circulate as multiples and reproductions. Museums traditionally prioritize objects, and tend toward permanence, toward the monumental and the unique rather than ephemeral reproductions. By contrast, media seem to threaten the 'aura' of the unique object, through making it available for close inspection by a mass audience (Brown 2001:16; Benjamin 2002: 105). Yet if we look at the development of exhibition design we see a similar tendency to both dematerialize and bring objects closer. We can see it in interwar exhibition design, which replaced frames and glass cases with peep-holes, and paintings and artefacts with photographs. A related development occurs in historical and industrial museums, which turn to reconstruction and simulation in their attempt to bring the past closer. Since the 1960s, science centres, in order to be 'hands-on', have rid themselves of artefacts altogether and devised new display devices as a means to exhibit abstract concepts. All of these, I argue, suggest that museums have become increasingly mediatic.

New digital media are commonly seen as dematerializing. The word 'virtual' is often used to describe the representations produced in these media as a world separate from, and substituting for, concrete reality. Even in this case, or espe-cially in this case, it is worth remembering that media representations are also tangible physical things, that it is not simply a question of opposition between the 'virtual' and the 'real' worlds. Computer terminals are increasingly mini-aturized, until they can be held in a palm, or concealed in a flat screen. Yet the

activities they enable in 'virtual' space are dependent on massive material changes in real space, including the laying of cables and a vast infrastructure and global industry that makes great demands on human labour and material resources.

The conventional model of media would not include museums because their traditional emphasis on original objects, as opposed to representations, limits circulation (although touring exhibitions do increasingly circulate numerous objects, the fragility, size or value of many artefacts means that they remain fixed in one location). Media are thought of as technologies of communication (such as print, telegraphy, television, film), as distinct from technologies used for other purposes (carpets as a technology, or food technology) (Angus 1998). That model of media views media technologies as purely oriented toward the movement or broadcast of messages or media content from transmitters to receivers. It is rejected by some of the major theorists of media. They emphasize the ways in which media become a material means by which people experience the world. Writing in the 1950s, Harold Innis conceived of the gap between sender (or transmitter) and receiver in terms of temporality as well as spatiality, so that a statue, without moving an inch, communicates from one historical moment to another, while a letter on paper, which is relatively ephemeral but mobile, communicates across space. Through this time/space distinction, Innis mapped the physical characteristics of media onto different kinds of social organization. Each medium has a 'material bias', which includes its orientation toward spatial or temporal transmission, and in this way, the media of a given society set limits on what can be experienced and how it is experienced (Angus 1998).

Instead of presuming that the medium simply moves a message from sender to receiver, Innis saw its capacity to communicate as dependent on its material nature and as shaping of social institutions and practices. In his 1964 book *Understanding Media*, Marshall McLuhan developed Innis's notion of 'material bias'. He used examples which are not usually understood as media at all, such as the electric light and the railway. His phrase 'the medium is the message' implied that the significance of any new medium was not the uses to which it was put or the content but the 'change of scale or pace or pattern that it introduces into human affairs' (McLuhan 2002: 8). For McLuhan this was the 'content' of the medium. He opposed those who saw technologies as having no character or nature of their own. David Sarnoff, chair of RCA, the company that introduced television to North America, claimed that, 'The products of modern science are not in themselves good or bad; it is the way they are used that determines their value'. McLuhan responded with the suggestion that we replace the phrase 'products of modern science' with 'apple pie', 'smallpox virus', or 'firearms', to get a sense of the ludicrousness of the statement (2002:

11–12). McLuhan rejected the notion that use or specific content determines value, not because there is no meaningful difference between television programmes, or what is between the pages of one book and another, but because he believed that the greater impact of each medium was not to be found there. He argued that media technologies ought to be considered 'staples or natural resources' on which certain economies come to depend, which shape social organization, and which consequently have effects on 'the entire psychic life of the community' (McLuhan 2002: 22).

McLuhan's insistence on the shaping role of technologies was also an insistence on the materiality of media. This materialism is shared by Raymond Williams, one of the founders of British cultural studies and a critic of McLuhan. Williams opposed the way that McLuhan reduced media to technology (Williams 1977: 159). McLuhan distinguished the medium and technology from the social activities and psychic life which they configure. Influenced by the work of the Soviet linguist Volosinov, Williams emphasized that meanings cannot be dissociated from the material in which they are produced nor from social interaction between people. He rejected the separation of human activity and technology implicit in McLuhan's work. Media for Williams meant 'material social practice', not an 'intermediate substance' (1977: 165). While McLuhan saw human activity as shaped by media technologies, Williams saw it as both shaped by and shaping of media, but most importantly, he saw human activity as sensuous and material.

What are the consequences of these materialist theories of media for a consideration of museums as media? First, they allow for media to be thought of as more than a means to move messages across space. Second, they suggest that to consider museums as media would mean paying close attention to their tangible and experiential aspects. Third, they invite us to attend to how the substantial, material form of the exhibition circumscribes and delimits both human activities and ideological content. The media historian Friedrich Kittler (1999) argues that certain media are oriented towards the production of certain kinds of knowledge and subjective experiences, and resist others. He shows how modern media (from around the 1880s) split and differentiate sensory information into sound, images and so on. He argues that this shapes the kinds of knowledge that can be produced. This argument is strongly influenced by the French historian Michel Foucault's theory of *discourse*. While Foucault argued that a discourse constructs its objects, Kittler sees media as fabricating discourses, according to their own material 'bias'. In this respect, Kittler's theory combines form and content: media transform our reality by shaping both experience and discourse. One of the most radical contributions Kittler makes to the way we think about media is that he redefines media to prioritize the archiving or storage function, which is played down in most media theory.

Where media studies has chiefly focused on the use of media for circulation and reproduction, and spatial transmission, Kittler regards the same media in terms of their recording function. This is connected to Innis' notion of temporal transmission. Considered in these terms, all media are museum-like. Kittler notes that all media extend the 'realm of the dead', for they make more of the past present; he defines media not by their ephemerality, immediacy and dematerializing effects, but their role in preservation and attempts at immortality (1999: 13).

As we have already seen, the early twentieth-century avant-garde rejected the museum's preservation of the dead past in favour of new technologies associated with speed and immediacy, and with a greater relevance to the present. Yet these new technologies themselves would extend the 'realm of the dead' through recording and archiving. Far from being a remnant from the past, Victorian historicism and overaccumulation were characteristically modern. Dependent on the new media technologies of the day, they were set to expand with the expansion of the media, as more and more ephemeral and intangible aspects of present reality could be technically reproduced and preserved. The history of the modern museum coincides with the history of modern recording media. The new media technologies of the late nineteenth century did not outmode the museum, but developed the museum project, and their potential in this regard was quickly seized upon by museums. While some popular museums closed their doors when faced with the competition from cinema, others made very early use of the various media for both display and archiving (Sandberg 2003: 35).

This argument holds not just for analogue media but also for digital media and information technology in which concepts of memory, storage and archiving are fundamental. Many writers (including Kittler) trace the emergence of new media and information technology to military developments. However, there is another argument that databases and hypertext have precursors in the classificatory and archiving systems developed in museums and libraries, particularly in the work of Otto Neurath and Paul Otlet, founders of museums in Vienna and Brussels in the early twentieth century (see Chapter 5 and this chapter, section 2). Some scholars have argued that the recent growth of the media and of information technology, in the context of broader economic and global changes, led to a massive expansion of forms of control (Deleuze, cited in Crary 1999: 76). Yet these early figures were primarily concerned with finding new ways in which accumulated knowledge could be disseminated in a new mass society. The museum became mediatic in their hands. This does not simply mean that a lower priority was given to artefacts in the museum, but also that the museums' relation to its audience changed – both in the direction of democratization *and* in the direction of increased control. This apparent contradiction is an issue we will explore more fully throughout the chapter.

The mediatic museum

In 1972, the director of the Natural History Museum in London decided to redesign its exhibits. It was felt that 'the existing exhibitions were dull, old-fashioned, irrelevant and too technical' (Miles 1996: 184). The 'New Exhibition Scheme' at the museum drew on three sources to reinvent how the exhibits addressed visitors and how the design and production of the exhibitions were organized. These sources were: the Isotype system invented by Otto Neurath between the 1920s and 1945; programmed learning, an educational approach that originates in the work of B.F. Skinner in the 1950s and is based on a notion of interaction as reinforcement (see *behaviourism*); and Frank Oppenheimer's Exploratorium in San Francisco (established in 1969). The New Exhibition Scheme began in 1975, introducing professional designers and exhibit researchers into the museum. They were to work in consultation with museum experts – curators, scientists and educators – to produce specifications for the exhibition designs, which would then be built by artists and technicians. The scheme resulted in several innovative and notable exhibitions – *Human Biology* (1977) *Introducing Ecology* (1978) and *Dinosaurs and Their Living Relatives* (1979) (Stearn 1998: 371). However, by 1991 the team was disbanded and the museum began to contract out their exhibition design to independent companies. Roger Miles, who implemented the scheme at the museum, said in 1996: 'This was a retreat from the high ground of our original hopes and aspirations, in the face of the realities of working in the museum' (Miles 1996: 185–9).

The case of the Natural History Museum in London, as recounted by Miles, connects late twentieth-century museum practice with specific developments in education theory and exhibit design between the 1920s and the late 1960s. All of the three sources that inspired the New Exhibition Scheme were concerned with the processes of education, and two of them, Neurath's Isotype system, and Oppenheimer's Exploratorium, grew out of socialist political engagement. Both Neurath and Oppenheimer came to museums from an educational background, and both came to believe that the museum was the best means to inform and educate a mass audience. Both saw museum education as potentially liberating, empowering people with little social power by making arguments and facts accessible to them, and enabling them to better understand a complex natural and social world. Both believed that education should be participatory and saw the museum visitor as an active learner, capable of grappling with difficult concepts.

In this section we will consider the work of Otto Neurath. Neurath was a member of the Vienna circle of philosophers, and his Isotype system (International System of Typological and Pictorial Education) was a visual

language of icons or pictograms. He was also the founder of museums in Vienna and Holland, involved in town planning and housing projects in Austria and England. He had links to avant-garde art and design – notably the Bauhaus in Germany and Constructivism in the USSR. He was one of a number of people who were pivotal in the dissemination of modernist ideas between mainland Europe, Britain and North America. For our purposes he is interesting because of how his work was used, during his lifetime and posthumously, to reconfigure museums in a way which made them increasingly media-like. By considering his museum work and writings we can develop a clearer sense of the possibilities for a mediatic museum, of museums as media-forms and of how museums have become increasingly 'experience' centred.

In 1924, Neurath founded the Social and Economic Museum in Vienna, having been involved in running various museums since 1916 (Vossoughian 2003: 82). Funded by unions and the city government, the museum originated in the context of the dramatic changes brought about by the socialist welfare and housing programme. It set out to translate information relevant to Viennese

Figure 4 The *Gesellschafts- und Wirtschaftsmuseum* (Museum of Society and Economy) Vienna, late 1920s.
Source: Courtesy of the Department of Typography and Graphic Communication, University of Reading.

people's everyday lives into a graphic exhibition form readily understood by partially literate and illiterate people. The Isotype scheme took inspiration from Egyptian hieroglyphs and used visual icons to communicate statistical and factual information. The aim was educational, conceived along democratic lines. Neurath distinguished between his approach, which he termed the 'humanization' of knowledge, and 'popularization'. While popularization involves simplification of complex knowledge, humanization starts from people's everyday knowledges and experiences, avoiding technical terms without simplifying (Neurath 1973: 231–2). Neurath believed it was possible to separate neutral or objective statements from argument and opinion. The Isotype system was not intended to present arguments, but to arm people with neutral statistical information from which they could form their own arguments.

Neurath saw education as both the handing on of knowledge and of certain attitudes and techniques, notably the ability to meditate on matters (to analyse and contemplate, to think critically) which requires a certain amount of quiet, and habits of research and arguing (1973: 233). He was critical of those who too easily fell for the latest technology, arguing instead that each medium had advantages and disadvantages for educational purposes. Each medium has its own potential and its own properties. Film, for instance, has the benefit of being able to show movement, but its time-based nature means it is difficult for viewers to use film to make comparisons: a process crucial to education (Neurath 1973: 238). Museums and exhibitions had potential advantages over other media, which were held back by the conventional form they took:

> Exhibitions and museums have their characteristics distinguishing them from book illustrations, lantern slides or films. Visitors, for example, can stand around an exhibit, look for longer or shorter times, compare one with another. A filmgoer is presented with a set sequence, a scene appears and goes by quickly, he cannot turn back the pages like the leaves of a book. Museums are free for everybody, groups and individuals can go there, with or without a guide; their discussion could be supported by the visual material itself. Museums could play an important part in education. In fact they very often do not. Visitors are mostly overwhelmed and bored. Visits to museums are often 'ritual' visits. In museums, some people want to show something, directors, donors, etc.; they are more feudal than any other people in a democratic society.
>
> (Neurath 1973: 238)

The museum's democratic potential could be realized only if its exhibition function could be separated from ritual and from the self-serving display of wealth and knowledge. Neurath and his colleagues reinvented the museum.

A 1936 article about Neurath in the US magazine *Survey Graphic* described Neurath's museum:

> Traditionally, a museum director is a collector of exhibits, the keeper of a mausoleum, where scattered relics fag the brain and tire the feet. Boldly Neurath ventured into the Museum of the Future. His museum was located on the first floor of the city hall. It was a dynamic representation of the social, economic and cultural synthesis of the city. At night, when the rooms were open for workmen, he introduced novel illumination effects and movies.
>
> 'It was called a museum,' Neurath says. 'It was really a permanent exposition. It was not enough to show what the city did with its taxes, what opportunities and responsibilities Vienna offered to its citizens, and vice versa. Our exhibits and apparatus also made comparisons with other cities and countries and other periods of history.'
>
> (*Survey Graphic* 1936: 618)

For Neurath, at least, the novelty of the effects was subordinate to their clarity as communication technologies. As he wrote in 'Museums of the Future' (1933) the museum has a 'twofold task: to show social processes and to bring all the facts of life into some recognisable relation with social processes' (Neurath 1973: 220). To show social processes required cutting across the boundaries that traditionally and institutionally separated media and forms of knowledge. In other words: the museum's multimedia character develops out of – and is suited to – an approach that refuses to recognize the institutional partitioning of knowledge. This is because its aim is to enable connections and comparisons to be made for the purposes of democratic education.

Neurath reimagined a natural history museum, questioning the way typical displays prioritized identification of species, ignoring their human uses and compartmentalizing knowledge. Natural history museums tended to treat species separately from other species and nature as outside and separate from human society. Using the example of a whale exhibit, Neurath emphasized what people do with whales – how they hunt them, what goods they make from them (such as corset stays and soap), the economies that depend on them and the culture that emerges in relationship to them (fetishes, taboos, religious beliefs) (1973: 219–22, 241). This approach rejects the separation of the social and the natural that the traditional museum reinforces. As he wrote, 'Human fortunes are connected with this exhibit – starving seamen, hungry families of fishermen in the north of Norway. And so everything leads to men and society' (Neurath 1973: 220). This representation of the whale could be rather instrumental, disallowing an interest in the animal as such, outside human uses and human beliefs, but it connects the whale with the concerns, needs and interests

of the museum visitors. Indeed Neurath's 'humanization' of knowledge could be understood as one way of countering the problem Nietzsche had identified, namely of modern people being fed with 'indigestible stones of knowledge' (see Chapter 2).

Nietzsche's criticism was aimed at what I have referred to in previous chapters as the *encyclopaedism* and historicism of the Victorian era, but earlier in the eighteenth-century philosophers had produced encyclopedias as a means of orienting knowledge and history toward life, relating different disciplines and critiquing existing authority and hierarchies of knowledge. The encyclopaedia was to be a network of interlinked and discrepant information, not an overarching, totalizing system (Tega 1996: 65). Neurath's Museum of Society and Economy in Vienna was in this sense encyclopaedic in ambition and intended to produce knowledge geared toward everyday action. The museum was based in a belief in the possibility of rational, empirical knowledge of the world but also emphasized the incompleteness of knowledge. Neurath did not believe in absolute certainty, nor that the entire world could be understood according to one scientific theory (Cartwright and Uebel 1996: 41). Perhaps one of the ways to distinguish this kind of encyclopaedism from attempts to produce a totalizing explanation of the world is that it is oriented toward the reader, student or museum visitor, as opposed to the author, teacher or curator. Like the eighteenth-century encyclopaedia, it assumed or demanded 'the autonomy of the reader who was to regard the encyclopaedia as an instrument he/she was free to use so as to raise his/her level of historical awareness' (Tega 1996: 67).

The interdisciplinary approach Neurath and his team took was also multimedia. His pictograms, or Isotypes, were thought to be a kind of universal language not only because they could be read across cultures and language groups, but also because they could be inserted into a wide range of media. They were used as book illustrations, as posters and charts in museums, as slides in lectures and presentations, as animated images in film (the director Paul Rotha used the Isotype system in his 1943 film *World of Plenty*). The cultural historian and filmmaker Peter Wollen sees Neurath's Isotype scheme in the context of the spread of **Fordism** and **Taylorism**. Wollen traces the impact of Fordist/Taylorist ideas in the modernist avant-garde as well as in popular entertainment. He compares Isotypes to other forms of standardized culture such as the Tiller Girls (Wollen 1993: 40). Putting Neurath's work in this context raises questions about its complicity with the spread of technologies of control and administration.

The model of interpreting **mass culture** in relation to the mass production of standardized parts is derived from Marxist theorists Max Horkheimer and Theodor Adorno. Writing in the early 1940s, Adorno and Horkheimer saw standardized mass production and the rationalization of work through

Taylorism as producing **alienation** and conformism (Adorno and Horkheimer 1986: 120–67). The human faculty of reason, held out as a means for human liberation since the Enlightenment, had become, in the form of rationalization, an irrational instrument of domination. They saw the *culture industry* as applying these industrial principles to culture, bringing art within the sphere of administration', destroying its independence and 'purposelessness' and harnessing it instead to the market (Adorno and Horkheimer 1986: 120, 131).

Adorno and Horkheimer's critique of standardization could be applied to Neurath's work. Yet like a number of 1930s thinkers and social activists Neurath saw an emancipatory potential in social planning and the idea of a total global system (before these had been tainted by association with Nazism). The planned or administered society would counter the social inequalities fundamental to a market economy. It seemed possible to accommodate difference and discrepancy within a global encyclopaedic system. For Neurath, museums and the Isotype system offered a means to disseminate information, especially to illiterate and semi-literate populations, and he conceived of this as liberating, not as a means of domination. Standardization was for Neurath a means to make knowledge available on a mass scale. He anticipated the serial production of museums, where museums would be like public libraries with numerous 'branches', easily accessible to everyone. Like Adorno and Horkheimer, he recognized that standardization and serial production threatened the authority given to unique works of art and authentic originals, but like Walter Benjamin he hoped that mass-produced culture could also be emancipatory and democratizing (Vossoughian 2003: 82).

Perhaps it was inevitable that Neurath's museum ideas, formulated in relation to the planned economies of war and in revolutionary Europe, should become something very different when revived or reinvented in the late twentieth century, when a free market economy was again on the rise. In the 1970s, the attempt to introduce Neurath's 'humanizing' and interdisciplinary approach into the Natural History Museum in London (a large museum with well-established and very separate departments) was bound to be fraught with difficulties. Those difficulties were compounded by the fact that these ideas, born in 'Red Vienna', were being inserted into a Britain about to undergo radical change under the new Conservative government. Initially a group of 'communicators' or 'transformers' were employed to translate the arcane specialist knowledge into an exhibitionary form accessible to museum visitors, deploying the expertise of the different departments. What ensued, according to Miles, was 'a bitter public dispute between 1977 and 1982 over the worth of the exhibitions. However, the real cause of the dispute – the internal struggle for control over exhibition practice – never really surfaced in the public domain' (1996; 189). In this period museums began to benefit less from public funding,

and eventually introduced admission charges. The museum was becoming less accessible across social classes, less a place one would go for repeat visits. Design and marketing were expanding sectors, becoming increasingly powerful and professionalized. This was happening elsewhere too: Tamami Fukuda dates the emergence of professional museum design companies in Japan to the Osaka World Exposition in 1972 (2003: 96–7). As in the United States earlier, the same designers and companies were working in department stores and theme parks as well as designing museum exhibitions.

Neurath and his colleagues had tried to invent clear and systematic ways by which information could be democratically available. The museums of the 1980s were under pressure to find ways to engage people's attention, to make exhibitions innovative and spectacular and to draw high visitor numbers. By 1991, when the hard decision was made to contract out exhibition design instead of having it produced internally, the inspired attempt to shake-up and 'humanize' a rather stagnant and complacent museum had become instead a means to popularize museum-going. The aim was now to enable the museum to compete in a marketplace of leisure attractions, with ever more expensive and high-tech interactive exhibitionary environments.

Today, the fate of Neurath's ideas can be seen in a range of different developments. One is the museum as news media. The most well-known examples of this are the Newseum in Washington DC, and *Actualité*, part of the Cité des Sciences et de l'Industrie in Paris, where a continual flow of information is disseminated on large screens and through multimedia display. A number of major museums now employ journalists and have in-house production units, producing and editing news footage, as well as staging debates and broadcasting/webcasting debates and talks. These techniques are seen as increasing visitor participation and encouraging repeat visits, though they have also been criticized for abandoning the in-depth and object-based approach of traditional museums (Webb 2004: 22–5).

The notion of a serially produced or branch museum has also been realized in our time, most famously in the Guggenheim 'brand'. Solomon R. Guggenheim was an art collector who founded the museum of the same name in New York, built by Frank Lloyd Wright in 1959. The Solomon R. Guggenheim Foundation runs branch museums according to a franchise system, including museums in Berlin and Venice, and, perhaps most famously, the Guggenheim Museum Bilbao in the Basque country of Spain, which opened in October 1997. The Basque government finances and owns the museum, but the Guggenheim Foundation runs it. This initiative is intended to help regenerate the city of Bilbao and the Basque region through tourism. According to the economist Beatriz Plaza, between its opening in 1997 and January 2000, it generated a monthly average of 17,156 visitors to the region. Analysis of statistics from hotels in this

period suggests the visitors it attracted were from the upper income brackets. Plaza notes that while the Guggenheim brand name is not an infallible guarantor of prosperity, it did connect Bilbao to American capital and to the global news media which is dominated by US news-agencies (2000: 267–73).

While the Basque administration's policy had generally been to enhance and support the regional culture, the Guggenheim Bilbao represents a US dominated culture of international modern art. In a study of the contemporary relations between corporations and culture, Mark Rectanus describes the museum as a 'depot' for the Guggenheim's growing collections (2002: 180). He suggests that the Bilbao museum's exhibitions and acquisitions policy is in keeping with a larger tendency of globalization to erase 'differences between museums based on either regional, national or even arbitrary patterns of development' (Rectanus 2002: 180). The franchise character of the museum prevents it from contributing significantly to cultural development in the region, while it absorbs the local government budgets for culture. The primary benefit to the Basque country is economic, though even this is hotly disputed (Gómez and González 2001: 899). It relies on the museum being unique, and the architecture of the museum by Frank Gehry is a prime attractor.

The Gehry style promises to give to the museum a distinct identity while at the same time connecting it with Gehry's buildings elsewhere in the world. Gehry buildings are characteristically geometrically complex and illusionistic: computer-modelling is used to produce curved structures out of frameworks of steel girders, which are then covered by a skin of reflective stainless steel. The style is global in its lack of attachment to the building traditions, materials or climate of a specific location, postmodern in its emphasis on surface and symbolic form. The curves of the Guggenheim Museum Bilbao may resemble Basque fishing boats, but it has been also read as distinctively North American, its 'voluptuous' and 'monumental' character revitalizing US architecture (Goldberger and Muschamp cited in Rectanus 2002: 181–5). The museum is the product of both the economic need to emphasize a local and unique visitor experience, and an increasingly homogenous global system of franchising and marketable visual identities (Gómez and González 2001: 899).

Interactives and hands-on science

A similar political transformation can be found in interactive science exhibits. We have already seen that exhibition designs involving interactivity took on different significance in different social and political contexts (Chapter 2, section 4). The sociologist Andrew Barry writes of how ideas about interactivity circulate between museums and how interactivity was not invented or discovered

in one go, but developed episodically in spurts. As he suggests, technologies are not simply transferred from one museum to another but translated and transformed in the process, and interactive techniques took on new forms and meanings as they developed (Barry 2001: 130, 139). In the case of avant-garde exhibition design, the shift to the US in the 1930s and '40s had involved a translation of socialist conceptions of the 'active' citizen into a new conception of the American citizen as discriminating consumer. According to Barry, inter-active science exhibits also underwent a political shift, from being associated with political empowerment and creativity in the 1960s and '70s to a more prosaic attempt to increase the public understanding of science and make sci-ence museums more attractive to visitors (2001: 139). A 1960s to '70s emphasis on the visitor as active participant and the incorporation of the visitor into the exhibit through interactivity, becomes by the 1990s a kind of 'feedback system' in which visitors' engagement with exhibits is monitored and registered as part of the museum's 'internal audit' (Barry 2001: 140). Most importantly, interac-tivity has become 'a dominant model of how objects can be used to produce subjects', intended to turn 'unfocussed visitor-consumers' into 'interested, engaged and informed technological citizens' (Barry 2001: 147–8,129).

In this section I want both to explain these developments more fully and to connect them with the 'mediatization' of the museum. I see this process of translation and circulation as having various implications and working on vari-ous levels. First, as Barry suggests, it involves changes in the relationship between the exhibition and the body of the visitor. The visitor's body replaces the museum artefact as the thing that is examined in the display space, but also becomes increasingly subject to monitoring and surveillance. Second, as mentioned above, it involves shifts in the way visitors are conceived of as political subjects. Third, and central to my argument about the museum as media form, it involves changes in the way material artefacts perform in the museum setting, changes in what visitors are interacting with – to the extent that interactivity in the science museum has begun to move away from being about a hands-on interaction with the material and physical world.

Amongst the first interactive science museums and galleries were the Children's Gallery at the Science Museum in London (1931), the Palais de la Découverte in Paris (1937), the Deutsches Museum in Munich (1925) and the Chicago Museum of Science and Industry (1933). These were educational, intended to demonstrate scientific principles. They featured industrial engines in operation, demonstrations of experiments, machinery and moving models which visitors could activate using buttons and cranks. From the beginning, science museums were connected to the promotion of national scientific achievement and industry. They developed out of the great exhibitions and world's fairs, which cities took turns to host and where various nation states

mounted extravagant displays of their technologies, arts, trade and industry. The Palais de la Découverte was built for the Paris International Exposition in 1937 and the London Science Museum was originally part of the South Kensington Museum, London, established using items from the Great Exhibition of 1851. The Deutsches Museum was intended to celebrate German scientific and technological achievement, and was funded by both government and industry. It was the inspiration for the Chicago Museum of Science and Industry, which was established by the chairman of Sears, Roebuck and Company and opened during the Chicago World's Fair of 1933–4. As early as the 1940s sections of the museum were sponsored and even produced by industry (Butler 1992 :52–3).

Close connections with industry, commerce and government have meant that such museums tend toward glorifying technical and scientific achievement at the expense of critical perspectives (Hudson 1975: 105–6; Butler 1992: 52–3). At the same time they aim to popularize science, not just to increase public appreciation of science but to realize the potential for scientific achievement amongst populations with little scientific education. The San Francisco Exploratorium was influenced by these museums but its agenda was, in theory at least, more radical. For Frank Oppenheimer, interactive science exhibits had an explicitly emancipatory function. He stated the purpose of the Exploratorium as follows:

> The whole point of the Exploratorium is to make it possible for people to believe they can understand the world around them. I think a lot of people have given up trying to comprehend things, and when they give up with the physical world, they give up with the social and political world as well. If we give up trying to understand things, I think we'll all be sunk.
>
> (cited in Hein 1986: xv)

Oppenheimer was responding partly to a 1960s scepticism about science and partly to what he saw as a withdrawal from politics into mysticism. Consequently the Exploratorium excluded anything to do with parascience, the occult, extrasensory perception and so on, despite their popularity in San Francisco at the time. The Exploratorium was also intended to educate through play. This approach to education was shaped not just by its science museum predecessors but also by Oppenheimer's teaching experience and politics. Blacklisted in the 1940s because of his brief membership of the Communist Party in the late 1930s, Oppenheimer had become a cattle rancher and then a high school science teacher in Colorado. There he developed an interactive and experiential approach to science education (Hein 1986: 11). Such an approach derives, if indirectly, from various progressive theories of education which I will discuss in the next section.

As a physicist Oppenheimer was aware that modern science was far removed from the 'naked eye science' espoused by the early trustees of the AMNH (see Chapter 2, section 2). One of the central functions of the Exploratorium was to render perceptible the imperceptible. The interactive devices developed in the Exploratorium shifted the focus of the museum away from objects and toward the demonstration of scientific principles, processes and phenomena. The exhibits were no longer artefacts to be admired or looked at, but display supports intended to exhibit something other than themselves (Hein 1986: 36). In this sense the science centre contributes to the move away from the object centred museum.

This attempt to make perceptible the imperceptible was enabled by the use of Richard Gregory's work on perception as an organizing principle. Gregory is a British psychologist of perception whose work was used in the Exploratorium, and who later established the Exploratory in Bristol along similar lines to the Exploratorium. He was also involved in the design of the Perception Gallery in the 1977 *Human Biology* exhibition, produced under the New Exhibition Scheme at the Natural History Museum, London. In all these exhibitions, visitors were given centre-stage: in many exhibits the visitor's own body was both the subject and the means by which the visitor was invited to engage with the exhibit. For example, at the Exploratory, exhibits (which were called 'plores') could be divided into those which explored the physical world and those which explored the visitor's own perceptual experiences: 'Exploring Ourselves' and 'Exploring the World'. 'Plores' included colour blindness and hearing tests, an ECG which visitors could use to measure the electricity from their own hearts, and exhibits that tested reaction times as well as optical and other illusions (see www.exploratory.org.uk). Gregory saw illusions as a means to demonstrate how knowledge and sensation interrelate, specifically how a person's expectations and knowledge contradict or override the information provided by their senses. His theories of perception emphasize interaction and creativity – the mind interacts with the world in the process of perception, drawing on stored knowledge and hypotheses as well as immediate sensation, so that perception is essentially a creative act (Gregory 1990).

Using Gregory's theories, exhibits could be constructed that enabled visitors to have fun exploring their own sensory and cognitive responses. The Victorian glass case exhibits had placed the visitor as an observer, and the 1930s mechanical and chemical displays had positioned the visitor as an operator or user. But the Exploratorium incorporated the visitor into the exhibition, so that the visitor's body and mind become the subject and content. The emphasis on the visitor's own bodily experiences is connected to the view that the process of disseminating scientific knowledge should start with people's own everyday experience (Hein 1986: 6–7). Like Otto Neurath's concept of the 'humanization

of knowledge', the aim is to begin to dismantle hierarchies of knowledge and to level the relationship between visitor and museum, public and science. Furthermore, Gregory's work on perception allowed science centres to engage visitors' different senses while dealing with intangible and abstract content.

However, there are potential contradictions between perception-based exhibits and the aims of the Exploratorium as outlined by Oppenheimer as well as the aims which other science centres espouse. One such contradiction is noted by Andrew Barry (2001) who suggests that this focus on visitors as the subject of their own experimentation does not give visitors a sense of what it is like to be a scientist (as science centres might hope). While early scientists used their own bodies for experimentation, modern science is marked out as 'object-ive' through the dissociation of the scientist's own body from the process of experimentation (Barry 2001: 131). From the visitor's point of view, the distri-bution of knowledge is uneven: visitors seldom occupy the scientist's position. This is compounded by the possibility of reading perception-based exhibits as suggesting that experience is not to be trusted. Although Oppenheimer's stated aim was to demonstrate that it was possible to understand the world, the use of optical and other illusions could imply that the world is not easily knowable. Instead of seeing perception as their own creative and cognitive act, visitors might find themselves continually tricked by the exhibits on display. The gap between what you see something as, and what you know it to be, becomes apparent in certain kinds of illusion. On the one hand, illusions connect the museum or science centre to popular entertainment in the form of the funfair and the magic show, diminishing the unapproachable character of the museum. On the other, they can give the impression that the science centre, like the traditional museum, has all the answers and explanations, while all the visitor has is (untrustworthy) experience.

In the Exploratorium, this effect was countered by a politics of display which linked art and science and a deliberately makeshift approach to the manu-facture of displays. Found objects from street corners, junk stores, and yard sales were used in the construction of the displays. In her history of the Exploratorium, Hilde Hein claims that by using everyday things and examples drawn from day-to-day experience, staff 'sought to bring home the point that the wonders of the world are everywhere, directly under our noses but often unnoticed' (1986: 30). The everydayness of displays and the visibility of their workings were linked to the demystification of science. In art and media, col-lage and montage are historically associated with anti-illusory and demystify-ing practice. The montage aesthetic rejects seamlessness, making use of found components patched together into a new object or assemblage, which might just as easily be disassembled into its constituent parts. There was a similar patchwork aesthetic in the construction of the original Exploratorium displays.

Not only does this suggest that science is something ordinary and accessible, it draws attention to the 'fallibility and incompleteness' of the Exploratorium (and of science) and, according to Hein, it implies that change, disorder and uncertainty are 'not intolerable' (1986: xxi).

Another founding principle of the Exploratorium was a kind of techno-logical transparency. The processes by which display devices worked should be something that visitors could work out (with help) and the manufacture of exhibits was also considered a process that should be open and visible to the public (Hein 1986). Hein claims that Frank Oppenheimer became resolutely opposed to the use of computers as display devices and as a means to construct the Exploratorium's exhibits because of the impenetrability of computer processes to the user. The operation of computers is invisible, and watching someone use one makes for dull viewing (Hein 1986). Moreover, computers as display devices tend to conceal rather than reveal scientific processes. In science centres today they are used to calculate and display things such as visitors' physiological responses to certain stimuli, reaction times and so on, but the processes by which the computer calculates these things and represents them back to the visitor are hidden processes. Computers in this context appear as almost magical technologies. Oppenheimer was committed to demystifying science and technology – computers seemed to confound this project.

Another distinctive aspect of the Exploratorium, which has not always been emulated by other science centres, was its mix of art and science. The Explora-torium found its feet with the inclusion of the British exhibition, *Cybernetic Serendipity – The Computer and the Arts*. This was an exhibition curated by Jasia Reichardt at the Institute of Contemporary Art (ICA) in London. It travelled to the US, and was shown in the Corcoran Art Gallery in Washington, but did not continue to tour, apparently because art museums and galleries found it prohibitively expensive and dauntingly hi-tech (Hein 1986: 35). Accord-ing to Hein, the arrival of *Cybernetic Serendipity* at the Exploratorium was 'a turning point for the museum' and was celebrated as the official opening of the Exploratorium. *Cybernetic Serendipity* had opened at the ICA in the summer of 1968. Funded by a combination of corporate sponsorship (from IBM) and Arts Council funding, the exhibition was about the relationships between the animal/human and the machine and between technology and creativity. The exhibition included the products of corporations, research labs, computer art-ists and contemporary artists who worked with other forms of technology (e.g. Nam June Paik's TV sculptures) or whose work was not machine-generated but which was associated with a digital or machine aesthetic (e.g. Bridget Riley's geometric paintings). Avant-garde music, film and poetry were also included. A 1968 newspaper article described *Cybernetic Serendipity* at the ICA as 'a verit-able Luna Park of sideshows, display booths, and fun-houses, inviting visitors

to touch, push buttons, talk or sing into microphones and television screens, or listen to speakers and earphones issuing sounds and information' (Amaya cited in Usselmann 2003: 391).

Hilde Hein claims that *Cybernetic Serendipity* was in keeping with the ethos of the Exploratorium because it 'presented the machine as an agreeable collaborator rather than a mere tool or a menacing enemy. The machine was, above all, an extension of human capability and a complement to natural intelligence' (1986: 35). Yet it was this positive and optimistic view of cybernetics which disturbed those few critics who did not give the exhibition glowing reviews. They drew parallels with atomic science, refusing to accept the separation between scientific discovery and its social uses implicit in the exhibition's exclusion of the social context of the development of **cybernetics** (Usselmann 2003: 392). Against *Cybernetic Serendipity*'s presentation of cybernetics as a 'neutral development', a *New Society* article expressed the view that it is 'an instrument of a growing technocratic authoritarianism, which deserves the critical resistance and not the consoling fellowship of our artists' (cited in Usselmann 2003: 392). As the sociologist of museums, Sharon Macdonald (2004) argues that it was this 'consoling fellowship' which Oppenheimer sought in the Exploratorium. His own involvement with his brother Robert in the production of the atomic bomb perhaps informed his attempt to 'present science as a humanistic achievement like art' and 'to rescue science from its tarnished public image' (Macdonald 1998: 15–16). So one way of viewing the attraction of *Cybernetic Serendipity* for the Exploratorium is that an association with art could mend the split between the 'two cultures' of the arts and sciences, and imply that science and technology are creative, rather than an instrumental means of dominance and exploitation. But if we consider the specific character of the exhibition and the kinds of interrelations between art, science and technology established in *Cybernetic Serendipity*, we can also see how it enabled the Exploratorium to stake a claim for a certain kind of interactive science education as against another, emergent model.

The kind of interactivity it stood for is suggested by its title. Serendipity is a surprisingly modern word. Between its invention in the mid-eighteenth century and the 1950s it 'had appeared in print probably only twenty times', but from then on became a well-worn term (Daston 2004a: 29). Serendipity suggested the importance of distraction and the chance encounter. The science historian Lorraine Daston has pointed to the links between the modern concept of serendipity and the more ancient appetite of curiosity: serendipitous discoveries happen to those with the wandering but voracious desire for novelty, with an ability to combine 'focused attention and peripheral intellectual vision' (Daston 2004a: 29). In combination the words 'Cybernetic Serendipity' suggest a particular approach to interactivity, which favours unanticipated effects. In industry

and in avant-garde art, new technologies and methods were being used experimentally to encourage serendipity. The exhibition included artists associated with the Fluxus group: John Cage, Dick Higgins, Alison Knowles and Nam June Paik. Fluxus members were specifically interesting in making work that was dependent on the audience to complete it, and which occupied the interstices between different media–*intermedia* (Higgins 2002: 25; 91–9). Daston also mentions the efforts of postwar corporations and research institutes to plan serendipity by encouraging scientists and scholars to have fun, experiment and fraternize with people from very different disciplines (2004a: 31). This principle was put to work in *Cybernetic Serendipity*. The exhibition involved experimentation and collaboration on the part of artists, scientists and engineers. Objects conceived as art objects were deliberately made indistinguishable from those conceived as scientific experimentation (Reichardt 1968; MacGregor 2002).

Cybernetics usually refers to human–machine communication and is associated with efficient and managed interaction, through controlled feedback systems. Nevertheless by the mid-60s cybernetics had become associated with interdisciplinary projects and serendipitous careers that disregarded the boundaries between the arts and sciences. For instance, included in *Cybernetic Serendipity* was Gordon Pask's *Colloquy of Mobiles*, which consisted of robots that emitted and responded to beams of light, and which the audience could interrupt and confuse with hand-held mirrors. Pask had originally worked in theatre, and developed technological devices that produced deliberately unpredictable and open-ended responses to the actors' performances (Pickering 2002: 426–9). Other British figures involved in cybernetics included the architect Cedric Price, known for his use of new technologies and his radical ideas for responsive, interactive buildings, as well as the theatre director Joan Littlewood, who collaborated with Price on an unrealized project, the Fun Palace, in the early 60s (Design Museum 2005).

Yet parallel with these collaborative scientific, artistic and industrial efforts to put new technologies to creative use were efforts to use the cybernetic technologies and theories to regulate human behaviour. Cybernetics was adopted for the Taylorist purposes of analysing and reorganizing human action along efficient, machine-like lines. *Behaviourist* educational approaches took the notion of an interactive feedback system and used it for training people and animals. B.F. Skinner (mentioned earlier in this chapter) developed techniques of 'reinforcement' to reward and encourage correct responses. Translated into the exhibition's pedagogic relationship with its audience, serendipity and behaviourism spell two emergent models of interactivity: one where the audience's interaction with the exhibit produce unforeseen consequences and a range of possible kinds of knowledge (the audience as creative participant) and the other where the audience makes choices that produce certain 'reinforcing'

responses and where the knowledge produced by the exhibit is predetermined from the outset.

We might expect to see one or other of these models winning out in the many hands-on science exhibits which have appeared since the founding of the Exploratorium. Certainly we could look at individual 'interactives' and see them as either tending towards the serendipitous or the behaviourist. However Barry's analysis of the Cité des Sciences et de l'Industrie at La Villette, Paris, suggests that the visitor is invited to be a creative participant, and what they learn is not entirely predetermined, but also that the exhibit is designed to 'articulate bodies and objects' in such a way as to produce visitors as new kinds of subjects – as 'technological citizens' (Barry 2001: 148). This is a very different model of citizenship from the one Bennett identifies in the Victorian museum. Bennett reads the Victorian museum as designed to *discipline* the public. By contrast, Barry argues that interactivity in new science centres such as the Cité at La Villette suggests 'a much less rigid articulation of bodies and objects' not intended to regiment the body but rather to 'turn it into a source of pleasure and experiment' through pleasurable interaction. Play is not entirely serendipitous: the exhibit is designed to induct and accustom its visitors to a new technological world in which the boundary between human and non-human has become more fluid (Barry 2001: 144–9). In a society in which the public is increasingly required to make their own judgements on scientific and technical matters, interactivity is a means to shape them as 'responsible' and 'moral' citizens. The Cité works not only through the explicit communication of messages and knowledge, but also through a direct address to the bodies of visitors.

Writing about IBM's *Information Machine* display at the 1964–5 New York World's Fair, Ben Highmore states, 'It is the form of the display that addresses an audience with a "content" aimed not at the mind or the heart but at the body's own potential for change' (2003: 128). The *Information Machine* was a combination of cinematic experience and giant fairground ride, which lifted spectators into the air and bombarded them with images. Highmore reads it as turning technological modernity's traumatic effect on the fragile human body into a thrilling transcendence of bodily limitations and everyday anxieties (2003: 146–7). Similarly, interactivity in its current form may be less effective in facilitating the 'discovery' of scientific truths and principles than it is in popularizing a new set of machine–body relationships.

From things to experiences

In this chapter we have considered how the museum has become increasingly like other media, severing connection with artefacts in favour of representations,

but also how museums have incorporated various modern media. In particular the move toward computers as display devices, and the association of computers with interactivity, has had an impact on long-established notions of hands-on experience and education in museums (in Chapter 5, there is further discussion of the role of new media and information technologies in the museum). However, as I have suggested, the move away from artefacts is not a rejection of a somatic and sensory address to the visitor; rather it involves a greater emphasis on the visitor's own perceptions and body.

The philosopher Hilde Hein has argued that museums in general have moved from focusing on objects to an emphasis on the subject (2000: 66). Museums have become increasingly 'people-centred', attentive to visitors' own experiences and values. Importantly, this does not mean that these are equally valued. Indeed, one aspect of the change in museums which Hein describes is their self-perception as institutions devoted to shaping the values and beliefs of the public. For instance, the new National Museum of the American Indian in Washington DC has issued brochures describing the museum's aim 'to change forever the way people view Native peoples of this hemisphere. To correct misconceptions. To end prejudice. To stop injustice. And to demonstrate how Indian culture has enriched the world' (NMAI brochure, 2004). The project director at the Holocaust Memorial Museum, also in Washington DC, stated that it 'recast the story of the Holocaust to teach fundamental American values . . . pluralism, democracy, restraint on government, the inalienable rights of individuals, the inability of governments to enter into freedom of religion' (cited in Gourevitch 1993: 55). Dawn Casey, the director of the National Museum of Australia, faced with criticism regarding the museum's representation of the early conflict between the first Australians and the European colonists, argued: 'We see our role as changing people's attitudes' (Griffin 2002).

Hein argues that this emphasis on values and attitudes entails an increased appeal to people's emotional and sensory responses. She diagnoses a tendency toward the use of objects in simulations and reconstructions to elicit subjective sensations, emotions and feelings, rather than as objects of knowledge that might 'speak for themselves' (Hein 2000: 79). Museums are increasingly involved in the manufacture of experience (Hein 2000: 67). Hein uses the word 'experience' to refer to a concept of subjective aesthetic experience, which emerges in part in the art theory of John Dewey. Dewey shifted the emphasis from the art object (prioritized in traditional aesthetics) to the viewer's experience in its presence. Experience-oriented exhibits are story-centred, like media texts. They rely less on the authenticity and specific provenance of objects than on their 'corroborative power' (Hein 2000: 61). Like a television programme in which pieces of footage can be edited together to produce a sense of a place or time without deriving from that actual place and time, such story-centred

exhibits tend to emphasize the coherence of the story and its general truth over the specific artefact. The experience-orientation of the museum is connected to its increased mediatization, since it detaches objects and events from their place in time and space, and reproduces them in simulated form. An extreme example of this is the Beit Hashoah Museum of Tolerance. It is situated in Los Angeles, a considerable distance from where the events it represents took place. A range of interactive and immersive techniques are used to situate visitors in the story and to stimulate an emotive and subjective response. For instance the museum elicits empathy and identification through the use of identity cards which link visitors to real victims of the Holocaust, whose horrific experiences are narrated to individual visitors in stages as they move through the exhibit (Rugoff 1995: 105).

This increased emphasis on subjective experience in museums is encouraged by the discrediting of old dogmas about the objectivity of scientific and humanistic knowledge and of aesthetic value. In privileging subjective experience, contemporary attempts to make exhibits relevant to people's lives are very different from Otto Neurath's 'humanization' approach discussed earlier in this chapter. For Neurath, humanization described the process whereby exhibits are connected with the everyday lives of visitors. Neurath's branch museums would address visitors in their own localities and in relation to their own daily experiences. This appeal to the visitor's lived experience assumed that experience was social and translatable into knowledge. When combined with the facts presented to visitors by the exhibits, Neurath believed it could enable visitors to develop their own informed and critical perspectives relating to their own economic and social needs. By contrast, in contemporary experience-based museums, the locality and the specific life-experiences of visitors have little bearing. These kinds of exhibits appeal to our subjective feelings, encouraging us to trust those feelings as much, if not more, than any detached presentation of information. Exhibit designers increasingly rely on psychological approaches to attempt to control the ways in which visitors make sense of the exhibit and assimilate it into their own life-experience. The internal spaces of the Holocaust Memorial Museum, for example, are deliberately designed to produce psychological effects in visitors, effects heightened by careful use of music and other theatrical effects (Hein 2000: 65, 147). In this museum the immediate psychological effects may be feelings of dread and anxiety, appropriate to the horrific subject-matter of the museum. However, according to some interpreters, the overall psychological effect on certain visitors may even be therapeutic since the narrative ends with an American liberation and the USA as the country which offered safe haven to survivors, thus consolidating North American identity (Lennon and Foley 1999: 49).

One of the most useful insights of Hilde Hein's argument, in my view, is her

recognition of how diversity channelled through certain experience-led exhibitionary strategies may end up producing homogeneity. Museums may subscribe to the politics of multiculturalism, or emphasize pluralism and tolerance, yet at the same time aim to control and produce much the same experience for all visitors. The current strategies for manufacturing subjective experience that we may find in museums in the United States, and increasingly worldwide, are premised on an assumption of universal human sameness and monolithic truth. Hein (2000: 80) says:

> Underlying the promise of existential communion, and despite the appeal to 'diverse' audiences, the epistemological conviction remains strong – in museums as elsewhere – that ultimately there is one truth and that a single (and well-controlled) stimulus will recall it . . . Even as we stand, side by side, simultaneously undergoing our separate experiences, 'shaped' by a museum environment, we are prompted to carry away the judgement of a 'same' and publicly acknowledged reality.

Earlier in this chapter I discussed Theodor Adorno's writing on standardization. The differences between products appeal to our sense of distinction, of our difference from others, and give an appearance of choice and diversity. However Adorno argued that in a capitalist society dominated by mass production, these differences are actually superficial and conceal an underlying sameness. There is a parallel here: our own complex social attachments, the social basis for our different knowledges and understandings, and the real diversity of experience that we bring as visitors to the museum are subordinated to a controlled museum experience designed to reveal a larger, shared, and preferably unquestionable truth. This standardization of experience is also associated with commodification. The public museum has always been an institution devoted to the representation of universal truths, but it has not always dealt in experience in this way. This new orientation towards the production of experience has developed since the 1980s, during a period when free-market or neoliberal policies have steadily privatized and increased market control over culture, media and education. In this new social context, experience becomes a commodity, purchasable for the price of a ticket. Across a range of attractions, visitors are treated as consumers of experience; their sense of themselves as individuals is appealed to, while real and significant social differences are repressed or disavowed. Though she doesn't make much of it, Hein recognizes that the new experience emphasis is linked to commodification and to the emergence of a new *experience economy* (2000: note 12, 198).

We can distinguish between various kinds of exhibition strategies: between object-led and experience–led exhibits, or, as I did in Chapter 2, between hands-on exhibits and illusionistic and simulation-based approaches to display. But

these oppositions are too simplistic, and we can begin to make finer distinctions. Recent media theory undoes the opposition between simulation and artefact by encouraging us to think of all representations as material. The concept of *mimesis* is now used to undo straightforward oppositions between simulation and the real, and suggests how practices of imitation and copying are a fundamental means of contact between peoples and between things (Taussig 1993: xviii, 19–23). The immersive exhibits developed in Scandinavian folk museums, or the techniques Molly Harrison used at the Geffrye Museum (see Chapter 2) suggest some of the nuanced differences between the different mimetic and simulation techniques used by museums, which a simple opposition between experience and object cannot capture. It is possible to register concerns about the homogenizing effect of certain simulation techniques and at the same time value the attempts made by museums to capture and communicate aspects of intangible and lived culture through techniques of performance and mimesis. For example, in some children's museums and exhibits, such as the Tropen Museum Junior in Amsterdam, performance is used to enable children to gain knowledge through experience of the various cultures the museum represents. These children, like the child in Molly Harrison's example, are not role-playing. In putting on historical or regional costume and moving through furniture of the period or place, they do not necessarily have to imaginatively identify with children of other times and cultures or to pretend that they have had experiences they have never had. Instead, they have the opportunity to bodily feel, to experience, a small part of the lived experience of those other children.

Many exhibitions use hybrid techniques. Writing about the Holocaust Exhibition housed at the Imperial War Museum, London, Andrew Hoskins (2003) argues that the use of artefacts from the time underwrites the sense of an authentic and accurate history, and he associates this with a 'purist' as opposed to a 'populist' approach to history. Evidently the project director had an explicit policy emphasising authentic artefacts, rejecting 'theatrical recreations', and a display strategy 'intended to make the visitor think rather than overwhelm them with emotion' (Bardgett, cited in Hoskins 2003: 14). Nevertheless techniques are used to try and evoke a sense of 'being there' – so that the visitor moves in a journey through time. This object-based exhibition uses more than 30 TV screens incorporated into the surfaces of the display (Hoskins 2003: 19). Hoskins questions the notion that an artefact-driven display would avoid emotionally overwhelming visitors. Indeed, he argues that the exhibition's 'purist' approach, by not dealing with the Holocaust's presence in the years that followed, or with media and popular histories, makes it 'all the more uncompromising and overwhelming' (Hoskins 2003: 20).

Theories of learning through experience offer one way to rethink the opposition between object-led and experience-led exhibits. Contemporary museums

have strong pedagogic aims, as the directors' statements I have cited clearly suggest, and in subscribing to certain experience-oriented display strategies, they are subscribing to variants of experiential learning. Experiential learning includes a wide range of otherwise opposed educational approaches. Behaviourist education involves learning through experience, but what one learns is very tightly circumscribed and education takes the form of training. We can see a parallel in the use of psychological methods to stimulate certain moods and emotions in visitors. However the concept of learning through experience is also associated with the tradition of hands-on, object-based education developed by theorist–practitioners such as Friedrich Froebel, Jean Piaget and John Dewey, and the techniques they advocated differ greatly from behaviourist techniques.

Froebel designed educational toys intended to instruct very young children with little intervention from the teacher and through the child's own capacity for reasoning. 'Forms of nature' (mimesis), 'forms of beauty' (aesthetics) and 'forms of knowledge' (such as mathematics) could be learnt through playing with simple, unpainted wooden building blocks placed on tables marked with grids (Brosterman 1997: 37). To some extent, Froebel shared with the Romantics a belief in natural symbolism. If paintings could 'speak to the soul' or a landscape was endowed with a spiritual significance, so symbolic meanings could emanate directly from the visual and tactile manipulation of simple materials and objects. This is very different from the understanding of symbolism commonly used in cultural and media studies, which derives from semiotics. In semiotic theory, meaning does not arise naturally from things – it is culturally and socially attributed. Yet Froebelian education does share the materialist approach of the cultural studies tradition, insofar as it sees understanding and ideas as emerging from material interactions.

Though Froebel's understanding of symbolism would be rejected by later educational theorists (such as John Dewey), his approach to learning through play would be hugely influential. For many years the concept of learning through play was a staple part of the training of primary school and kindergarten teachers in many parts of the world. Other educationalists adapted Froebel's approach, but like him emphasized interaction with an environment (people and things) through play as fundamental to learning and understanding. The content of learning comes from this material and social interaction, not from formal instruction, so that education becomes a means to enable the child's self-realization through activity (this concept is similar to the Marxist notion of realization used by Lissitzky – see Chapter 2). In the later work of Froebel, and in Dewey and Piaget we find the view that what is learnt through certain experiences cannot or should not be predetermined (Imai 2003: 117, 120). In kindergarten education there develops a model in which mimesis,

performance and an emphasis on the interaction with a physical world are complementary, rather than opposed. The materials of play provide a structure within which improvisation can take place, and the outcomes of the experience are neither predictable nor predetermined. A Froebelian approach would conceive of objects and display in museums and exhibitions as enabling improvisational activities. Often in museums and science centres, hands-on and interactive learning does not include this improvisational aspect, and the intended learning outcomes are frequently tightly defined and singular.

Froebelian approaches to learning through improvisational play and simple materials became influential worldwide by the 1890s (Brosterman 1997: 90–103). At the same time, philosophical texts raised the issue of whether and how it is possible to learn from everyday experience in modernity. For instance, Dewey (1934) recognized that there were different kinds of experience – some of which could be learnt from and built upon, and some which could not. He saw modern labour (on assembly lines in factories, for instance) as separating the lived moment from communicable experience. This work relies on mechanistic, repetitive actions that are unable to be reviewed or understood in continuity with other actions, so that this kind of experience 'hardly deserves the name' of experience at all (Dewey 1934: 51). A similar argument to Dewey's was put by Walter Benjamin in the same period (1920s and 30s). Benjamin, writing in German, used two words which translate as 'experience' in English. One is *Erlebnis* which refers to the immediate, lived moment; the other, *Erfahrung* is that which is accumulative, reflected upon, and counts as knowledge. When someone has accumulated know-how or skills, they have experience in the sense of *Erfahrung*; when something happens to them, that experience is *Erlebnis*. Like Dewey, Benjamin characterized lived experience *(Erlebnis)* as becoming separated from *Erfahrung*. In the wake of the Great War, in the context of modern factory labour, it seemed increasingly difficult to exchange experiences, or translate the lived moment into something which could be narrated, passed on, developed. For Benjamin, modern lived experience is like that of the gambler, who does not improve her chances of winning, no matter how many times she repeats the game. He refers to this as the poverty of experience (Benjamin 1992a: 84; 1992b: 170–3).

The work of Dewey and Benjamin belongs to a large body of philosophical and cultural writings which argue that modernity has placed experience in crisis, by making it increasingly difficult to translate lived experience into communicable and accumulative knowledge. We have already encountered one version of this argument in Nietzsche's 'On the Advantages and Disadvantages of History for Life'. There Nietzsche argued that his age was marked by an excess of historical knowledge unrelated to experience, unable to be employed in everyday living and action (1997: 82). While Nietzsche attributed the problem

to Victorian historicism and saw its outcome as a kind of superficiality of character, for Dewey and Benjamin the problem is to do with a change in the structure of everyday life brought about by technical, social and economic forces. For Dewey, a potential solution lies in reintegrating aesthetics with work, and he contrasts (rather idealized) craft-type production with Fordist mass production (Imai 2003: 113). For Benjamin overcoming the poverty of experience meant rethinking aesthetic experience altogether (Highmore 2002: 66; Imai 2003: 114).

Benjamin associated the poverty of experience with the 'decay of *aura*'. In the first chapter, I mentioned how aura is associated with a kind of animism: 'To perceive the aura of an object we look at means to invest it with the ability to look at us in return' (Benjamin 1992b: 184). This animist or anthropomorphic relationship between people and (especially) art reveals how aesthetic experience retains the traces of a pre-modern structure of experience. Benjamin, along with many avant-garde artists, was interested in the experiential world of so-called primitive people, the insane and children, not for their own sake but for the way they gave the lie to Western philosophical models of experience based on a firm division between human subject and the external world of things (Imai 2003: 111–2; Benjamin 1996: 103). In the eighteenth and early nineteenth centuries, European art and culture still maintained a link between ritual and aesthetic experience and elements of this animistic relation to the world. While for Dewey, aesthetic experience offered an antidote to the poverty of experience, for Benjamin, the modern split between *Erlebnis* and *Erfahrung* had implications for aesthetics too. The aesthetic forms and genres which had previously been a means to make sense of and pass on experience were no longer adequate to the task. Benjamin characterizes modern lived experience in terms of fragmentation and shock, and addresses the question of what (popular and avant-garde) forms, practices and materials might be able to make this communicable as a first stage in a revolutionary transformation of the everyday. For Benjamin, new forms and techniques corresponding to the structures of modern experience might address human senses qualitatively transformed by the onslaught of sensation and shock experiences in modernity (1992b: 171; Imai 2003: 115). In this view, things still matter, not for their ritual and auratic value but for their capacity to jolt us out of an intoxicated or trance-like state, induced by the spectacular phantasmagoria of capitalist modernity.

Neither Froebelian education theory nor Benjamin's critical theory are opposed to mimesis or story-telling. What they have in common is that they place high value on the transformative power of things. From these perspectives, the material of the exhibit is not a way of leading visitors to the 'museum message', but is itself the content and substance of the activities which take

place within the museum (Imai 2003: 118). It is worth asking what exhibitory forms would be adequate to an exhibition practice which did not set out to control or shape visitor experience in order to inculcate certain values, but instead to connect with the lived experience of visitors on a sensory as well as an intellectual level. Perhaps to consider museums and exhibitions as media is less to do with how much technical reproduction replaces artefacts, and more about the extent to which these are spaces capable of articulating lived experience, as well as compensating for it with illusions.

Further reading

Hein, H. (1986) *The Exploratorium: The Museum As Laboratory.* Washington DC: Smithsonian Institution Press.

Hein, H. (2000) *The Museum in Transition: A Philosophical Perspective.* Washington DC: Smithsonian Institution Press.

Macdonald, S. (ed.) (1998) *The Politics of Display: Museums, Science, Culture.* London: Routledge.

Rectanus, M. W. (2002) *Culture Incorporated: Museums, Artists and Corporate Sponsorships.* Minneapolis, MN: University of Minnesota.

4 | PUBLIC

Clare patted Prince Albert's foot and thought: when I'm seventeen, in about a hundred years' time, and I fall in love, I'll have assignations here. 'Meet you under the blue whale' I'll say, 'or by the iguanodon', and we'll melt at each other, like in old films, all among the invertebrates.

(Penelope Lively, *The House in Norham Gardens*, 1974)

Itineraries

Museums and museum exhibitions make objects out of things and stage them for an audience. Yet the museum is also a space for romantic encounters, for day-dreams, for losing one's self or imagining one's self differently. These possibilities are seldom articulated in museum discourse – in the stated intentions of designers, curators, educators or directors – nor do they play a large part in the critical discourse on museums (an exception is Kavanagh 2000). Nevertheless museums have always had a dream-like or magical aspect: 'they come into contact, on the one hand, with scientific research and, on the other hand, with "the dreamy tide of bad taste" ' (Benjamin 1999a: 406). In this, they reveal their connection with the great industrial exhibitions and world's fairs, which began with the 1851 Crystal Palace exhibition, and which, much more explicitly, seemed to embody a world of fantasy and magic, even for those who did not visit:

> I myself recall, from my childhood, how the news of the Crystal Palace reached us in Germany, and how pictures of it were hung in the middle-class parlours of distant provincial towns. It seemed then that the world we knew from old fairy tales – of the princess in the glass coffin, of queens and elves dwelling in crystal houses – had come to life.
>
> (Julius Lessing cited in Benjamin 1999a: 184)

This reminiscence suggests the degree to which the Crystal Palace was the perfect casing for fetishized commodities, and how it harnessed a deeply rooted European cultural imaginary to the world of industrial production.

These mythic and fantastic aspects of exhibitions may work ideologically. This view would certainly chime with the critical literature on museums which sees their displays and their architecture as acting to form visitors as subjects, impressing a particular ideological content and reinforcing existing power relations. But it is worth entertaining the notion that the dream-potential of the museum – not just its symbolic connotations but the opportunities it offers for wandering and fantasizing – might also (and simultaneously) offer a taste of freedom. As they merged industrial capitalism with a collective fantasy life, the great exhibitions also offered spaces for various kinds of subject–object relations, the development of new practices, modes of attention and types of experience which were not necessarily anticipated or considered desirable. Museum spaces, too, work on their audiences in ways not necessarily intended by their authors.

The uncanny and fantastic qualities of museums and exhibitions are common themes in popular fiction, but this has been given little attention in the critical literature. Gaynor Kavanagh (2000) has written about the relationship between personal memories and the objects held in history museums, and the way in which history museums work with visitor memories. Other writers have described the museum as a space apart from the everyday, using Foucault's concept of *heterotopia* (Hooper-Greenhill 1990). However in most critical studies of museums, subjective experience is understood primarily in relation to the ideological production of subjectivity. This they have in common with media studies. However, while studies of media and film may see representations as *interpellating* subjects through processes of unconscious identification and (mis)recognition, museum studies have emphasized how visitors, by following an itinerary through the exhibition space, enact the exhibition narrative. Over the next few pages, I look at how a number of studies explain how visitors' performances are elicited by the museum's space. The second section considers how aesthetic experience is associated with certain kinds of attentive practices and a certain effect of an object on a subject. The third section discusses museum claims to universality, and occasions when these are contested, in relation to concepts of subjectivity and identity. The final section is about how certain kinds of taste and attachments to objects become the basis of gendered and sexualized social distinctions and identifications.

Tony Bennett gives several examples of the performative aspect of museums. In Henry Pitt Rivers' 1891 proposal for an 'anthropological rotunda', Bennett traces the belief 'that a museum's message should be capable of being realized or recapitulated in and through the physical activity of the visitor' (1995: 183). Pitt Rivers held the view that if this circular building was correctly designed, then even 'the most uninstructed student' could learn the meaning and history of each object, simply by following the route and observing the spatial

arrangement of objects within the building (Pitt Rivers cited in Bennett 1995: 183). In the Musée Carnavalet in Paris, visitors are guided by means of arrows through a sequence of rooms arranged according to the 'familiar narratives of French nationhood'. The main interruption in such narratives is the French Revolution, and here the before and after of the revolution are marked by a spatial discontinuity – visitors pass from one building into another (Bennett 1995: 184). A further example is the Jardin des Plantes in Paris, the botanical gardens outside the Muséum National d'Histoire Naturelle. Lee Rust Brown reads the gardens as complementing the classificatory arrangement of specimens inside the museum. He refers to the pathways in the gardens as 'media' by means of which visitors 'walked through the plant kingdom just as one would "think through the steps" of a classificatory arrangement of information' (Brown 1992 cited in Bennett 1995: 185).

The exhibition narrative that visitors enact and embody through their movement may not always be an explicit one, that is, neither explicitly intended by the curators nor explicitly read by the visitors. In a 1978 article about the Museum of Modern Art (MoMA) in New York, Carol Duncan and Alan Wallach analysed how the visitor participated in a 'ritual walk' organized by the 'script' of the architecture and artworks in the museum. MoMA, they argued, was structured as a labyrinth, and like the labyrinth in myth and ritual, it was 'an ordeal that ends in triumph' (2004: 483, 492). MoMA is known for the teleological history instituted in the 1930s by Alfred H. Barr's arrangement of the collection. In Barr's art history, American abstract art is presented as the culmination of developments in European art. Duncan and Wallach read this teleology as a gendered narrative, one in which European paintings and sculptures of female nudes come to represent the mother/earth who must be overcome in the struggle for spiritual transcendence. The latter is represented by the progressively mystical and abstract works on the higher floors of the museum. According to Duncan and Wallach, by negotiating the windowless and labyrinthine white spaces of MoMA and obediently following the route laid out for them, the visitor 'lives' the 'struggle' between the material and the spiritual – between the demands of corporeal existence and the longing for unity with the divine. The triumph of aestheticism and abstraction in art, the release of art from social content, comes to represent the triumph of spirit. Ultimately, in Duncan and Wallach's (2004) reading, the museum does the ideological work of transforming the experience of social alienation (in a capitalist society) into an individualist notion of freedom.

In Duncan and Wallach's semiotic reading of MoMA, as in Tony Bennett's examples, the significance and material presence of individual objects is subordinate to their place in the sequence (see also Chapter 1). For instance, they do not suggest that every European painting of a female nude in the museum

actually represents earth mother/goddesses, nor that every abstract painting at the end of the sequence represents the triumph of spirit, but rather that they come to represent this through the museum's staging of them. In Pitt Rivers' proposed rotunda, the visitor would still need labels to identify each artefact or specimen within the exhibition, but their spatial ordering makes explicit their place in relationship to the other specimens, that is, the larger message regarding the movement from one historical period to another.

Another example is given by the cultural geographer Richard Hornsey. He writes about the *Britain Can Make It* exhibition, held at the Victoria and Albert Museum in London in 1946. Hornsey notes that though at first the exhibition seems to be about the individual commodities on display, its impact, as recognized by visitors, was more to do with the construction of spaces, and through that the validation of certain kinds of social and domestic activity (2004: 32). *Britain Can Make It* was organized by the new Council for Industrial Design, and intended to educate the taste and shape the lifestyles of its visitors, as well as promote British design, in the aftermath of the Second World War. Hornsey places it in the context of wider reconstructive efforts, and especially in relation to Patrick Abercrombie's plans for the reconstruction of post-war London. The plans included zoning the city into discrete spaces for residence and industry, play and work, and so on. Through spatial planning, the exhibition and the planning documents prescribed the social activities that were to take place in the city. The most popular part of the exhibition, the Furnished Rooms, were *in situ* exhibits, mock-ups of rooms much like the simulated rooms of the folk and historical museums, and especially the furnished rooms displayed in the Ideal Home Exhibitions. They were arranged according to function: schoolrooms and offices, kitchens, bathrooms, bedrooms, living-rooms, each allocated to a fictional inhabitant described by occupation. These Furnished Rooms 'were less about the artefacts that would fill Britain's post-war homes than where these objects would be placed and how they would be arranged'. Visitors were invited to think like planners, and to imaginatively involve themselves in the construction of social spaces (Hornsey 2004: 34).

Britain Can Make It was the first major British exhibition to have a heavily controlled route through its displays. Hornsey connects the attempt to control visitors' movement through the exhibit (and the monitoring of their time spent there) with wider anxieties about controlling space and social activity in the city, and he associates the movement of people around the exhibition with developing forms of citizenship in an era of decolonization and reconstruction. He reads the controlled flow of visitors as a microcosmic version of other forms of circulatory movement: the circulation of traffic within the city and the international flow of commodities and sterling that would link the nations of the new commonwealth (Hornsey 2004: 37, 58). Bennett similarly identifies the

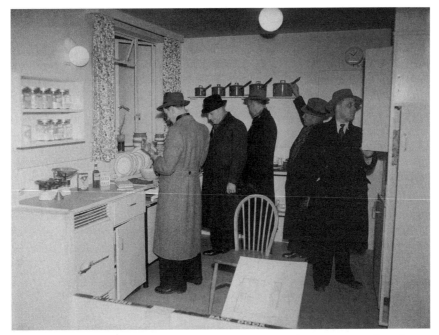

Figure 5 Design for the kitchen of a cottage in a modern mining village by Miss Edna Mosely ARIBA, displayed at the *Britain Can Make It* Exhibition, 1946, in the Furnished Rooms Section. © Design Council and the Design Council Archives, University of Brighton.

controlled movement of visitors through exhibition spaces as part of an effort to produce new forms of citizenship. He sees the emergence of techniques of visitor control as developing much earlier, in nineteenth-century museums in which visitors followed itineraries 'governed by the irreversible succession of evolutionary series'. These itineraries make the narrative content of the exhibits materially embodied, 'a matter of doing as much as seeing', but they also turned objects into 'props for a performance in which the progressive, civilizing relationship to the self might be formed and worked upon' (Bennett 1995: 181, 186). Bennett conceives of these new practices of embodied spectatorship as a means of impressing an ideology, and for the production of a disciplined self. In Hornsey's account, the exhibition acclimatizes people to new forms of social control and social organization.

Bennett possibly overestimates the success of the Victorian museum's spatial narrative. He states that 'the museum visit thus functioned and was experienced as a form of organized walking through evolutionary time' (Bennett 1995: 186). Other writers, drawing on Dutch and German examples, have emphasized the

chaotic character of many nineteenth-century museums and, crucially, their illegibility to visitors. At the Boymans museum in Rotterdam, for instance, the entire collection of paintings was crammed onto the walls, and the rooms were very dark until the museum was rebuilt after a fire in 1864. The museum provided very little contextual information about its collection, with visitors having to rely on the travel guides such as Baedeker's (Noordegraaf 2004: 34–8). In a study of German ethnographic museums at the turn of the twentieth century, H. Glenn Penny (2002) shows how these museums appeared almost incomprehensible to many of their visitors. He suggests that the German museums were unable to fully organize their collections because of their commitment to an ethnographic project which required that they collect incessantly, and which privileged collecting over any narrative organization of displays. The collecting and display functions of the museum conflicted with one another and consequently visitors sometimes found themselves unable to interpret the crowded displays. For many visitors the museum seemed either illegible or just packed full of strange things. Those visitors who took the objects of ethnography to be curiosities made their incoherence meaningful. For others, the unreadability of the displays caused frustration and confusion (Penny 2002: 163–214).

Nevertheless where the displays were ordered and arranged by the ethnologists, they should have at least spoken to a certain middle-class audience who had a *museum set*. However, Penny uses the example of a 1909 critical response to the Grassi-museum in Leipzig to suggest that some displays did not even make sense to this audience. At the Grassi-museum collections were arranged geographically, one region following another, so that the visitor's progress through the exhibition 'mimicked a long circular voyage of discovery'. This display, which would have made sense to ethnologists, seems to have left visitors puzzled and with only a vague impression. Museum directors and ethnologists were aware of this and complained about the 'mindless' wanderings of visitors (Penny 2002: 202).

In the German ethnographic museums, the collected objects were deliberately displayed to facilitate comparative analysis, and were not placed in hierarchical or developmental sequences. Still, the audiences had different expectations. Local élites wanted the aesthetic they knew from art museums: 'quiet halls for their contemplation, organized in a way that would allow for their easy movement through the displays and which would satisfy their spectatorial gaze' (Penny 2002: 14). Here, and in museums throughout Europe, this social group pressed for more regulation of museum spaces and expected displays to be orderly and readable (Penny 2002: 199). For visitors who did not have the 'museum set', the problem was even greater. The democratization of these museums at the turn of the century meant the introduction of a new audience drawn from the working class and lower middle class, with different expect-

ations and ways of seeing. Penny suggests that the lack of a common interpretative framework between these visitors and the ethnologists was compounded by two factors: the increased specialization and professionalization of the ethnologists, and the incompatible experiential worlds which the new visitors brought to the museum. Penny argues that a population was arriving at the museum from a world saturated with images, representations and displays of non-Europeans that directly contradicted the ethnographic project as Bastian and his colleagues understood it. Museums began to be read as articulations of racial and cultural difference, as proclamations of European superiority, instead of the 'human unity' they were intended to express (Penny 2002: 16, 210–1).

Penny also suggests that this population came with changed ways of seeing in response to the 'discontinuous heterogeneity' of modern urban life (compare Sandberg's notion of 'composite viewing habits' in Chapter 2). The idea that the new mass audience would develop new modes of attention was introduced in early twentieth-century journalism and cultural commentary, and theorized in that period by Siegfried Kracauer (1987) and Walter Benjamin (2002). More recently, this idea has been expanded in Wolfgang Schivelbusch's theory of panoramic perception (Schivelbusch 1986). These writers argue that ways of seeing and attending to the world are affected and qualitatively transformed by the technical arrangements of everyday experience in modernity. These could include (in no particular order) mass-urbanization and the introduction of the assembly line; the introduction of electric and gas lighting of streets and interiors; travel at speed on trains; new technologies of visual reproduction. As feminist writers on modernity have suggested, those experiences are differentiated according to social position and gender (Pollock 1988; Wolff 1990; Wilson 1992). The net result is that the people who come to the museum arrive with differently attuned but distinctly modern 'ways of seeing'.

According to Penny, these ways of seeing were antithetical to the ethnological project because they replaced the gaze with the glance and produced a 'cognitive distance' that rendered visitors mere observers rather than participants (2002: 213). This is reminiscent of early cinema critics' descriptions of film audiences, for whom a contemplative gaze is impossible, since 'the stimulations of the senses succeed each other with such rapidity that there is no room left for even the slightest contemplation to squeeze in' (Kracauer 1987: 94). Because of this change in the audience, according to Penny, the German ethnographic museums came under pressure to follow the natural history museums in producing didactic displays intended for a broad public of all social classes and ages. As in the natural history museums, displays were simplified and organized around a narrative, and exhaustive collections were replaced by representative artefacts (Penny 2002: 146–7). Thus in the early twentieth century, the liberal

humanist ethnological project of the nineteenth century became a pedagogic
tool of imperialist ideology.

Penny sees his account as disputing those histories of ethnographic museums
which emphasize their role as a vehicle of ideology and in disciplining a public.
However, I do not find it entirely incompatible. The German museum directors
eventually accepted linear and didactic displays (Penny 2002: 206). Elsewhere
too, worries about visitor behaviour in the museum had led to increasingly
controlled linear and didactic displays and the effacement of the museum's role
as a 'liberal' gentlemanly research institution (see Chapter 2). In Europe, North
America and Australia, the fact that visitors persisted in reading the exhibits as
curiosities or wondrous spectacles was frequently cited as evidence that
museums should reform their display techniques and reduce the number of
objects on display. Penny's argument is that the audience itself was a significant
factor in changing the museum toward increased control of audience, more
didactic displays and an imperialist message (2002: 13). This view that dem-
ocratization undermines the participatory and open-ended character of the
museum recalls the argument made by the German cultural theorist, Jürgen
Habermas, regarding the public sphere. For Habermas (1989) the price of the
expansion of the public sphere is the loss of its participatory character. An
élitist public sphere was predicated on a shared training in high culture. Lacking
this training, the wider public brings with it cultural expectations and practices
formed in relation to a mass culture and, according to Habermas, becomes a
public of passive consumers rather than active participants.

Both arguments support the widely-held belief that mass culture and everyday
life in modernity address people as consumers. However, it's worth noting that
those writers who initially characterized modern everyday life in terms of an
excess of stimuli and abrupt shocks did not see it as having a consistently
pacifying effect. For Simmel and Benjamin, the possible responses to the shock
experiences of modernity include an armoured consciousness which allows the
sensory world to impact very little on it, and an intoxicated state resulting from
unprotected exposure to overwhelming sensations. These responses are gen-
dered: armoured consciousness is associated with masculinity and immersion in
sensation is associated with femininity (and viewed in terms of passivity and
vulnerability) (Henning 1999). In the museum, they correspond to the indifferent
stroller and the intoxicated gawper: two figures which occur repeatedly in
museum discourse. In museum discussions of visitors, perhaps the greatest
anxiety is not that visitors might read 'against the grain' but that the museum
might be meaningless to its visitors or have no impact at all on them.

According to Benjamin (2002), these responses to the shock experiences of
modernity are addressed by mass media which provide a technical and aesthetic
equivalent to the shock-based experiential world. This can be explained as a

kind of mastery of trauma through repetition, which is how Freud (1984) characterizes the infant's game of *Fort-da*. Benjamin writes of how narrative film, for instance, marshals a chopped and repetitive structure into a coherent representation. In doing so, it achieves what older cultural forms (such as the epic, the bourgeois novel, oral storytelling) could no longer achieve: the translation of lived experience (*Erlebnis*) into an aesthetic form appropriate to a distracted and intoxicated audience (Benjamin 2002). Perhaps the unintelligibility of ethnographic museums was related to the outmoding of the narrative forms they deployed. Yet curiously, in their illegible state, they actually come to correspond to everyday urban experience – in their excess of stimuli, their collapsing of geographical distance, the juxtapositions and jumps between apparently disconnected things, the sudden encounters with the different and the 'other'. This kind of overcrowded museum mirrors the experience of modernity but does not allow for mastery. By contrast, Hornsey reads the popular Furnished Rooms of the *Britain Can Make It* exhibition as a *Fort-da* game, in which the trauma of the Blitz – when homes were literally ripped open by the bombing – is re-enacted and domesticated through the public display of domestic interiors viewed through a missing fourth wall (Hornsey 2004: 62–3).

One way the history of museum display techniques could be told is in terms of a turn to visitor choreography, and to an increasingly bodily and affective address. This is a process of uneven development, happening earlier in some countries and some types of museums than others. Other kinds of exhibitions and exhibitionary spaces, such as world's fairs, though they have a different relationship to popular culture and commerce, also develop exhibitionary technologies which control the movement of visitors. Indeed, the display techniques used in twentieth-century world's fairs are often much more obviously addressed to the bodies of visitors, transporting them on moving walkways and seats, and producing affects and sensations close to those of the ride and the roller-coaster (Highmore 2003). A common thread emerges across Sandberg's notion of the folk museum refiguring the experience of modern mobility, discussed in Chapter 2, through Highmore's reading of the IBM *Information Machine* as recoding traumatic experiences of machinic modernity into a thrilling taste of what it might be like to be processed by a machine (see Chapter 3), through Hornsey's reading of *Britain Can Make It* as reworking the trauma of war and anticipating the social-spatial control in the post-war reconstruction plans. In each of these examples, the affective content goes beyond the narrative content of the exhibit. They show us how increasingly controlled and affective exhibitionary environments are more than a means to hammer home 'museum messages'. Instead these environments work to resolve and make coherent everyday experiences of technology, which take different forms at different historical moments, through the production and reproduction of new forms of

Figure 6 Attendant seated in front of a cross-section display of a house showing the distribution of hot water and electrical services at the *Britain Can Make It* Exhibition, 1946. © Design Council and the Design Archives, University of Brighton.

subjectivity. Indeed, modernity is characterized by its 'compensatory moves', its attempts to remake coherence, as well as by its production of incoherent sensation (Sandberg 2003: 118). Even where the museum appears unintelligible to visitors, it can still work to habituate them to certain kinds of modern experience.

In this bodily address to a mixed mass audience, museums and exhibitions nevertheless privileged certain subject positions, which some bodies could squeeze into more easily than others. (Bennett 1995: 189). Hornsey reads both the Abercrombie plans and the *Britain Can Make It* exhibition as working hard to suppress the 'leaking' in of other kinds of unprescribed and illegitimate

practices and uses of space, such as those associated with male homosexuality, which threaten the functionalist model of living that the exhibition offers (Hornsey 2004). Yet museums and exhibitions are also spaces of contact and intermingling; indeed Bennett sees this as a crucial part of their reforming function. While he sees working-class men as 'the primary target' of mid-nineteenth century British museums' reforming zeal, women were important within these spaces for their 'civilizing influence' on men (Bennett 1995: 31–2). However, as I will argue, museums have historically achieved their mass address not through an attentiveness to the diversity of their audience, but instead by universalizing socially and culturally particular experiences, judgements and relationships with objects.

Aesthetic experiences

Museums validate certain practices of attention and devalue others. In turn, these practices of attention validate the objects held in museums. Indeed, museum objects, in order to retain their value, must be repeatedly legitimated through acts of attention. Competing interpretations and value judgements within the museums and the disciplines re-evaluate and reinforce the canons of valued objects, devaluing some, newly valuing others, while leaving a relatively stable core of agreed value. In this way the value of museum objects and modes of attention mutually reinforce one another. Through this network of relationships that make up the museum, the value of certain cultural prac-tices and objects, and the social values of what Stuart Hall has termed the 'dominant particular' culture, are made to appear universal and unquestionable (1991: 67). In this section, I look more closely at how the particular becomes 'universal', and the ways in which subject–object relations are staged by the museum.

In Chapter 1, I looked at how in the eighteenth century the transfer of ritual objects into the museum and the development of aesthetics contributed to a change in aesthetic value, which became a mysterious quality or aura possessed by the singular masterpiece. These developments helped establish a new aes-thetic relationship in the art museum, where certain highly-valued objects were attributed the power to 'speak to the soul' of sensitive individuals. The art museum was also shaped by developments in aesthetics, and in particular Immanuel Kant's theory that aesthetic judgement could be universally valid and pure. Art museums continue to rely on this notion. It is assumed that the artwork needs to be viewed in the right circumstances, with little distraction, and the viewer guided toward looking in the right way, but that, apart from this, art objects do not require much contextualization. This view was expressed by

the current director of the British Museum, Neil MacGregor, in his previous role as the director of the National Gallery in London:

> I think that the point for the public of museums is not that the public should learn something but that they should become something . . . I think that the role . . . of scholars and curators is not to put themselves between the public and the objects, not in any very elaborate sense to explain the objects, but to exhort the visitor to a direct experience, to an unmediated vision.
>
> (MacGregor 1994 cited in Trodd 2003: 17–18)

MacGregor claims that art museums, and the practice of aesthetic contemplation, are transformative, as religious ritual is intended to be transformative (Duncan 1995: 13). He is opposed to explanation as mediating and interfering with the visitors' communion with the objects. Yet, as I have suggested in previous chapters, no experience in the museum is unmediated. Nineteenth-century aesthetes were able to experience paintings as directly addressing their souls because of the trajectory by which these paintings had entered the museum and because of their own (formal and informal) training in new modes of perception and appreciation. The directness of the experience seems to legitimate the view that aesthetic experience transcends the ways of seeing belonging to a specific culture and class, and that aesthetic qualities are innate in those art objects designated as canonical. Thus MacGregor expects this passionate and transformative experience of the art object to be available to 'the public' in general, with some prodding and directing.

On the one hand, museum visitors are expected to experience the art object in a 'direct' and 'unmediated' way, but on the other hand they are supposed to be discerning, able to make aesthetic judgements, and to find aesthetic value in those objects admitted into the canon. This attitude ignores the fact that the mode of attention and value system required for aesthetic experience are tacitly learnt through immersion in a specific culture. Through appropriate acts of attention, the quality of an artwork supposedly reveals itself. In practice this means that far from being universal, aesthetic experience is one way in which museums function to differentiate populations. This argument was put by the sociologist Pierre Bourdieu (1997, 2003). He conducted visitor studies in art museums in the 1960s and found that the ability to make such judgements was measurably linked to social class. A taste for art and the ability to discern between different kinds of art is one way that people establish their position. Art becomes capital, not just because it can be owned, accumulated and directly exchanged for cash, but also because a disposition toward art can be cultivated and used as a social and cultural asset (Bourdieu 1997, 2003). Taste and connoisseurship are embodied forms of cultural capital, not simply reflecting

social position but also enabling the reproduction of social class – 'classes make themselves through the medium, not just of economic struggles, but of cultural struggles for distinction' (Fyfe 2004: 47). Bourdieu argued that the education system and museums did not distribute this cultural capital, but instead reproduced its unequal distribution from one generation to the next. The art museum underwrites the value of knowledge about art and a taste for art, defining what counts as cultural capital through its collections. Through museums, as well as schools and universities, cultural capital is institutionalized, and its value maintained. At the same time, art museums, together with the academic discipline of art history and practices of connoisseurship, legitimate and universalize aesthetic value.

Bourdieu found that the art museum of the 1960s claimed to be relevant to all the public because it was open to all, but that it actually functioned to cement the relationship between social and economic position and culture. Bennett makes a similar point about museums in general, though he views them, not so much as institutions which ratify and reproduce cultural capital as 'instruments for the reform of public manners'. According to Bennett the public museum might seem to address 'an undifferentiated public made up of free and formal equals', but in its function it regulates and prevents 'the forms of behaviour associated with popular assemblies' (1995: 90). The link between visitor behaviour and aesthetic experience is made in Carol Duncan's concept of museum-going as a form of ritual. Through the enactment of ritual forms of behaviour, transformation is achieved – visitors 'become something', to use MacGregor's phrase (see Preziosi and Farago 2004: 475–7, for a critique of this approach to art museums as ritual experiences).

Science and natural history museums also work to produce universal value: collecting, classifying and organizing objects to produce an historical world narrative which is intended to transcend the limitations of culture and religion – to be an objective account of the world. The authority of science is derived from its attempt to be objective and value-free, and on this basis Western scientific knowledge claims precedence over other kinds of knowledge. Here too new interpretations, even as they contest older ones, can be seen as a force for renewal. Thus the natural history museum is not overly unsettled by disputes over classification, species boundaries, or changed understandings of evolution, providing that certain scientific concepts that underpin the museum remain consistent. Science museums also increasingly resemble art museums in their attempt to elicit transformative experiences. Hilde Hein (2000) argues that all museums now work to produce an experience modelled on aesthetic experience (see Chapter 3).

The dioramas first introduced this notion of scientific education through aesthetic experience. Typological and evolutionary displays relied on a kind of

comparative looking that notes surface resemblance, moves from left to right and commits things to mind based on their arrangement in a visual sequence. The dioramas, however, invite a 'deep and penetrating' gaze, much closer to the gaze associated with looking at art (Dias 1994: 171, see also Chapter 2). In their presence, visitors describe being inspired to environmentalism, being transformed, or having a moment of revelation – all things associated with the quasi-religious character of aesthetic experience. The notion of a 'transformative moment' has gained currency in museum and zoo design. The view that museums should offer 'compelling and transformative experiences' is held by the prominent museum designer Ralph Appelbaum (cited in Poole 2000). Appelbaum's company designed the interior of the Newseum in Washington DC, the exhibition halls of the US Holocaust Memorial Museum, the Hall of Biodiversity in the AMNH and the Horniman Museum's World Music Gallery, amongst others.

The emphasis on experience displaces the emphasis on artefacts. This is a curious aspect of aestheticizing displays – the aesthetic originates as a discourse concerned with the concrete and the particular, with the sensuousness of the world – yet the concern with producing a life-changing impact overrides that encounter. As museum design becomes about setting the stage for transformative experiences, objects become little more than props or stimuli. The human subject addressed by such displays is an inward-looking subject. Another way of explaining this is that the experiences offered are solipsistic. Didier Maleuvre (1999) has traced the emergence of this solipsistic aesthetic in the nineteenth century. He sees it as the product of the disciplinary society, as Foucault defines it (Foucault 1979: 201–2). For Foucault, 'discipline' requires that people interiorize social norms and become self-policing. This leads to an emphasis on interiority and the psyche and makes for a self-regarding subject, to whom the objective world matters only in relation to the feelings it provokes (Maleuvre 1999: 154–5). Even as the overaccumulation of artefacts in the museum, knick-knacks in the bourgeois home and mass-produced goods in the market threatens to force 'the subject to surrender to objectivity', bourgeois society actually produces a 'derealization' of the object (Maleuvre 1999: 198, 156).

Maleuvre writes of how the central character (Raphaël) in Balzac's realist novel *La Peau de Chagrin* attends to the objects he encounters in an antique shop/art gallery. He 'is not interested in the object per se, in its material thingness'. Instead, the artworks and antiquities he encounters there are stimuli for daydreams, 'free-wheeling mental associations' and 'the world dissolves into a solipsistic fantasy' (Maleuvre 1999: 208). The 'subjectified object' becomes an empty plastic form. Raphaël believes in 'the compliance of objects', they speak to him, and affirm him. This kind of 'aesthetic behaviour' treats the work of art as nothing but a blank slate for imaginary projections. Naturalistic pictures

especially lend themselves to this : landscapes, for instance, become spaces into which the viewer imaginatively enters. This is the antithesis of the Kantian aesthetic. Art is reduced to 'a mere extension of the psyche'. Maleuvre sees this aesthetic stance as 'anti-aesthetic by today's standards' (1999: 210–12). Nevertheless the contemporary focus on producing 'experience' through arranging exhibitions as a set of psychological stimuli invites precisely this kind of solipsism. If the aim is to provoke feelings and associations in the visitor, a simulation will do just as well as an object.

Though it treats the museum as a trigger for subjective experience, solipsistic behaviour does not undermine the museum's claim to universality. On the contrary, the appeal to solipsism is associated with naturalism or realism which, of all kinds of representation, most effectively effaces its own cultural specificity as it erases the signs of its own production (Bal 1996: 13). However, some acts of attention do threaten the museum by challenging its claim to universality. These are the ones that reveal the culture of the museum to be limited in its applicability – and which relocate it as the particular culture of a dominant minority. The following section discusses repatriation claims on the part of 'indigenous peoples' or 'First Nations'. I consider how these challenge the legitimacy of the museum, and how museums respond by attempting to integrate these peoples' cultural practices into the museum, or through renewed appeals to universality.

The universal museum

First Nations have repeatedly demanded the repatriation of human remains held in European museums. These demands challenge the museum's socialization of its objects. While the scientists working with the collections use them as research material, the communities arguing for their return view them as ancestral remains. For some scientists and museum professionals, the handing-over of the remains from collections and their burial would mean an 'irreparable' loss in terms of scientific knowledge – knowledge that, they argue, might be of use to the very communities which are demanding repatriation (Steel 2004: 22–5). The repatriation conflict, as it relates to both human remains and cultural artefacts, is overdetermined by colonial relations: colonized peoples are contesting and exposing the museums' role in the continuation of colonial violence and unequal relations into the present.

The blanket refusal of repatriation claims by some major museums can be read as a reassertion of the cultural superiority of ex-colonial powers (Steel 2004: 22–5). The 2002 Declaration, signed by the directors of over 30 of the world's greatest museums, including the Hermitage in St Petersburg, the Metropolitan

Museum in New York, the Berlin State Museum, the British Museum and the Louvre, which described their museums as 'universal' institutions, may be read as a resort to universalist claims in the face of demands for repatriation. According to Geoffrey Lewis, the Chair of the International Council of Museums' (ICOM) Ethics Committee, the 'real purpose' of the Declaration was to aid these institutions in resisting claims for repatriation (Lewis cited in O'Neill, 2004: 191). In particular, the Declaration is seen as motivated by the British Museum's desire to head off the well-publicized repatriation claims relating to the Benin Bronzes and the Elgin Marbles.

In other cases, museums and legislators do consider repatriation claims, but in a case-by-case way. Claims for human remains are assessed according to whether an ancestral line links the remains to the people claiming them. Those people's particular cultural rituals and practices relating to death and to ancestors are also taken into account. Against such claims, the scientific arguments emphasize their universal basis: the ability of these remains to contribute to the sum of human knowledge, and the idea that the remains should be available for future generations, not just the present one (Steel 2004: 22–5). Thus the arguments for and against the return of remains is cast as a conflict between particular and local interests, and global, universal ones. Both the intransigent position and the case-by-case approach assume the universal validity of museum concepts and practices. The signatories of the Declaration base this claim in the size and diversity of the museum's audience. For instance, the director of the Metropolitan Museum asserted that 'in these large museums the audiences are . . . the whole world'. As the head of Glasgow Museums, Mark O'Neill has argued, this ignores populations for whom museums are, for economic, geographic, or cultural reasons, irrelevant – including some of the populations demanding the return of objects (O'Neill, 2004: 196).

Those museums taking an intransigent position see in the conflicts over specific artefacts a larger political struggle and take a 'tip of the iceberg' approach to relatively small claims. For instance, in 2004 the British Museum and Kew Gardens in London lent two etched barks to the Melbourne Museum. These barks originated in Australia and only three are known to exist. Just before the Melbourne Museum's exhibit closed, its parent institution Museum Victoria received 'an emergency declaration' which claimed ownership of the barks on behalf of the Dja Dja Warrung and Jupagalk people. While this placed the Melbourne Museum in a very difficult ethical and legal situation, the British Museum responded with warnings that it may be unprepared to lend artefacts in future. An article in the museum's journal reported that other European museums would be watching the dispute over the barks carefully, and that an outcome in favour of the Dja Dja Warrung and Jupagalk people may lead to museums refusing to lend to countries with substantial First Nations

populations, such as Canada and New Zealand as well as Australia (Morris 2004: 10–11).

The fact that claims to universality are used to head off repatriation claims reveals the colonial basis of such claims. That is, by claiming to hold these objects for the good of the entire world, the museums presume either that they know best what is in the interests of First Nations, or simply that these people are not included in the world (O'Neill 2004: 196). However, historically the public museum has always aspired to universality. A central part of the project of the large national museums of Europe was to 'symbolize a nation united under presumably universal values' (Duncan 1995: 47). The collection is seen as part of the national patrimony and held for humanity as a whole (Clifford 1997: 121). Claims to universality work to maintain hierarchical relations between the centre and the peripheries, asserting the superiority of dominant (global) culture over marginal and local cultures. Thus community-based or tribal museums tend to be viewed as limited and relatively insignificant because they address and respond to a localized community.

The anthropologist James Clifford has written about two Northwest Coast tribal museums in Canada: the U'mista Cultural Centre and the Kwagiulth Museum and Cultural Centre, both built to hold regalia repatriated in the 1970s. These objects had been seized by the Canadian government as punishment for their use in an 'illegal' potlatch held by Kwakwaka'wakw people (known as Kwagiulth) in 1921–22 (Clifford 1997: 124–5). However, as Clifford notes, the museum itself is a Western institution, imposed on the communities as a condition of the repatriation (Clifford 1997: 145). Even so, it can be appropriated, though how tribal museums reinvent this institution varies. The Kwagiulth Museum reinvents the idea of the museum in Kwagiulth terms, placing emphasis on family ownership as conceived within Kwagiulth culture, and addressing a Kwagiulth audience. The U'mista Cultural Centre emphasizes the moment of the potlatch, the seizure of the objects, and its tragic impact on the communities. It gives a more explicit overall message 'of hope and pride' about the event and about tribal culture (Clifford 1997: 134–6). This museum has a more cosmopolitan outlook, collaborating and engaging in dialogue with majority museums and attempting to speak for the Kwagiulth to both tribal and non-tribal audiences. These differences in approach speak of different interpretations of the museum as institution and contested versions of events within the communities. They show how such museums, inserted into local and culturally particular practices, orient themselves differently to the larger canonical narratives and institutions (Clifford 1997: 122). They also suggest the diversity contained within terms such as 'local', 'tribal' and 'community' (Clifford 1997: 141–4).

The relationship between the 'global' and 'local' is further complicated by

the fact that identity is now commonly defined not just in terms of political constituencies, culture and kinship but according to marketing categories. As competitors in the 'experience economy' museums have becoming increasingly concerned with identity defined in this way, sometimes commissioning visitor surveys using market research categories to classify visitors. I want to use the example of a small exhibition in a museum in my home city of Bristol in the UK, to illustrate the incommensurability of these concepts of identity, and the kinds of representations which arise from them.

Pow Wow was held at the Empire and Commonwealth Museum (now 'rebranded' as 'Empire and Us') in 2004–5. The Empire and Commonwealth Museum deals with a difficult but important subject. With uneven success, and minimal government support, it has made genuine attempts to address and involve a culturally diverse audience in the representation of a shared history. The museum's own visitor studies reveal it has succeeded in attracting an audience of young adults and older people from a relatively broad range of ethnic groups. However, until recently it did not appeal to the parents and young children who make up the mainstay of many museum audiences (the so-called 'buggy brigade'). *Pow Wow* was a deliberate attempt to develop this audience. The exhibit represents life aboard a British ship bound for New England, and a glimpse of the life of the peoples of that region. It was advertised as 'a totally immersive and interactive themed exhibition about Native Americans' which starred 'Pocahontas and pirates' (*Pow Wow* press release, Empire and Commonwealth museum 2004). In this way the exhibit's publicity connected with established areas of interest for children and also with the popular interest in Pocahontas (driven by the Disney film). It competes with the other leisure activities available for this audience group: in Bristol, places like the zoo and the city museum, but also soft-play centres, play-groups and parks, some of which may have themed play areas such as pirate ships and tepees.

Pocahontas was named Matoaka, a member of the Powhatan confederacy, resident of what is now the State of Virginia. The *Pow Wow* exhibit represents the Jamestown colony and the encounter between settlers and the Powhatans and the Algonquian peoples. It includes a simulation of a tepee, although the Powhatans and the Virginia Algonquians lived in wigwams (round houses) or longhouses. Near the tepee is a display encouraging children to choreograph their own rain dance and another inviting them to make their own feathered headbands. The museum shop sells plastic tomahawks and headdresses. The exhibition text acknowledges that the tepee is not entirely accurate. Yet at the same time it focuses on a geographically and historically specific settlement, which is discussed in detail in labels, signs and handouts in the exhibit. This dual and apparently contradictory address can be accounted for in terms of the dual audience – the parents, literate and probably well-educated, and the

children, many of them pre-literate and learning through play. Few of this audience will be descended from the first peoples of America. The exhibition decisions were informed by particular notions about young children's pleasures and comprehension. A degree of historical accuracy was sacrificed in order to inspire an enthusiasm and empathy for Native American culture in general amongst preschoolers and primary school children. In economic and marketing terms it was a success, attracting a new audience to the museum, many of whom have responded positively to the exhibit. It was not without controversy – some North American visitors have expressed concern and a trustee resigned in reaction to it. The Powhatan nation was not consulted (though it takes a strong position on representations of Pocahontas and has complained to Disney about the historical distortions in the film).

This example is not being singled out because it is unique, but rather because it dramatizes some important tensions. It demonstrates how, in museums which are dependent on ticket sales and have limited state support, the goal of broadening the audience may take precedence over a consistently accurate representation of a community which has little or no presence in the region. According to Moira Simpson, museums in European nations 'now distanced from the problems they caused' have been slow to address issues relating to those populations which have remained in the ex-colonies (Simpson 1996: 2). This is evident in the *Pow Wow* exhibit. The exhibits in 'Empire and Us' as a whole could be read as a very particular, liberal version of imperial history; nevertheless the museum, through its practices and policies, and its community projects (including its radio station) do demonstrate a sensitivity to questions of cultural diversity within Bristol and within Britain. Orientation toward the audience does not necessarily entail consideration or consultation of other stakeholders elsewhere. The need for caution in the representation of seventeenth-century Virginia is not felt as intensely as it would be in Virginia now, nor as intensely as the need for caution in representing the history of the diverse communities in Bristol. The example of the *Pow Wow* exhibition shows how increased sensitivity to local cultural diversity does not necessarily correspond to more sensitive representation of all indigenous peoples. It also shows, I think, the non-fit between the current, market-led emphasis on expanded audiences and broader understandings of cultural diversity.

Moria Simpson sees museums in non-European Western countries such as Canada, the United States, New Zealand and Australia as more responsive to repatriation claims and questions of cultural diversity due to pressure from indigenous communities (1996: 2). One strategy, practised by the Smithsonian Institution, and again relating to Native American culture, has been to reinvent the colonial museum by integrating Native American cultures and practices within it. The new National Museum of the American Indian (NMAI), a

branch museum of the Smithsonian, opened its new building on the National Mall in Washington DC in 2004. It is an enormous and prestigious institution, which has cost hundreds of millions of dollars, and is the result of lengthy negotiations regarding the reinvention of the Museum of the American Indian in Manhattan, owned by the Heye's Foundation. The Museum of the American Indian showed the culture of the colonized from the perspective of the colonizers, and its huge collections were objects acquired, often forcibly, from Native American tribes. While Canadian museums returned the Kwagiulth items in their collections, this museum kept hold of the 33 items they had from the Kwagiulth potlatch.

However, in 1989 the NMAI was established and set about 'beginning to integrate Native world views into standard museum practices' including both 'behind the scenes' and display practices (Rosoff 2003: 72). By the time I visited the museum in the mid-1990s, the displays did incorporate tribal perspectives. In some exhibits, video and audio technologies were used to provide explanation of the artefacts by the peoples who had produced and originally owned them, and the history of the forcible imposition of European culture was explicitly addressed. Native Americans seemed to be representing their own history and cultures. The new NMAI is a celebration of indigenous culture intended to be authored by its 'stakeholders' – with Native American curators and director, and made in close consultation with tribal communities. The museum deliberately excludes the colonial perspective that had previously shaped all museum representations of the first peoples of North America. Politically it can be read as a great coup, since it geographically locates indigenous culture at the symbolic centre of the nation-state. However, as Clifford suggests, this strategy is also associated with a liberal pluralist politics, which incorporates or integrates Native Americans without disturbing the larger structures of the nation-state and the museum (against this he advocates decentralized and multiple *contact zones*; Clifford 1997: 214).

For some, the NMAI does disturb the 'museum idea'. For instance, in a recent newspaper article, Tiffany Jenkins (2005) criticizes the new museum in the Mall for restricting access and research 'on the basis of birth and background' and by turning the secular institution into an 'establishment of worship'. Jenkins accepts the traditional museum claims to universality, and sees the NMAI as a threat to that. She wants to defend the secular and democratic institution of the Western museum. Yet interestingly, the aspects of the museum that she points to (the restricted access given to women and non-Native people) can also be read as symptomatic of an ideology about 'traditional cultures' which is deeply rooted in the institution of the museum. I will argue that, inadvertently, Jenkins' account, and other accounts closer to the museum, suggest that the NMAI risks reinforcing conservative notions about indigenous cultures.

Since its founding in 1989, the NMAI has set out to involve Native American communities. Staff consult tribal elders and religious leaders regarding the return and burial of remains in the collection, the loan of regalia back to communities for the purposes of dances and celebrations, and the repatriation or display of sacred objects. The museum initiated 'traditional care practices', such as the Crow practice of smudging sacred objects with sage during a full moon. Staff members themselves initiated the implementation of these care practices in the museum, and encourage Indian people to share their knowledge of how to care for the objects. One of the problems with integrating these practices, however, is that they sometimes conflict with conventional museum practices, such as 'professional care standards' (Rosoff 2003: 75–6). Nevertheless the museum tries to accommodate diverse beliefs and cultural practices, and these include the recognition that 'objects are alive and must be handled with respect' and respect for taboos on displaying or storing men's and women's objects and excluding women from touching certain objects.

Despite revealing a real concern with repairing the museum's colonial past, and making good its relationship with first peoples, such well-meant attempts are politically problematic. For one thing, Native American cultures are seen almost wholly in terms of religion and tradition, despite the fact that the museum holds plenty of everyday and non-ceremonial objects too. This is a conservative definition of culture, yet it is accompanied by a relativism which attempts to seamlessly integrate incompatible belief systems and practices (of Western culture and of different Native American cultures). The assumption of coherent and unified tribal identities, and the emphasis on religion and ceremony, reproduces the social hierarchies within these communities, particularly those based on gender. The museum risks reproducing old anthropological notions of 'traditional' or 'primitive' cultures as unchanging, static and ahistorical – as existing outside modernity. Such an approach could reinforce a view of indigenous cultures as always purposeful and dominated by rituals of great significance. In other words, it disallows the possibility that certain practices and objects can be cultural but not hugely meaningful, that rituals can sometimes be arbitrary.

Western notions of authenticity pervade some new museum approaches to their non-Western, and especially their indigenous, collections. While accepting that 'objects are alive', they disallow them a social life, as if the years in the museum can be wiped out with the introduction of 'traditional care practices', increased respect for objects and their reintroduction into the practices and ceremonies of their previous owners. This gives the museum more authenticity too, and increases the aura and ahistoricity of the objects. Since the object remains a museum object, and as such is recontextualized, the incorporation of

these practices could even be seen as an extension of *in situ* display techniques, which attempt to reconstruct the original context of the object within the museum's walls. In the U'mista Cultural Centre, as Clifford (1997) describes it, the emphasis is rather different: the potlatch objects are displayed to evoke the 1921 potlatch, and the text that accompanies them describes the events and relationships that surrounded it. The potlatch is not simply represented as the original, authentic context for the objects, but as an historical turning point in which the objects were key actors.

By privileging original meanings and acts of attention, the museum can end up with a renewed authority over its audience, establishing a very didactic relation to them. It would seem to suggest that only certain acts of attention are valid, and that these forms of attention are only available to some people. Jenkins argues that the NMAI promotes the ideas that 'know-ledge and truth reside in identity' and in its policy of having only Native Americans as the curators 'advances the idea of impenetrable differences between fixed identities' (2005). The combination of fixed notions of identity and culture defined in terms of tradition and conformity to collective norms and ideals can actually be quite an oppressive one. Didier Maleuvre (1999) argues this, and defends an idea of culture as a space for liberation from oppressive tradition. Instead of turning culture into 'a static essence or blood-and-soil substance', the museum ought to 'debunk the sacrosanct aura of culture which it is partly responsible for establishing' (Maleuvre 1999: 110–2).

The artist and writer Jimmie Durham has interrogated in his work the ways in which white Americans appropriate Indian culture as cultural heritage, and the political consequences of the assumption that First Nations are more 'authentic'. After the Smithsonian took over the Heye's Foundation collection, he participated with other American Indians in a panel to discuss the repatriation of the collection:

> A man asked us what we would do, for example, with the thousands of pairs of beaded moccasins. We had no real answer. What *could* one do with thousands of pairs of beaded moccasins? The Smithsonian is, perversely, a perfect place for them. It is the ultimate official collection.
>
> (Durham 1993: 201)

Durham recognizes that repatriation of the moccasins is not practical, yet he also sees the role of the 'official collection' in the nation state. The Smithsonian is the United States' foremost collecting institution, and as such plays a significant role in the representation of the nation to itself, and specifically in the United States' self-definition as a nation which is able to incorporate and assimilate other cultures. From the perspective of those Native Americans,

including Durham, who continue to reject the sovereignty of that nation, the demand for repatriation continues to serve an important political function:

> All this century, American Indians have gone to court for the right to exist separately from the United States. That litigation is ongoing and the written laws are on the Indian side. If the Smithsonian, just as it is making its final consolidation, must be the first to concede to any sort of American Indian autonomy, its function as the imperial collection is diminished in a central area of its project.
>
> (Durham 1993: 204)

The question is whether the NMAI constitutes a 'return' of the collections or an extension of the Smithsonian's collecting practices. In other words, are the concessions it makes to American Indian autonomy sufficient to count as repatriation, or is this another version of the tendency of *in situ* displays to expand the boundaries of the object? Barbara Kirshenblatt-Gimblett describes the art of the ethnographic object as 'an art of excision', involving 'surgical' questions: 'Where do we make the cut?' (Kirshenblatt-Gimblett 1998: 18–20). Is the Smithsonian simply engaged in making the 'cut' in a different place by incorporating present day Native American culture into the museum?

Mirroring the museum

I began this book with a discussion of how the museum turns 'things' into museum objects. In the first chapter, I discussed some of the connections between that and the wider changes in the relations between people and things in an era of capitalist commodity production. Here I will argue that there is a sexual politics at stake in the value attached to certain collecting practices, tastes, and relationships to objects. In the modern period, homosexuality and femininity become associated with an over-identification with matter. Gendered and sexual identities are invested in relationships with certain kinds of material things, and in relation to the museum.

Hierarchies of taste and value are established along gendered lines. This is one of the insights of feminist art historians who questioned the absence of art by women in the canon of art and in art museums. Writing in the 1970s, Linda Nochlin and Germaine Greer pointed to the enormous obstacles for women artists including their historical exclusion from formal training and education, and the lack of information about female role models (Greer 1979; Nochlin 1991). In 1981, Griselda Pollock and Roszika Parker addressed the question of what might constitute greatness in art, and challenged the aesthetic criteria against which women's art was judged and found wanting. They emphasized

the number of women artists who did achieve fame and success in their time, only to be later excluded from the canon and from the museums. This even meant that some works of art by women were assumed to be by men, and re-attributed to male artists. They examined the hierarchical relationship between genres of art and between high art and decorative (or 'applied') arts, and argued that the exclusion of women is systematic and intrinsic to the project of art history and of the museum, a project that depends on and reproduces notions of femininity. They showed how the category of 'genius' was gendered, and how aesthetic theory repeatedly associated masculinity with spirituality and women with the material and the bodily. Femininity is associated with the ornamental and decorative, with those art forms placed low on the hierarchy of the arts (e.g. embroidery and quilting as opposed to painting). Ideologies of femininity limit and circumscribe women's participation in cultural production. But they are not simply a means to exclude women; instead, Parker and Pollock suggest, an ideology of gender structures art history and the museum (Parker and Pollock 1981: 169–70).

In the nineteenth century the distinctions set up between the 'high' and the 'feminine' arts corresponded to the establishing of a more rigid division between private and public social realms, which limited women's access to public art forms. In Chapter 1, we saw how the luxury debates of the late seventeenth and early eighteenth century attributed opulence and overconsumption to women, as a specific response to political absolutism, economic crisis and the role of women in the French court. In the nineteenth century a sharp division between private and public practices of consumption and display is established along gender lines. These developments became rigid and naturalized: women 'by nature' seem to belong to the domestic sphere; 'by nature' their taste tends toward the decorative, the opulent, the superficial. Reciprocally, a taste for the decorative and the ornamental comes to be seen as feminine.

The art historian E. H. Gombrich sees this negative association of women and ornament as dating back to classical antiquity (Schor 1987). However, the baroque culture of curiosity attached a good deal of value to ornament. Highly ornate, detailed ornaments and artefacts featured heavily in curiosity collections, as did 'monsters' and natural anomalies. The eighteenth-century classical revival rejected the ornamental and the detail in art, aligning them with the monstrous, and opposing them to the sublime and to genius in the arts. For instance, Sir Joshua Reynolds, in his *Discourses on Art*, delivered to the Royal Academy in London between 1769 and 1790, argued that the painter ought to 'correct nature', and abstract from 'her' forms – leaving out the '*accidental deficiencies, excrescences* and *deformities* of things' – to produce a representation of the 'perfect state of nature' (Reynolds cited in Schor 1987: 15; emphasis

in the original). The unique and peculiar in nature are no longer a key to understanding but an obstacle, and to faithfully repeat these in painting is to pollute the representation (Schor 1987: 16). The effect on the viewer is understood in terms of a loss of perspective, a lack of hierarchy, confusion and distraction. For Reynolds, a profusion of detail means that 'the eye is perplexed and fatigued' (Reynolds cited in Schor 1987: 19).

The feminist theorist Naomi Schor shows how detail has repeatedly been discursively linked with women, with inferiority and with a feminine inability to transcend matter. However, the gendered and sexualized connotations of detail and ornament are not only about the exclusion of women from cultural production, but also about the policing and regulation of certain models of selfhood in women and men. In the nineteenth century, the fascination with decorative and sensuous things was seen as leading, in women, to a susceptibility to the allure of the commodity. In men and women, immersion in the sensations of modernity tended to be thought of as symptomatic of a feminine self – a self grounded in nature, in the tangible and the particular, incapable of abstraction and critical distance. To give into the sensations of modernity was associated with passivity, which in turn was associated with femininity (Ross 1988: 101–2; Henning 1999: 38–42).

This is complicated by the fact that the commodity itself is feminized in the nineteenth century to the same extent as it is fetishized. Abigail Solomon-Godeau has examined the visual conflation of femininity and desirability as it developed in French commodity culture from the 1830s. She notes the historical shift away from the male body as a vehicle for the representation of the erotic and the beautiful: 'the image of femininity as an image of desire is a fully modern one . . . because its masculine analogue was now for all intents and purposes foreclosed' (Solomon-Godeau 1996: 117). Not only does the commodity take on the image of femininity (adorned by and advertised via images of desirable women) but in nineteenth-century commercial representations women seem to become commodity-like. In a heavily display-oriented culture, women epitomize the spectacular and women's bodies are increasingly depicted in fetishized ways: isolated, flattened so that flesh becomes a smooth surface, presented as object-like and offered up for possession. The commodity-fetish is both eroticized and expressed 'as a desire *for* the feminine' (Solomon-Godeau 1996: 128–33). As Solomon-Godeau points out, when Marxist writers (such as Haug, discussed in Chapter 2) write of the false appearances which eroticize the commodity, they fail to notice that this is also a gendered process: the commodity is eroticized as female, and as with women, its appearances are not to be trusted (Solomon-Godeau 1996: 113–5).

In the writings of some early twentieth-century modernist artists and architects there is a repeated rejection of femininity that is connected with

the rejection of ornament and with the 'weight of the past' associated with Victorianism. Ornament is seen as naturally linked to women (to the same extent as femininity is seen as a natural attribute of women) and therefore women, by definition, cannot be modern. Women are represented as the bearers of tradition, femininity coded as anti-modern. Ornament is also associated with the Orient and the primitive, that is, with an eroticized 'otherness' and the antithesis of progress. While one important strand of modernism was explicitly Orientalist and decorative and celebrated 'primitivism', another strand rejected it in favour of a more rationalist modernity (Wollen 1993). The most famous example of this linking of femininity, ornament, and the anti-modern can be found in the architect Adolf Loos' 1908 essay 'Ornament and Crime' which links women's fondness for the decorative and the ornamental with that of the Papuan 'savage', while arguing that modern man must reject ornament. For Loos, ornament was associated with commodity status (Colomina 1994: 37–43).

Loos also saw ornament as symptomatic of degeneracy and homosexuality – belonging to 'dilettanti', 'fops' and 'suburban dandies' (Colomina 1994: 38). In his view, ornament was inappropriate to the depth and individuality of modern identity:

> Primitive men had to differentiate themselves by the use of various colours, *modern man wears his clothes as a mask*. His individuality is so strong that he cannot express it any longer by his clothing. *The lack of ornament is a sign of intellectual power*.
>
> (Loos cited in Colomina 1994: 35; emphasis in the original)

If lack of ornament is related to modern selfhood or identity, ornament came to signify an absence of selfhood, a display grounded in nothing. This notion of a contentless self-presentation was historically associated with male homosexuality long before Loos. According to Foucault (1978) the concept of sexuality and the connected development of male homosexual identities can be traced to early modern Europe. The emergence of a notion of sexuality as a permanent orientation is linked to the extended class-conflict between the old landowning aristocracy of Europe and the developing bourgeois class. In an essay on the prehistory of 'camp' (as both a taste and a way of being, or performing) Thomas A. King argues that the constructions of selfhood, the gestures, and material accoutrements belonging to the aristocracy became 'transcoded' as markers of homosexuality by the bourgeoisie, and subsequently appropriated by early homosexual subcultures circa 1700.

Seventeenth-century courtly society in Britain and France placed the emphasis on social performance and display, carefully cultivated poise and gestures, and excessive dress. This kind of self-presentation was introduced to

Britain by the virtuosi who were aristocratic antiquarians and 'curious men', collectors of rarities and connoisseurs (King 1994: 32–3). The bourgeoisie, rejecting aristocratic legitimacy, as well as Roman Catholicism, read this performance of self as deceptive and superficial. Against it, they set a different model of selfhood which emphasized interiority and content. The bourgeois self was expressed in modest, pious conduct and dress (King 1994: 26–7). An emphasis on surface appearances suggested economic risk, a lack of social usefulness, and the sexual non-productivity and excess of sodomy. Certain gestures and forms of deportment, as well as the curious and ornate objects of aristocratic collectors, all become signifiers of suspect sexuality and of an empty subjectivity.

By the mid-eighteenth century in Britain the poise and mannered posture of 'fribbles' was thought to reveal them as 'sodomites' and represented 'the absence of subjectivity (conscience, sincerity, identity, utility, sensibility) once assigned by the bourgeoisie to the aristocrats as a class' (King 1994: 40). Sodomy had been 'aristocratized', so that aristocratic mannerisms and practices could be appropriated by members of other social classes as a form of homosexual identity, or at least, a means of 'un-identifying' with dominant models of selfhood (King 1994: 40–1). The practice of collecting ornamental, decorative and ornate objects becomes part of that construction of identity.

In 1964, in her 'Notes on Camp', Susan Sontag described 'an improvised self-elected class, mainly homosexuals, who constitute themselves as aristocrats of taste' (Sontag 1966). King's essay is partly a response to and critique of this influential text's rather apolitical understanding of camp. Camp was described by Sontag as a 'sensibility', a taste cultivated by homosexual men, for certain kinds of things such as Tiffany lamps. The problem with this argument is that camp becomes a set of stylistic traits that just happen to be associated with male homosexuality rather than, as King and others have suggested, an oppositional model of selfhood which rejects dominant notions of authenticity and masculine subjectivity. King argues that 'taste' developed as a response to 'the excessive performances of the self that we might call Camp today' (1994: 36). Taste was about the development of a facility for moral and normative judgement, about the alignment of 'manners and morals', about decorum and the correcting of excess. Taste is public and social: the virtuosi, on the other hand, were perceived as asocial and narcissistic (King 1994: 35–6). The relationship between the virtuoso collector and the objects he collected was not understood in terms of taste and judgement but in terms of a mutual social uselessness, superficiality and superfluity. Collected objects were 'knacks' or 'knick-knacks', a term which could encompass trinkets and ornaments, tricks, toys, objects with low use-value and curiosities. A knack could also signify dextrous ability, as it does today, while knackers meant both testicles and castanets, linking the

virtuoso to castration via the term 'knackered' (King 1994: 38–9). In short, the 'knack' encompassed the performance and mannerisms associated with homosexuality as well as the objects that virtuosos collected.

The association of aristocratic flamboyance with male homosexuality continues in nineteenth-century dandies and in the aesthetic of decadence. According to the literary historian Janell Watson, aesthetes in the late nineteenth century collected decorative art objects in rejection of 'rationalism, utilitarianism, scientific positivism, and progressivism' (1999: 13). In France, such objects were usually described as 'bibelots', like the 'knick-knack' a term which could cover antiques associated with the pre-Revolutionary regime, or new mass-produced goods sold in the *magasins des nouveautés*. The bibelot's association with the feminine, the ornamental, and the decorative arts made it subordinate in the hierarchies of the Academie des Beaux-Arts and of classicism, thus 'it becomes a vehicle for anti-classical and anti-Academy sentiments (Watson 1999: 17). However, as the bibelot became mass-consumed, and found in every bourgeois and petty-bourgeois interior, the dandy set himself apart from other collectors of bibelots by his ability to spot the rare collectible. In this way dandies and aesthetes engaged in games of social distinction (Watson 1999: 20). Dandies and aesthetes, though not always homosexual, refused the standard male roles of economic productivity and familial reproduction. Their collecting practices formed part of this refusal. Literary theorist Leora Auslander (1996) draws a distinction between the dandies' collecting and other kinds of collecting. She argues that collecting through auction houses and antique markets was a form of masculine consumption at a time when consumption was heavily coded as feminine. Practiced in moderation, such collecting mirrored museum practices, and gained respectability through association with knowledge-production and patrimony (Auslander 1996: 88–9). But excessive collecting did not fit this model of masculinity, especially where it was unrelated to financial investment, or knowledge production, and the basis for opulent public displays (Auslander 1996: 85).

However we cannot disregard the museum's own associations with over-accumulation and with a kind of superficiality of character (see Nietzsche, Chapter 2). Watson points out that the bibelot was seen as bringing the museum into the bourgeois household, and so precipitating cultural decline. If the museum displaces art by removing it from its original site, turning it into merely a fragment, the bibelot displaces it again and fragments it again by miniaturizing it to fit in the bourgeois salon (Watson 1999: 24). The French critic Paul Bourget, writing in 1885, saw museums as encouraging 'dilettantism and criticism' as opposed to 'genius and creation' (Bourget cited in Watson 1999: 22–3). For Bourget, bibelot collectors such as the Goncourt brothers were '*des hommes de musée*', men of the museum, 'subjects constructed in and by a

world of objects'. Collecting keeps company with '*ennui*', 'neurasthenia' and 'artificial passions' (Watson 1999: 25). Bourget saw the bibelot as a sign of the displacement of human agency onto objects and of a passive and submissive attitude to the world of things. The immersion of dandies and aesthetes in this world seemed to indicate a loss or absence of subjectivity, echoing the earlier view which linked aristocratic collecting and display, and homosexuality with a kind of empty or contentless selfhood.

A similar dangerous immersion in the thing-world was seen by critics as symptomatic of French nineteenth-century realist writing such as that of Flaubert, Balzac, and Zola where the cult of the detail threatened to destroy narrative coherence. Didier Maleuvre reads Balzac's mania for descriptive detail, lists and inventories as betraying 'a desire for panoptic totalization' but also as ordering 'the subject to surrender to objectivity' (Maleuvre 1999: 198). Maleuvre sees realist literature as responding to, or mirroring, the way in which the immense accumulation of goods in the era of mass production and museums threatens the subject. Overaccumulation cannot be accommodated, cannot be pieced together, though there is a constant attempt to do so. The aim of realism is to reduce the author to a recording device, and as in an analogue recording, everything that can be registered is recorded – regardless of its significance (see Chapters 3 and 5; Maleuvre 1999: 197–8).

In the editors' introduction to a collection of critical writings on the museums, Donald Preziosi and Clare Farago argue that 'museums are essential sites for the fabrication and perpetuation of our conception of ourselves as autonomous individuals with unique subjectivities' (Preziosi and Farago 2004: 3). This chapter has suggested something of this process, considering how the museum operates as an instrument of power concerned with forming identities and subjectivities, with fashioning selves. However, I want to emphasize that the museum simultaneously reveals and even exemplifies the limits of this modern activity – the inability of the bourgeois model of selfhood (the depth model) to cover all ground. The association of certain collecting and consumption practices with women and with homosexuality in men points to the way in which overaccumulation, the madness of museums, has been historically regarded as a kind of deviation, a threat to normative identity.

Further reading

Bennett, T. (1995) *The Birth of the Museum: History, Theory, Politics*. London: Routledge.

Watson, J. (1999) *Literature and Material Culture from Balzac to Proust: The Collection and Consumption of Curiosities*. Cambridge: Cambridge University Press.

Noordegraaf, J. (2004) *Strategies of Display: Museum Presentation in Nineteenth- and Twentieth-Century Visual Culture*. Rotterdam: Museum Boijmans van Beuningen, NAi Publishers.

Maleuvre, D. (1999) *Museum Memories: History, Technology, Art*. Stanford, CA: Stanford University Press.

5 ARCHIVE

I dream of a new age of curiosity. We have the technical means for it; the desire is there; the things to be known are infinite; the people who can employ themselves at this task exist. Why do we suffer? From too little: from channels that are too narrow, skimpy, quasi-monopolistic, insufficient. There is no point in adopting a protectionist attitude, to prevent 'bad' information from invading and suffocating the 'good'. Rather, we must multiply the paths and the possibility of comings and goings.

(Foucault 1988: 198–9)

Archives, indexes and copies

Museums are memory machines. That is, they are a technical means by which societies remember, devices for organizing the past for the purposes of the present. They are a product of societies which have an historical consciousness and which treat material things as evidence or documents of past events. By historical consciousness, I mean an understanding of time which is different from the cyclical understanding of time associated with nature – the cycle of the seasons, of birth and death, day and night, of regeneration and degeneration. Historical consciousness is characteristic of societies that pass on the past to the present through techniques such as oral storytelling, writing or pictures. The French historian and publisher Pierre Nora asserts that modern memory is 'first of all archival. It relies entirely on the specificity of the trace, the materiality of the vestige, the concreteness of the recording, the visibility of the image'. The museum and the archive ratify a past through material substance, and contain the 'external props and tangible reminders' of collective memory (Nora 1996: 8).

This chapter considers how museums, archives, storage systems and collecting practices put material things in the service of memory and history, and how new exhibition practices bring museum and archive closer. The first section considers museum and exhibition practices which might help us think about the

relationship of the museum to the archive, to index card systems, to mass reproduction and to the database. The second section picks up Nora's notion of modern archival memory and attempts to show how Walter Benjamin's work on memory and experience offers an alternative model for thinking about the relationship of archival history to individual memories and collecting practices. The third and final section of this chapter considers the return to curiosity in contemporary art, in virtual museums and in new exhibit design. It explores something which is anticipated in the Foucault quotation above: the way in which new media and the internet seem to imply new epistemological and aesthetic models, which have more in common with the private curiosity cabinets or *Wunderkammern* of the sixteenth to eighteenth centuries than they do with the late Victorian public museum.

To the archive is delegated the task of remembering. This kind of collective memory cannot be separated from the apparatus of governance. State archives delimit what counts as the material of history, what constitutes the past. The material records they contain constitute the official versions of events and represent the organization of lives according to state regulations (as in the registers of births, marriages and deaths). Their documents do not simply record what happened but were also actors within it: shaping social relationships, laying down the law. Unlike archives and libraries, museums tend to be understood as collections which are displayed according to an organizing narrative, yet neither archives nor museums can entirely contain their contents. Inscribed within the archive are other memories and other narratives which leak through the official documents. Social historians sift through the archive for these, reconstructing other histories and counter-memories. While the classificatory system of the archive keeps its documents in order, the museum does this more effectively through a combination of classification and display. Display gives things their documentary and evidentiary function. In the storeroom, they are ambivalent and frequently opaque, difficult to read purely in favour of one version of history or another. This fact is made most explicit in those artists' projects which have taken existing museum collections and organized them to display hidden histories or counter-narratives. Perhaps the most renowned of these is Fred Wilson's exhibition *Mining the Museum* where he displayed and relabelled objects from the collection of the Maryland Historical Society in Baltimore. In this way, Wilson made the collection speak of the hidden histories of African Americans and Native Americans which the Historical Society displays had suppressed (Wilson 1994; Karp and Wilson 1996).

Other artists' projects have drawn attention to the irrationality of the museum, and the connection of its collecting and archiving practices with the consumption practices of the wealthy. In his 1969 exhibition *Raid the Icebox* at Rhode Island School of Design, Andy Warhol insisted on exhibiting whole

collections of objects just as they were arranged in the storerooms, to the irritation of the curators. The shoe collection, when exhibited in its storage cabinet, became a display of Imelda Marcos-style consumption. Objects were shown in various states of disrepair: the chairs used for spare parts, paintings that were ripped and stained. Mouldy catalogues were exhibited as if part of the collection, and fakes from amongst the paintings were chosen in favour of authentic masterpieces. On top of this, Warhol 'specifically requested that each of the individual items in the exhibition, whether valuable or not, be catalogued as completely as possible' (Bright 2001: 284). Warhol's exhibition did not use the museum's collection to construct counter-memories, or alternative histories, but rather to challenge the whole notion of the museum as an organized, objective or systematic ordering of things. The museum director had expected artist-curators to curate an exhibition according to their own arbitrary taste and so, assuming Warhol perhaps possessed classic 'camp taste', had tried to direct him toward valuable domestic items such as porcelain figurines and rich fabrics (Bright 2001: 284). What he hadn't expected was that Warhol would use the opportunity to expose the arbitrariness of the museum itself.

We could read the exhibition as part of Warhol's larger negotiation of sexual identity insofar as the rapidity and lack of selectivity with which he chose things (which Deborah Bright describes as 'like a shopaholic on speed') are associated with a lack of subjectivity that he cultivated, most famously in his repeated assertions that he wanted to be a machine. However Bright suggests that the exhibition bore the marks of Warhol's 'proletarian sensibility', putting overaccumulation on display and exposing the economic and social motivations which the museum represses (2001: 288). More recently, many artists have made it their job to interrogate, critique, mimic and expose the museum itself. The list is very long but would include (in no particular order) the artists Hans Haacke, Louise Lawler, Annette Messager, Mark Dion, Marcel Broodthaers, Thomas Struth, Christian Boltanski, and Jimmie Durham, amongst many others (Putnam 2001). Through the work of such artists, as well as through that of innovative curators in all kinds of museums, local and national, museums have reflected openly on their own practices. Exhibitions now challenge the ways in which certain objects and collecting practices are deemed more valuable than others (for instance in 'People's Shows'; Mullen 1994). The historical relation of museums to colonialism, to capital, their complicity in the reproduction of ideologies of race and gender, and their reliance on collecting practices such as hunting, are no longer completely repressed or unspeakable. The arbitrariness of acquisitions policies and the ways in which histories can be constructed and reconstructed through collections have been explored through new exhibition practices. These practices make explicit how the museum may seem to be about the past and

about objects, yet is actually as concerned with organizing the present and with social relationships.

The museum, modern archiving systems, and the inventory all attempt to organize space as well as time. Their development was due to imperialism, exploration and trade which entailed collating and organizing information relating to geographically distant places. By the 1920s a whole host of new museum and archive projects were developing which were concerned with giving the new mass audience a sense of the world in which they lived. If the Victorian museum was concerned with the production of citizens who identified with the nation-state, these projects are concerned with the production of new forms of world citizenship. Architecture theorist Anthony Vidler has described how, from the turn of the twentieth century, the role of the museum began to be redefined. Attempts to turn the museum into 'an instrument of instruction' used every technical aid available to teach a mass audience 'about its own place in the world, its geographical, social, technological and cultural potentialities' (Vidler 2001: 163–4).

One such project was Otto Neurath's Museum of Society and Economy in Vienna (discussed in Chapter 3), another the Palais Mondial (World Palace), founded by his friend and collaborator Paul Otlet in 1919. Otlet was a lawyer and bibliographer. He had founded various international organizations and been involved in the peace movement. He also created the Universal Decimal Classification system, a revision of the Dewey Classification System, which is still in use today. The World Palace was situated in the Palais du Cinquantenaire in Brussels. Here Otlet housed the massive filing card system he had been developing since the 1890s, as well as displaying items such as model aeroplanes, scientific tools and instruments, projectors, optical devices, navigational devices, and printing equipment, many of which were remnants of the Brussels World's Fair of 1910 (Vossoughian 2003: 84).

The artefacts in the museum were associated with transport and communication technologies. The index card was also a technology, enabling data to be stored in standardized form and systematically retrieved. This filing system was developed in the mid-nineteenth century, designed to allow accumulated knowledge to be organized and put to use. This has been written about as an issue of policing, because police record systems were a central technology in the development of new forms of (disciplinary) social regulation in the nineteenth century. In accounts influenced by Michel Foucault's work on the joining of knowledge and power, the paradigmatic archive is the police archive (Tagg 1988; Sekula 1993). Perhaps it is not incidental that Otlet's background was in law. However, we can trace another history for the index card, which does not dissociate it from government altogether, but is more suggestive regarding the relationship between museum and database. One account sug-

gests that the index card emerged in the redistribution of aristocratic and monastic libraries after the French Revolution, when titles and details of books were marked on the backs of playing cards (Tenner 2005). Whether or not this marked a definitive moment of change in the management of collections and inventory-keeping, it does suggest a relationship between the emergence of the filing system, the democratization of treasure (see Chapter 1) and the new mobility of objects in the age of museums and emergent capitalism. In libraries and museums, a written ledger can do perfectly well as an inventory, but as objects in the collection are moved or redistributed, each record needs to be laboriously written out once more. The index card is a solution to a need for standardized records, which could be rapidly retrieved, and to the 'fundamental problem of the archive, the problem of volume' (Sekula 1993: 358). But it is also a solution to the new mobility of objects and data.

If the index card is a means to manage a new situation in which data (and objects) accumulate en masse and are exchangeable, it is perhaps not surprising that index cards were first used by banks (from the 1850s) and libraries (after the 1860s). Police identity cards came into use in Paris in 1883, pioneered by Alphonse Bertillon (Sekula 1993: 357–62). These cards combined the technology of the card filing system with the technologies of human measurement (anthropometry) and photography. The photographer and photography theorist Allan Sekula describes Bertillon's system as 'the first rigorous system of archival cataloguing and retrieval of photographs' (1993: 373). Sekula notes that Bertillon's system was part of a wider 'grandiose clerical mentality' associated with positivism, rationalization and Taylorism (1993: 374). He cites the *Institut International de Bibliographie*, founded by Otlet, which recommended that photographic prints be archived according to the Decimal Classification System. Viewed through the police archive, Otlet's bibliographic and museum projects are exercises in bureaucracy and social control. However from another angle Otlet's own archiving efforts can be read as part of a utopian internationalism, in which the technology of the filing system was a means to decentralize and democratize knowledge, allowing for broad public access and for cross-referencing of information.

The filing system enabled systematic knowledge to be dissociated from notions of typicality. Standard index cards could be used to inventory all sorts of things. Using a classification system any item could be allocated a number and recorded on an index card, and retrieved for inspection at will. For Otlet, the index card filing system could be extended from a device for keeping a record of world literature to a means of cataloguing the world itself. Museums generally treat objects as representative of categories, often emphasizing typicality over idiosyncrasy, turning the particular and the contingent into the material for larger narratives and ideas (see Chapter 1). Otlet's projects

combined the technology of the archive or filing system with the communicative capacity of the museum. In his plans for a World City in Geneva, a project begun with the architect Le Corbusier but never built, he described as its centrepiece a new World Palace called the Mundaneum which would include objects and collections but would be mainly intended to make explicit the ideas and cultures which shaped them (Vidler 2001; Vossoughian 2003). In the hands of Otlet and Neurath, the museum would respond to the potential of mass reproduction and communication technologies to cross national boundaries and create a world culture. Together they planned 'a network of museums dispersed throughout the world' as well as various publications, including a world encyclopaedia. These serially produced Mundaneums would consist not of unique and unrepeatable objects but of reproducible parts. Otlet wrote that the Mundaneums 'will collect and conserve objects but they will never have to be rare or precious, [as] copies and reproductions will suffice in backing up ideas' (cited in Vossoughian 2003: 87).

Reproduction enables objects to become standardized and comparable. As Andre Malraux noted in his 'Museum Without Walls' (originally titled *Musée Imaginaire*), reproduction imposes a 'rather specious unity . . . on a multiplicity of objects'. This is particularly the case with monochrome photographic reproductions:

> Black and white photography imparts a family likeness to objects that have actually but slight affinity. When reproduced on the same page, such widely differing objects as a tapestry, an illuminated manuscript, a paint-ing, a statue, or a medieval stained-glass window lose their colours, their texture and dimensions (the sculpture also loses something of its volume), and it is their common style that benefits.
>
> (Malraux 1967: 83–4)

By stripping diverse artistic products of their original significance and func-tion, photographic reproduction makes the meanings of art a matter of stylistic comparison, a project that the museum had already begun (Krauss 1996: 343). Photography doubles the **museum effect**, taking the already decontextualized museum objects and equalizing them through enlargement and reduction, the loss of relative proportion, and similarities in lighting, cropping and photo-graphic composition. The museum can be seen as extended, insofar as repro-duction enables objects to travel beyond the museum walls and everything to become subject to museum-like decontextualization.

Otlet and Neurath used mass reproduction alongside new processes of infor-mation retrieval to reinvent the museum, returning to an older convergence of museum, archive and library. Media theorist Wolfgang Ernst sees the Centre Georges Pompidou (Beauborg) in Paris as 'actually realizing Paul Otlet's 1934

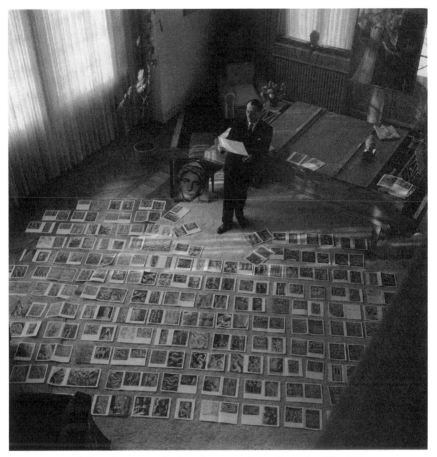

Figure 7 André Malraux with the photographic plates for The Museum Without Walls, ca. 1950.
Source: Photo © Paris Match/Jarnoux.

call for the (re)convergence of museum, archive and library in an all-embracing documentation science' with its combination of temporary exhibition spaces, museum of contemporary art, forum and library (Ernst 2000a: 30). In Otlet's combination of museum and documentation centre, the distribution of knowledge was as crucial as its accumulation (as opposed to the centralized model of police bureaucracy for instance). In the museum, as Ernst says, 'Historical narrative was a means to master the arbitrariness of collections' and museum display produced narratives of nation by organizing the relationships between objects. As Otlet and Le Corbusier's Geneva plans reveal, the Mundaneums were not intended to do away with narratives of progress (see Vidler 2001).

Nevertheless, technologies of data retrieval and now digital processing, make it possible to replace historical narrative by cross-referencing and the mere 'co-presence' of objects (Ernst 2000a: 21, 29–30). A form of memory akin to computer RAM (Random Access Memory) replaces historical narrative.

Otlet has been hailed as a 'forefather of the internet' for the advances he made in data organization and retrieval. Yet this is a teleological claim. It is perhaps more useful to see interest in Otlet as shaped by current preoccupations. The rediscovery of his work in the 1990s coincided with new understandings of media and of museums in the light of developments in new media and computing. We don't need to see his work as a step in a linear progressive development toward contemporary cultural forms in order to see its relevance for the interpretation of these forms.

Ernst sees museums as becoming increasingly centred around information processing. The post-1900 museum was premised on the separation of storage and display, the museum disavowing the 'nondiscursive' and arbitrary character of the storeroom through didactic displays. Only in this context could Warhol's *Raid the Icebox* operate critically, by exposing what ought to be concealed. Now, Ernst argues, museums such as the Museo Gregoriano Profano in Rome involve 'a modular processing of past documents by means of a flexible, archive-like presentation of artefacts that no longer separates storage techniques from didactic display techniques'. By using the aesthetics of the storeroom in its display, the Museo Gregoriano Profano 'makes the museum memory transparent' (Ernst 2000a: 26). Instead of storing objects for eternity, and organizing them into narratives to produce historical consciousness and shape national identities, the museum now operates as a holding container, or 'flow-through and transformer station' (Ernst 2000a: 25). In Ernst's view its prime function is to 'teach the user how to cope with information' (Ernst 2000a: 18). The arbitrary mass of the collection is now not managed through totalizing narrative but technically, through the model of data-processing and retrieval. The museum becomes increasingly like new digital media, whose fundamental form is the database, and which reduce all kinds of sensory data to numerical code (Manovich 2001:23).

The early index and record card systems had ambivalent potential. They could be democratizing, distributing knowledge amongst the population, but also centralizing, put to use in administering and regulating populations. In their inexhaustible accumulation of the irreducibly particular, they could dispense with the tyranny of the representative and the typical, but they also appealed to a rationalistic, bureaucratic dream in which everything can be assigned a number, reduced to data and filed. The merging of museum and the logic of the information society is similarly ambivalent. In doing away with the old split between front and back regions in favour of a new transparency,

the museum offers a new level of access and a democratization of the meaning-making process. This can be seen in open stack systems, the use of digital kiosks and information centres in museums and the advent of the virtual museum. The same developments might also be interpreted in the context of the transformation of visitors into 'customers' and a new emphasis on customer choice associated with supermarket supply–demand economics. This ambivalent potential of new exhibition design, open storage systems and new media in the museum is discussed in more detail in the last section of the chapter.

Those developments in museums which connect them to digital data processing might also be understood in the context of a society of accelerated production, consumption and waste cycles. Stuff and data is sifted through, designated disposable or worth preserving. The material for memory is already preselected. However not all waste disappears. Much of it remains, constituting another form of material memory, a counter-narrative to the memories elicited by the museum. As Ernst reminds us, the traces of the past exist as pollution and chemical contamination as much as any deliberately preserved material, so that 'the true tragic archive is the soil, the industrial fallow land' (2000a: 28). The following section considers some other ways in which traces of the past are understood to inhere in objects, and what this does to an understanding of archival memory.

Collection and recollection

I began this chapter by describing modern memory as archival, using Pierre Nora's work. Yet the notion that the detritus of industry might constitute a material memory hints at the possibility that things might be more than souvenirs or documents, that they might somehow contain the past without being designated as mnemonic objects. In fact that is a central aspect of Nora's argument: he distinguishes between 'true memory', which is 'rooted in the concrete: in space, gesture, image and object' and history, which uses physical traces as a means to reconstruct the past (Nora 1996: 3, 8). In the archive and the museum, things symbolize or signify past times, whereas true memory, for Nora, is embedded and embodied.

Here I will examine Nora's distinction between true memory and archival memory more closely, and compare it to Walter Benjamin's 1930s writings on memory and collecting. Both writers distinguish between a memory embedded in material traces and archival memory. They also both periodize memory, arguing that collective practices of remembering and ways of relating to the past change with industrialization and modernity. Yet the political difference between them is significant. Benjamin was concerned with memory as a means

of disrupting dominant history, giving the lie to ideologies of progress and history used as justification for the present order. He combined a theological concept of revelation with a Marxist understanding of revolution, suggesting that an attention to the traces of the past in the everyday could pierce the dreamlike state induced by capitalism and help to produce a kind of 'awakening' necessary for revolutionary change.

Nora's historical project, on the other hand, has been read as a contribution to the neo-liberal reaffirmation of French national identity (Anderson 2004). In the 1990s he compiled a massive collection of historical writings which share an interest in *lieux de mémoire* – French history as the study of those events, sites and rituals that have come to symbolize the collective national past and have gained mythic or nostalgic associations. In his view, authentic collective memory is now lost, and *lieux de mémoire* have taken its place. Nora argues that by the end of the nineteenth century, archival memory and history supplant true memory, which becomes individualized and privatized as a psychological matter (1996: 11). *Lieux de mémoire* mediate between private memory and public history, acting as sites of collective memory.

The decline of 'true' social memory produces a collective sense of loss and uprootedness leading to a longing for the past, a desire 'for the feel of mud on our boots' (Nora 1996: 12). Separation from the past turns everything into a 'trace', something that could potentially become historical evidence. It also, in Nora's view, lays the ground for the artificial and creative reconstruction of the past, for only when the past seems dead to us can it be brought to life through reconstruction and simulation (1996: 13–4). The job of the historian, it seems to Nora, is to 'substitute for imagination', to attend to those vestigial sites where 'our depleted fund of collective memory is rooted' and bring the past to life (Nora 1996: 6, 20). For his critics, Nora's category of *lieux de mémoire* becomes a roundabout means of reviving the traditional subjects and landmarks of French national history against alternative histories (Anderson 2004).

Many commentators, from Quatremère de Quincy on, have seen museums as unable to provide an authentic experience since they sever things from their social context and their place in the world. For that kind of critique, museum objects represent the past, but can never embody it or provide true access to it. Oddly, Nora's view of the task of the historian shares a similar frame of reference as that anti-museum discourse, though his conclusions are very different. For him, the historian's (and I suggest the museum's) task of artificially resuscitating the living past is sufficient and to be celebrated. Their job is to bring the past to life, compensating for the loss of an authentic collective memory by creating a feeling of the immanence of the past in the present. However, other writers have challenged the idea that the museum might act as compensation for modernity. Instead they argue that it actually conspires in detaching the

present from the past, replacing authentic memory, destabilizing the sense of the past and contributing to the modern memory crisis that it attempts to resolve (Spencer 1985: 60; Terdiman 1993: 13–16; Huyssen 2000:34).

Nora's distinction between authentic/true and artificial/archival memory is one he inherits from philosophy. This distinction implies an earlier wholeness, a time in which felt and embodied experience meshed with larger collective narratives, in which the past was felt in the present because it was embedded in the material environment and embodied in people, in their gestures, their language, their appearance. In many ways this opposition between true and archival memory is problematic. It contrasts an idealized, authentic past with an artificial and alienating modernity. Furthermore, the notion that memory is written on the body has its roots in the nineteenth-century understanding of hereditary, organic memory, where memory was thought of as leaving physical 'traces' on the brain, which could then be inherited by successive generations. Organic memory theory informed nineteenth-century ideas of racial hierarchy and social degeneration. It also shaped theories of consciousness, history and memory that have outlived it, such as Freud's psychoanalysis (Otis 1994).

Tony Bennett has argued that the very concept of true memory that Nora uses is itself produced in and through the museum. That is, he argues that this kind of memory is not natural, pre-modern and written on the body as Nora suggests, but only becomes imaginable in the 'technological and archival conditions' of modernity and through certain modern 'technical and representational devices' such as evolutionary museums (Bennett 2003: 41). Organic memory theories derive from pre-Darwinian theories of evolution which argued that an organism evolved by responding to particular stimuli that surrounded it, retaining ('remembering') that response as a physical trace and passing it on to the next generation. In this evolutionary model, the body is a palimpsest on which experiences or stimuli leave layers of partially erased traces, so that each individual physically preserves a record of accumulated traits (Otis 1994). Bennett points to the relationship between the way in which the mind was thought of as layered and new archaeological understandings of the layers of the earth as an 'evolutionary storehouse'. Even the metaphor of the palimpsest had only come to stand for a text in which past writings were preserved (rather than erased) because of modern chemical techniques that allowed old inscriptions to be recovered from vellum manuscripts (Bennett 2003: 48).

In other words, this new concept of a natural, organic memory was the product of emergent technical and archival practices which gave visible form to historical, evolutionary change. Bennett argues that the notion of an organic, or embodied, collective memory is 'an effect of the evolutionary museum's functioning as an evolutionary accumulator in which all pasts are stored and made simultaneously present' (2003: 51). In this way, Bennett abolishes any

distinction between an older social and collective memory – which is relatively unmediated or immediate – and modern archival history, seeing the first as a cultural by-product of the latter. He also seems to suggest that there is no outside to the constructed collective memories of historiography and the museum, or to put it another way, that memory is either reducible to individual psychology or entirely socially constructed.

Walter Benjamin's writings suggest other ways of thinking about this. He drew on the notion of a memory trace and on Freud's layered, palimpsest model of consciousness. His theory of memory and history supports Bennett's view that the true/archival memory distinction could only be thought in modernity, that this memory theory is marked by the conditions in which it was produced. Nevertheless he maintained that experience in modernity is qualitively different than pre-modern experience and that practices of remembering have also changed. Benjamin considered that there were certain practices of memory and remembering which might challenge, or at least exist outside of, dominant culture and its ideological versions of history. For Benjamin practices of collecting, and the notion of objects or artworks having aura, are closely connected to this discussion of memory. Benjamin's theory of memory is complex and incomplete, dispersed across several writings. Here I will focus on those aspects which allow us to situate this understanding of memory and history in relation to Nora's and Bennett's.

Benjamin does not use the distinction between true and archival memory, but works from Marcel Proust's distinction between voluntary and involuntary memory. Proust's famous description of how the madeleine cake – soaked in a little camomile tea – brings the past flooding back, epitomizes the relationship between involuntary memory and things. A chance encounter – usually a physical sensation such as a taste or scent – vividly conjures up a past experience. By contrast, voluntary memory is the memory of the intellect. It gives information about the past but 'retains no trace of it'. This kind of memory consists in recalled facts, rather than depth of experience. It produces knowledge which is repeatable. It imposes itself on things – from the knotted handkerchief to the souvenir, to the thing turned into a museum artefact. For Proust, the past can only be 'actualized' involuntarily. He viewed involuntary memories as rare, chance occurrences, and the past as:

> somewhere beyond the reach of the intellect and unmistakeably present in some material object (or in the sensation which such an object arouses in us), though we have no idea which one it is. As for that object, it depends entirely on chance whether we come upon it before we die or whether we never encounter it.
>
> (Proust cited in Benjamin 1992b: 155)

Benjamin suggests that in pre-modern society, voluntary and involuntary memory, as well as collective and individual memories, would be bound together through ritual, ceremony and festival (1992b: 156). Like Nora, Benjamin periodizes memory, but he associates the pre-modern period with a unity of voluntary and involuntary memory, and the modern period with their splitting. Involuntary memory as the chance experience of an isolated individual is a modern concoction. Benjamin uses Freud's work on memory to explore this concept further. In his 1920 essay 'Beyond the Pleasure Principle', Freud (1984) suggested that consciousness operates defensively, protecting against external stimuli. Conscious preparation enables us to reconcile external stimuli with our experience. Memories are not registered by consciousness, but at an unconscious level. As Benjamin says, 'in Proustian terms this means that only what has not been experienced explicitly and consciously, what has not happened to the subject as an experience, becomes a component of the *mémoire involontaire*' (1992b: 157).

Freud derived his view that memory is primarily unconscious from the organic memory theorist Ewald Hering, as well as his tendency to think of memory in physical, textual terms (Otis 1994: 188). In 1924, he updated the model of the mind as palimpsest to the model of the mind as mystic writing pad – a toy notebook on which words can be written and then made to disappear, but still remain in partial traces on a layer underneath (Freud 1991; Leslie 2003: 172–3). Memory traces are permanently etched on the unconscious, but consciousness itself receives no such permanent marking – instead the process of conscious reflection dissolves any impact of an incident by allocating it 'a precise point in time' and giving it 'the character of having been lived' – that is, turning it into 'an experience' (*Erlebnis*). Benjamin thus places Freud's theory within the context of a broader characterization of urban modernity as heightening and multiplying shock experiences. The defensive shield of consciousness must continually 'parry the shocks' of urban and industrial life, with the result that sense impressions do not enter experience in its deeper, cumulative sense (*Erfahrung*), but are simply registered as moments that have been lived through (Benjamin 1992b: 158–9). When memory traces surface unbidden, they produce an impression of a depth of experience, of the past *in* the present. It is no accident that the sense which most frequently stimulates involuntary memory is the sense of smell. A scent 'deeply drugs the sense of time', it 'may drown years in the odour it recalls' (Benjamin 1992b: 180). Memory traces, like the traces of use on an everyday object, or the marks of an artist's hand, give an impression of historical connectedness which Benjamin refers to as 'aura'. Auratic experiences, in other words, can be provoked by those everyday and otherwise inconsequential things and sensations that stimulate involuntary memory. The images and impressions that arise in involuntary memory are suffused in aura

because of the sense that they are both distant and present. In Benjamin's writing the concept of aura is to do with this perception of distance. However it is through ritual and tradition that the two kinds of memory are brought together; 'contents of the individual past combine with the material of the collective past' (Benjamin 1992b: 156).

The decline of ritual and tradition means, for Benjamin, the decline of aura, which increasingly takes refuge in the chance occurrences of involuntary memory. His argument about the decline of aura, and also the connection of this with the development of the museum and of other media, is best explained through the example of art. Prior to the museum age, art objects had aura because they were situated within a living tradition and had ritual and cult value (Hanssen 2000: 77). Modernity destroys ritual and tradition, not least through the decontextualization of ritual objects in the museum. The artwork in the museum continues to have aura insofar as it continues to be associated with 'secularized ritual' and an authentic, unique experience. Nevertheless, 'exhibition value' gradually replaces 'cult value', as art objects can be 'sent here and there' severed from any fixed social and physical environment. Mechanized mass reproduction extends this process, totally severing the artwork from its location, and multiplying it endlessly (Benjamin 2002: 106; Benjamin 1992b: 182–3). For the mass audience, the contemplative and rapt attention associated with aura is replaced by the urge to get hold of things, to bring them close through reproduction and at the same time, by a tactile, habitual, distracted relationship with new mass artforms such as film (Benjamin 2002: 105, 119–20).

As Benjamin says, philosophers have tended to despise this turn of events, seeking instead to rescue 'true' experience from the 'standardized, denatured experience of the civilized masses' (1992b: 153). Benjamin preferred to turn his attention to those poets, writers and artists who faced the contemporary situation and plunged themselves into it. Charles Baudelaire, through the 'correspondences' established in his poetry, finds himself holding 'the scattered fragments of genuine historical experience' (Benjamin 1992b: 181). Marcel Proust turned himself into an 'apparatus', sacrificing his self 'for the sake of things' (Pensky 1996: 177). Proust discovered that things speak, yet to decode their speech requires a certain self-sacrificing rigour. Benjamin describes Proust's 'loyalty to an afternoon, to a tree, to a sunbeam cast upon the wallpaper; loyalty to dresses, to furniture, to perfumes or to landscapes' (Benjamin cited in Pensky 1996: 177). The theorist Max Pensky describes involuntary memory for Proust as 'an accomplishment *over* intellectual memory, over the conscious application of subjective meanings upon the range of experiences presented to consciousness' (1996: 173). Proust's cultivation of involuntary memory is a committed act of mastery, 'the constant attempt to charge an entire lifetime with the utmost mental awareness' (Benjamin 1999b: 244).

For Benjamin, aura belonged both to the ideological affirmations of historical continuity and to the sites of its undoing. He wrote of the way that the aura of an object overcomes the alien character of past moments and cultures by pulling us into them, taking us there. Benjamin was famously ambivalent about aura, recognizing its importance for making sense of experience, but also its tendency to produce a conservative illusion of historical continuity that served the ideological purposes of the present. Benjamin read Proust as providing a means for understanding how (auratic, involuntary) memories might 'serve to disrupt a hegemonic historical continuity' (Pensky 1996: 170). He shared with Proust an interest in how things, especially commodities, might provide the material for a different historical understanding, through moments of 'profane illumination', glimpses of the recent past which reveal the level of forgetting necessary to dominant historical narratives. The world of things and sensations provides everyday interruptions which give the lie to a dominant ideology of historical progress, and which denaturalize the present social order. In Proust, in Baudelaire and in the surrealists, Benjamin finds aesthetic and cognitive strategies that cultivate such chance occurrences, that find revelation or 'awakening' in the everyday, the trivial, the outmoded and the out-of-date. They develop an ability to attend closely to material, a sensitivity to things, to the 'correspondences' between them.

It is not only in art and literature that this occurs. Benjamin points to collecting, including (especially) the collecting practices of children, as sharing this attentiveness, this ability to listen to the thing-world. The collector who collects without financial or status motivation has a sensitivity to things that allows them to be more than 'objects for a subject' (Pensky 1996: 185–6). The collector lifts commodities out of the cycle of production and consumption, and liberates them from use-value. Benjamin saw 'true collectors' as understanding their collections historically, giving things back their historical place, and thereby making them 'present' and meaningful once more (1999a: 207 and 201). He also asserted that collectors re-enchant objects since by giving them a new context in the collection they release them from the existing regime of value. Through their gentle and attentive relationships to things, they allow us to glimpse a world not dominated by exchange value.

The return to curiosity

The idea of re-enchanting things has also been taken up in writings on museums. Re-enchantment in this context is about releasing things from the tight explanatory and didactic framework of the modern museum and allowing them to regain the attributes of the marvellous and the curious. For instance, James

Clifford (1985) has made the case for exhibits which emphasize the marvellous 'otherness' of ethnographic objects, rather than explaining them away. He argues that making such objects strange once more may be crucial in undermining 'a possessive Western subjectivity'. Clifford suggests that we should

> accord to things the power to fixate, rather than simply the capacity to edify and inform. African and Oceanian artifacts could once again be 'objets sauvages', sources of fascination with the power to disconcert. Seen in their nomadic resistance to classification they could remind us of our *lack* of self-possession, of the artifices we employ to gather a world around us.
>
> (1985: 244)

Clifford sees this in terms of fetishism. In other words, and in keeping with the discussion of fetishism at the very start of this book, he sees the relationship with things on which the museum is based as rooted in the fetishistic, possessive relationship to things characteristic of capitalism. This is concealed in the museum beneath a veneer of instruction. Stripping away this veneer could reawaken the sense of wonder that these objects initially invoked. Clifford argues that the objects of Africa and Oceania might be capable of revealing the Western investment in possessions and the desire for the exotic and other that underlies it.

Stephen Greenblatt (1991b) defines wonder as 'the power of the displayed object to stop the viewer in his or her tracks, to convey an arresting sense of uniqueness, to evoke an exalted attention'. He opposes it to 'resonance', by which an object may 'evoke in the viewer the complex, dynamic cultural forces from which it has emerged and for which it may be taken by a viewer to stand' (Greenblatt 1991b: 42). Though Greenblatt sees value in resonance too, he regrets what he sees as the turn toward it in museums at the expense of wonder (1991b: 53). However, the notion of a 'return to curiosity', which the art historian Stephen Bann (2003) uses, incorporates both wonder and resonance. For instance in a discussion of contemporary art exhibitions, Bann suggests that the curiosity cabinet allows us to view objects as 'a nexus of interrelated meanings – which may be quite discordant – rather than a staging post on a well trodden route through history' (2003: 120). Like Clifford, Bann recognizes the potential of the curious and the marvellous to undo the museum's claim to authoritative knowledge, whilst maintaining its potential as a space for contact and critical understanding. While media and museums attempt to ignore or conceal contradiction, curiosity actually allows for, and even encourages it. The aesthetic arrangement of the curiosity cabinet corresponded to an epistemological structure based around 'sympathies', analogy and resemblances (Foucault 1970: 18–37; Hooper-Greenhill 1992: 102–26). The curiosity cabinet in its original incarnation was a very élite affair (though it had its popular

equivalent in annual urban fairs, where some of the same objects held in court collections would sometimes be shown). The 'return to curiosity' is, however, seen as a means to make the museum more dialogic and polysemic. The Foucault quotation with which I began this chapter directly links curiosity with a more interactive, two-way media, multiplying 'the possibility of comings and goings' (Foucault 1988: 198–9).

For these writers, a return to curiosity implies a different construction of knowledge in the museum, and the rejection of linear, historicist arrangements of objects. Their views appear to complement recent developments in museums, which since the 1980s have begun to move toward hybrid display techniques. We can now see across a range of museums ways of grouping the collections which would have been unthinkable in the late Victorian or Edwardian museum, or even in the modernist museum. In natural history museums, an emphasis on endangered species, environmentalism and biodiversity has changed the criteria for grouping specimens, so that now they are frequently arranged not according to species, habitat or geographic location, but in ways that express their interdependence and interrelatedness. Visual diversity and similarity become a means of communicating biodiversity and, in the case of ethnographic museums, cultural diversity and hybridity or cross-cultural influences. New elaborate exhibition designs have begun to recall the crowded and decorative displays depicted in well-known engravings of early curiosity cabinets. For instance, the Hall of Biodiversity in the American Museum of Natural History, New York includes a wall covered with taxidermy specimens, 'spirit specimens' in jars and mounted insects, as well as screens displaying video footage of animals. In the Primates Gallery in the Natural History Museum, London, skeletons dance, suspended from the ceiling. In the Grande Galerie de l'Évolution at the Muséum National d'Histoire Naturelle in Paris, a Noah's Ark-style procession of animals is displayed in the centre of the enormous space, while stuffed monkeys appear to climb a metal scaffold on the walls. At the Museum Naturalis in Leiden, the Netherlands, some specimens are displayed under glass in the floor, others amassed on glass shelves with minimal labelling. In exhibits developed since the 1980s, visitors are expected to navigate between very different kinds of information and modes of representation. Poetic and visual connections and resemblances are just as possible as scientific comparisons. Decorative and suggestive compositions replace both the hyper-realism of the diorama and the sparse didacticism of evolutionary arrangements.

In the Hall of Biodiversity at the AMNH, butterflies flock up the wall. I have never seen butterflies flock. Perhaps they do. But the pattern they form resembles a network or the expanding branching tree structures used in interactive media. It is also reminiscent of 'artificial life' computer programs in

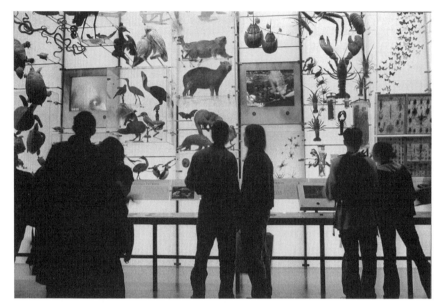

Figure 8 The Hall of Biodiversity at the American Museum of Natural History in New York.
Source: Photograph by the author with kind permission of the AMNH.

which simple scripts or rules cause groups of animated creatures to act collectively in apparently complex ways – such as birds flocking. Artificial life theory is based on mimicking or simulating biological evolution. What is interesting is that these apparently decorative arrangements of specimens replace the simulation of the visible habitat and appearance of animals (which we find in the dioramas) with a simulation of larger principles relating to biodiversity and new theories of biological life. Or rather, the arrangement corresponds to the visual forms associated with these theories.

In many new exhibition designs, the displays are designed to be dazzling, incorporating illusionistic multimedia displays that combine real objects with computer interfaces and video footage in projections or screens embedded in the display. In the display of musical instruments in the Horniman's Museum in London, unseen projectors and mirrors throw videos of people playing the instruments onto the glass of the cabinets containing the instruments themselves. These floating rectangular images resemble television or computer screens, but without borders and without substance – you can see through the glass surface on which they appear. In this and many other displays, glass is no longer intended to be ignored, no longer something we look through but not at, as it was in picture framing and in traditional vitrines. In the Grande Galerie de

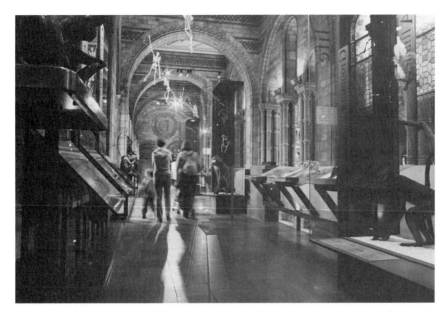

Figure 9 The Primates Gallery at the Natural History Museum, London.
Source: Author's photograph, reproduced courtesy of the Natural History Museum.

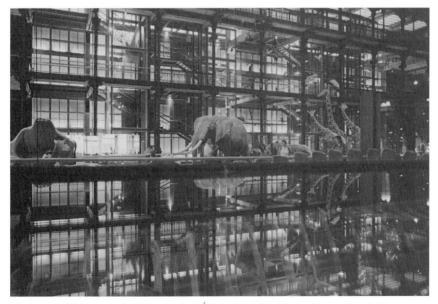

Figure 10 The Grande Galerie de l'Évolution, Paris. Architects Paul Chemetov and Borja Huidobro, scenography René Allio.
Source: Author's photograph.

l'Évolution, glass stands in for a penguin's ice floe or is used to invisibly suspend fish and crustacean specimens at the same time as evoking their watery habitat. In new exhibitions, glass is the magical substance that holds together the display, at times self-effacing and nearly invisible, at other times, made visible by having images on its surface, or deliberately displayed to be seen from the side exposing its blue-green density.

Just as it had at the Crystal Palace, glass still succeeds in seeming to be simultaneously the epitome of high technology and simplicity itself. Yet I think that the way glass is used in such exhibits is different from some of its earlier uses. For instance, a number of writers have described the use of glass shelving and glass supports in combination with boutique lighting and minimal labelling as part of an aestheticizing tendency in museum display. Unlike many other materials, glass does not easily bear the signs of wear. Immediate traces of use (fingerprints for instance) can be wiped away. Its hard, reflective surfaces show little signs of age and use. This, plus the fact that fashions in glass display techniques are shared across the museum and the store, reinforces the sense that glass is the perfect fetishistic casing, isolating displays from time itself, and dissociating them from the human social activities which made them meaningful and valuable in the first place. Sandwiched between sheets of glass, isolated by a single spotlight, and set against a plain background, artefacts and specimens seem to float, and draw attention only to their formal, visual qualities (Torgovnick 1990: 81; Duncan 1995: 19; Clifford 1997: 114). In displays of African art for instance, such techniques have been used to encourage a respectful approach to the products of non-Western cultures, now perceived as objects of beauty as much as objects of ethnography. Though well-meant, such an approach may end up reproducing Eurocentrism, imposing Western ideas about art and aesthetic experience onto quite different cultures whilst making it difficult to make comparisons or develop a contextual understanding (Clifford 1988: 189–214).

However, I want to argue that in the new kinds of displays which I am loosely calling 'curiosity-style', glass is sometimes used differently, to encourage and produce, not restrain, comparisons and correspondences, and to connect different areas of the exhibition space. For instance, at the National Museum of Ethnology in Leiden, glass was extensively used in the displays when they were redesigned between 1996 and 2001. The intention was 'to show the collection in as pure a way as possible, without stagey effects or trickery' (Ban de Sande cited in Staal and de Rijk 2003: 95). Glass could give an impression of the objects standing for themselves whilst at the same time preventing the various cultures the museum represents from being seen as static, disconnected or discrete from one another. At Leiden, large panes of glass are used to suspend objects and also allow visitors to see through to other parts of the display, to see parallels

and relationships between objects in foreground and background, as well as objects placed alongside one another. The redesign took as a model George Perec's novel *Life: A User's Manual* in which 99 interlinked parts piece together the lives of the inhabitants of a Parisian apartment building. Perec's novel tells 'an infinite amount of stories brimming with detail within a tightly designed space', and offered a model for 'the treatment of superabundance', because its 'open structure' allows the book to be 'read in countless different ways' (Frans Bevers and Steven Engelsman cited in Staal and de Rijk 2003: 60, 97).

This emphasis on interconnectedness and correspondences represents a paradigm shift in the ways in which knowledge is structured and visitors addressed, across a range of different kinds of museums. Such developments are linked to changed understandings of the museum's relationships with its visitors. The director of the Louvre acknowledges this, asking:

> How can we reconcile the new social and educational role of the museum with our heritage sometimes heavy with styles of presentation that is based on categories largely inherited from the 19th century and intended only for the connoisseur and the art historian? We talk of comparisons, corresponding echoes, parallels, cross-references, and yet we display our collections in departments, by techniques, by schools. At a time when much thought is given to *mondialisation*, we are still constrained by the cultural boundaries of the past. What is at stake is certainly the understanding by the public of what it sees.
>
> <div align="right">(Loyette cited in O'Neill 2004: 198)</div>

Loyette associates historicism with the nineteenth-century museum. However, Bann has pointed out that even modern art museums did not abandon the historicist paradigm: 'The Museum of Modern Art, in its original form and until quite recently, simply enshrined the pantheon of great modern artists and their works in due, historical succession' (2003: 120). The desire to reach and communicate with visitors had to be balanced against the role of the museum in giving 'historical and objective validity' to the art objects in its collection, and therefore suppressing the curious and subjective motivations guiding collecting practices (Bann 2003: 126). Nor it is simply a case of choosing between a return to curiosity, with its emphasis on interconnectedness and diversity, and straightforward historicism. Bann mentions other rejections of historicism introduced in the 1990s 'with mixed results'. These have led to 'a more punctual, thematic, and often (it must be admitted) haphazard association of ideas' (2003: 120).

In the Tate Modern in London, the evolutionary paradigm for displaying modern art – introduced in the 1930s by MoMA director Alfred H. Barr – has been replaced with a thematic arrangement. The challenge the Tate Modern

faced was how to rehang an existing twentieth-century art collection in ways which would increase the range of possible interpretations and move from a singular historical narrative to a multiplicity of stories (Blazwick and Wilson 2000). The decision was made to hang the collection according to themes which derive from the traditional classifications of genre in painting, reinvented to accommodate the preoccupations of twentieth-century art. The genre of still life is translated in Tate Modern into a series of rooms entitled 'Still Life/ Object/Real Life'; landscape becomes 'Landscape/Matter/Environment', portraiture and the nude are given modern relevance with the title 'Nude/Action/ Body', historical narrative and allegory are updated as 'History/Memory/ Society'. Arguably, this new thematic arrangement has contributed toward the popularity and accessibility of the museum. It offers an interpretative framework which allows the audience to make connections across works of art produced out of very different concerns, in a wide range of media. It deals with the difficulty of interpretation by grouping objects according to subject-matter.

This arrangement may well be experienced by visitors as more flexible and open than the evolutionary model that had dominated modern art museums. However, flexibility of interpretation is not always experienced as something liberating. In some cases it could be disorienting. We could see this in similar terms to the problem identified by the art historian Hal Foster in interpreting contemporary art, where the proliferation of different interpretative frameworks makes the critic or the visitor 'like an anthropologist who enters a new culture with each new exhibition' (1996: xii). Though Foster is referring specifically to the difficulties of interpreting contemporary art rather than the full range of twentieth-century art, this observation captures something of the difficulty facing the non-specialist visitor to art museums which have discarded the certainties of the old historicist and evolutionary arrangements. The knowledge needed to understand those older arrangements of modern art might adequately be understood as a form of cultural capital in Bourdieu's (2003) sense of a stable and institutionally maintained system of distinction. The opening up of interpretative possibilities in new museum arrangements may work to challenge that stable system of distinction but at the same time it befits a new situation in which social position is maintained through the ability to keep up with the latest cultural shifts and changes (Watkins 1993: 32).

At Tate Modern, as at the natural history museums and ethnographic museums that I have mentioned, the museum remains a teaching machine. The certainties associated with evolutionary and historical arrangements may have gone, but access to the collections is still mediated through the arrangement of the display, interpretative text in the form of wall panels, leaflets and so on, and the generic headings under which the work is distributed into the four sections. Arguments against didacticism and the role of curatorial interpretation in the

museum were put in the 1970s. Some curators and critics disputed the value of making visitor access of the museum heavily mediated by curatorial interpretation, arguing instead for a 'de-schooling' of the museum (Illich cited in Ames 1992: 89; Ames 1992: 96). Like Otlet in the early years of the twentieth century, they placed the emphasis instead on the museum as archive and community resource.

One strategy associated with de-schooling is the unravelling of the traditional separation between research collection and display collection via 'open storage'. Michael Ames sees this strategy as helping to democratize the museum and free the collection from the interpretative straitjacket which curators place on it. He has described the approaches to accessible storage introduced in various museums in Western Canada in the 1970s and 80s. His examples range from the system used at a university anthropology collection (the University of British Colombia Museum of Anthropology, where Ames was the director), to the system adopted in the small community museum of Port Alberni in British Colombia, and that considered, but ultimately not carried out, at the Glenbow-Alberta Museum in Calgary. Ames recognizes the practical difficulties associated with open storage, and the ways in which certain techniques are suited to different kinds of museum. At the university museum, a system operating a little 'like a large library or supermarket' works well for research and teaching, while in the community museum, accessible storage accompanied by some interpretive displays and a simplified catalogue becomes a means 'for members of the community to participate collectively in the recovery and documentation of their own history' (Ames 1992: 89–97).

I first encountered an open storage system relatively recently at the newly opened Darwin Centre at the Natural History Museum, London. The Darwin centre is very significant, making an historic reversal of the separation of storage and display at that museum, which was begun in the late nineteenth century. As early as the 1880s, when the museum moved to its present site in South Kensington, a separate and rather evocatively named 'spirit building' was built to house the specimens in glass jars which were considered an unsightly fire risk (Stearn 1998: 55, 75). Now the Darwin Centre makes many of these specimens visible to the visiting public, including many type specimens (on the basis of which species are identified – see Daston 2004b). Meanwhile tours, events, video-links and webcasts puts 'behind the scenes' practices such as dissection on display. The glimpse behind the scenes of the museum and the sight of the original specimens collected by Darwin and others can be thrilling, but by comparison with Ames' examples, the Darwin Centre remains heavily interpreted (mediated), providing very limited and closely controlled access.

As I suggested earlier, today open storage techniques are associated with democratization, access and flexibility and also with the increased dependence

of museums on a global market. Together with the use of new media kiosks to give visitors greater access to collections, open storage suits the shift toward visitor choice and the emphasis on personal selections associated with consumer culture (Hooper-Greenhill 1992: 211–15; Hein 2000: 65–87). This transfer of responsibility from author or media provider to readers or consumers is similar to that found elsewhere in the media: in interactive media generally, in 'interactive TV', and in the relaxing of certain forms of media censorship. The privileging of the reader in interactive media is comparable to how large corporations pass costs and labour from the company onto customers (Manovich 2001: 44). Flexibility in the museum is linked to increased flexibility in capitalist labour relations and production, which is associated with demand-driven ('just-in-time') small batch production, subcontracting and the rise of sweatshop and temporary labour (Harvey 1989: 173–97).

Flexibility is also connected to the 'hybridization' of the museum, as museums increasingly find that the way to compete in a global marketplace of attractions is to 'exploit the plasticity of the museum idea' by combining 'wide-ranging collections with spectacular architecture and elaborate settings – places to eat and loiter as well as to view the exhibitions' (Prior 2003: 64–5). Contemporary museums are now hybrid spaces, incorporating numerous shops, information centres, restaurants and cafes, and even (at the World Museum in Rotterdam) travel agents. They are hybrid too, in their use of display techniques and the range of exhibits and events on offer, including corporate events, rooms available for private hire, permanent and temporary exhibitions (Rectanus 2002; Prior 2003; Noordegraaf 2004). The museum becomes 'something like a television station producing different programmes for different audiences' (Barry 2001: 141). Marketing and corporate branding have come to dominate museums (Macdonald 1998: 118). It is now extremely difficult to disentangle the institutional, corporate and state interests shaping exhibitions. Subject specialisms become less significant as museum directors and other workers move from ethnographic museum to science centres and art museums to natural history museums. A limited number of design companies and specialist contractors produce costly and spectacular one-off designs for large museums worldwide. Consequently there is greater diversity in each museum, but more homogeneity across museums, even whilst each museum emphasizes its distinctive character.

It is clear that there are (at least) two possible perspectives on some of the recent developments in museums: one sees the museum as shaped by global markets, where diversity and multiple stories are a means of attracting audiences; the other sees the museum as something which has become increasingly accessible and democratized, committed to pluralism and addressing a more diverse audience. It is not a question of choosing between these two views.

Rather we can see both as tendencies at work, pulling museums in different directions, though the use of closely related display techniques and exhibition strategies.

The new display aesthetic has been shaped by a revived interest in curiosity cabinets (especially in natural history museums) and this aesthetic is associated with an epistemological structure that privileges allegorical and arbitrary associations, correspondences and resonances. Though some of the museums I have discussed in this section are large and spectacular, curiosity is associated with miniaturization, with a wonder that can be inspired by 'small and shabby objects', more so than with technical or architectural spectacle (Adorno cited in Bann 2003: 125–6). It is associated with the pleasure in things and in their accumulation, with amassed small objects rather than isolated and monumental ones. The Museum of Jurassic Technology in Los Angeles exhibits miniature collages made from the scales of butterfly wings, and sculptures on pinheads, amongst many other curious and marvellous things. The collection of curiosities and marvels at the Chateau d'Oiron in Poitou, France, is work bought or commissioned from contemporary artists and in these the once discrete categories of artefact and natural object can be seen to merge. Stephen Bann gives the example of the French artist Hubert Duprat who works with jewels and precious metals, even providing them as material for caddis flies. These insects take the minerals and construct their chrysalises from them, which appear as tiny jewelled cases. Duprat's art recalls early modern curiosities that combined nature and human artifice (such as drinking vessels made from nautilus shells and coral) and as Bann argues, 'the "wonder" arises precisely from the difficulty of separating out the agency of the artist from the pure spectacular potentiality of the natural world' (2003: 127–8). In the most thoroughgoing curiosity museums, the fake is indistinguishable from the real, the artwork indistinguishable from the museum, and nature and human artifice mimic one another.

Wider evidence of a revival of the culture of curiosities might include the artist-taxidermist Tia Resleure's non-realist taxidermy (anthropomorphic 'grotesques' in the Victorian and Edwardian tradition – see www. acaseofcuriosities.com) and the photographer Rosamond Wolff Purcell's documenting of curiosity collections and museums, as well as a number of recent illustrated books on curiosity cabinets (see for instance Mauries 2002). One possibility is that this revival of interest in curiosities is a kind of return to thinglinesss in the face of expanding 'virtual worlds'. However in my view this is not the case, since a proliferation of curiosity museums can be found on the World Wide Web. The term 'virtual museum' is very much overused, and I purposely exclude from this category all those websites that work primarily as promotional and outreach sites for large museums (see Huhtamo 2002: 1–3). By

'virtual museums' I mean those hundreds of peculiar collections that exist on the Web (and often only there) such as the Kooks Museum, the World Famous Asphalt Museum, and the Russian Communal Flat Virtual Museum. These websites – sometimes art projects, the websites of collectors, personal research projects, or student sites – grow out of the tradition of the dime museums, curiosity museums and odd idiosyncratic museums, as well as out of the availability of websites as places to display personal obsessions. The virtual museum makes explicit the link between a return to curiosity and the development of new media. In both there is a turn toward networked and decentered knowledge, and a privileging of arbitrary associations and resonances. A number of writers have commented on the way in which the internet rewrites the structures of memory and knowledge, challenging the hierarchical ordering of the archive and appearing much more like a cabinet of curiosities (Ernst 2000b; Gere 1997, 1999).

The return to curiosity is not a return to the hierarchical universe of the original age of curiosity, but a turn to a plurality of perspectives, of ways of attending to objects, and of narratives. The curiosity cabinet and curiosity museum are now associated with challenges to traditional hierarchies of objects and information, of what counts as worth preserving or archiving, and an embracing of the anomalous, the odd and the monstrous. Most of all, I think, curiosity is about contact – about bringing things closer, and prying them open, the pleasures Benjamin saw in the mass audience's response to film. Contact and closeness do not necessarily require the actual presence of the thing – indeed as Benjamin observed, reproductions, copies and likenesses are often the means by which the world offers itself for close inspection (2002: 105). But they are about overcoming a distance between self and thing, subject and object. It has become a basic premise of cultural and media studies to set out to demonstrate how the world we experience is socially constructed, produced through texts, discourse and ideology. Yet media and culture are also sensuous, and the world of things is not passive but acts upon us. The pleasure of curiosity, as I suggested at the beginning of this book, is connected with its ability to unseat a secure sense of self, and with close contact with that which is strange and other. If museums are to work as contact zones and facilitate these encounters, they might also appeal, as the curiosity cabinet did, to the correspondences, sympathies and resemblances that appear between outwardly disconnected things.

Further reading

Bann, S. (2003) The return to curiosity: shifting paradigms in contemporary museum display, in A. McClellan (ed.) *Art and Its Publics: Museum Studies at the Millennium*. Oxford: Blackwell.

Putnam, J. (2001) *Art and Artifact: The Museum as Medium*. New York: Thames and Hudson.

Rectanus, M. W. (2002) *Culture Incorporated: Museums, Artists and Corporate Sponsorships*. Minneapolis, MN: University of Minnesota.

GLOSSARY

Affect: Affect refers to subjective feelings both psychological and physiological. It encompasses more than physical sensation, but is also distinguished from emotion. Emotion incorporates the notion of expression or display of feelings, and is culturally shaped: different societies recognize different ranges of emotions and have conventions for their communication or expression. According to the cultural theorist Brian Massumi, affect, on the other hand, is experienced as 'moments of intensity'. It belongs to experience before it is made sense of or emotionally responded to. Massumi sees emotion as that which captures affect and turns it into something which can be expressed, or given meaning.

Alienation: This term comes originally from the philosopher Hegel, but is used here mainly in its Marxist sense which refers to the way in which conditions in a capitalist society estrange workers from one another, from the products of their own labour and even from themselves.

Animism: The belief that objects can possess souls or consciousness was associated with so-called primitive societies. See also **fetishism**.

Aura: Aura is a concept developed by Walter Benjamin which refers to both the mystical, cult or ritual value of the unique artwork and the ability of things to offer an authentic or direct relationship with a past moment. It is a term which is often used rather one-dimensionally to argue for a progressive political potential for new (non-auratic) media. It is also sometimes used to argue for the unreproducible emotive power and significance of the unique object or work of art. However Benjamin was more ambivalent about aura, and the concept is more complex than these uses allow. Auratic experiences can be provoked by objects which embody tradition and historical continuity, especially handmade objects which bear the marks of their moment of production, but also by everyday events and sensations.

Behaviourism: Behaviourist psychology analyses mental life in terms of stimulus (sensory input) and response (behavioural output) and is concerned with the scientific observation and conditioning of human and animal behaviour. Behaviourism

became influential as an educational approach from the late 1950s, through the work of B.F. Skinner. Skinner was particularly known for his theory of 'reinforcement' – events or factors which increased the rate or intensity of response to a stimulus. His experiments with rats pressing levers suggested that an interactive feedback system that rewarded certain responses could be used to condition or train people.

Commodity aesthetics: Term coined by the German Marxist philosopher Wolfgang Haug. Commodity aesthetics is about false appearances: even if we desire an object for its usefulness, all that counts from the seller's point of view is the appearance of usefulness. Thus the appearance and sensual aspects of the commodity become dedicated to inspiring desire on the part of the buyer. Part of this process is that ordinary mass-produced goods are made to appear more luxurious (and better-quality) than they actually are.

Commodity fetishism: According to Karl Marx, in a society where different kinds of producers only meet at the point of exchanging their products, and where money mediates that exchange, the social relationships between producers appear as relations between material objects. Exchanges of goods make equivalences between the very different (and in reality, unequal) kinds of work that go into producing them. Their value in the marketplace is unrelated to their use, and determined by the human labour 'congealed' in them, but concealed in the exchange process. This makes the goods exchanged in the market start to seem 'mystical', like fetishes (see **fetishism**) and appear to take on human character. Exchange value appears as a natural quality of an object, and so the continual rise and fall in value also appears as a natural or chance process, as a movement of things rather than something controlled by people (Marx 1976: 164–6).

Conspicuous consumption: The economist Thorstein Veblen used this term in his influential book *The Theory of the Leisure Class* (1899) to describe the way in which the American ruling class regarded ostentatious possessions as necessities, and used them as a means to display social status. Conspicuous consumption has been adopted as a term to describe the use of excessive or wasteful consumption as a means of socially distinguishing oneself.

Contact zone: This term comes from Mary Louise Pratt's work on travel writing and was introduced to museum studies by James Clifford. Pratt uses the term to refer to the space of colonial encounters in which previously separated people come together. This is not an easy mingling but involves 'conditions of coercion, radical inequality and intractable conflict'. The concept of a contact zone places the emphasis on the mutual, improvised interrelations of colonizers and colonized (Pratt 1992: 6–7).

Culture industry: This is what Theodor Adorno and Max Horkheimer call industrialized mass culture, the culture of monopoly capitalism which is entirely geared to the production of profit. The culture industry 'impresses the same stamp on everything', and the apparent variety of cultural products conceals an underlying sameness and serves only to give an appearance of choice. Distinctions between films, magazines and so on, are not simply distinctions in form or content, but the result of a system of classifying people as types of consumer.

Cybernetics: This is a term invented by Norbert Weiner in the 1940s in connection with his work automating anti-aircraft systems in World War II, and is associated with human–machine communication and with efficient and managed interaction through controlled feedback systems. Weiner was interested in 'machine intelligence' and in the parallels between computers and the human mind.

Department store: The department store is a late nineteenth-century phenomenon. The Bon Marché and the Magasin du Louvre in Paris both opened in the 1850s. Among the first in the United States were Macy's in New York, which opened in 1857, and Marshall Field's which opened in Chicago in 1879. By the last decade of the nineteenth century, every big city in the United States had at least one.

Desire: For Freudian psychoanalysis, desire is predicated on lack, and things become objects of desire by virtue of their absence. Sigmund Freud and later Jacques Lacan see lack shaping desire in a larger sense too: the sense that, in becoming socialized, we have lost a sense of wholeness, of oneness with the world of things, that we had as infants. Ultimately desire is the desire for wholeness, for a return to an infantile sense of plenitude that we lose in the process of becoming socialized, even of learning to speak. The promise of the commodity – a promise on which it always reneges – is to make good that lack.

Discipline: This is used here in the Foucaultian sense. In *Discipline and Punish* (1979) Michel Foucault argued that an older regime of government, based in displays of power and spectacular punishment has become gradually replaced, with a new 'disciplinary' regime, characterized by an emphasis on observation, training, correction and reform. Punishment becomes concealed rather than spectacular, and citizens are encouraged to regulate themselves through internalizing the corrective and judgemental gaze. According to Foucault, discipline works to produce 'docile bodies', regimenting behaviour and reproducing norms. Most importantly, discipline operates productively – producing knowledge, subjectivity and reality – rather than censoring or repressing.

Discourse: Now very commonly used in cultural and media studies, this term encompasses all that which is said, written or communicated within a culture. The notion of discourse used in these disciplines is influenced by linguistics but also by the work of Michel Foucault. A discourse is a set of statements that emerge from a particular social context or attempt to articulate a particular object or phenomenon. According to Foucault, the tacit or explicit rules that apply in a given social and institutional context shape what it is possible to say and a discourse constructs the very objects it describes. For instance, he showed how a range of institutional discourses (legal, psychoanalytical and so on) produced 'homosexuality' and 'heterosexuality', which become lived social realities, with their own effectivity, but which didn't exist as such prior to the discourse. One impact of the widespread use of discourse theory is the tendency to assume that there is nothing outside discourse. Recent theories that challenge this view include theories of **affect** and **mimesis**, 'thing theory' and Bruno Latour's approach discussed in Chapter 1 (known as 'actor–network' theory).

Diorama: The habitat diorama shares its name with the attraction invented by Louis Daguerre. Daguerre's dioramas were specially-designed buildings that displayed

painted backlit scenes before an audience on a revolving platform. The changes of lighting in front and behind the scenes gave the illusion of motion and of time passing and heightened the realism of the scene. The success of Daguerre's diorama declined with its novelty, and it disappeared during the mid-nineteenth century.

Encyclopaedism: I use this term very broadly to refer to the omnivorous appetite for knowledge of the Victorian bourgeoisie, in a period when it was still believed that everything could be gathered, classified and systematically known. Yet this concept has its origins in the work of the eighteenth-century French philosophers Diderot and d'Alembert whose *Encyclopédie* was published between 1751 and 1772. The French encyclopaedists saw their project as a collection of all existing knowledge and as a stand against irrationalism and they believed that scientific, political and social progress would result from their work.

Eugenics: The eugenics movement was founded by Sir Francis Galton, Darwin's cousin, who adapted evolutionary theory and the selective breeding of animals to the project of producing an 'ideal' society. Eugenics influenced the attempts by various national governments in the first half of the twentieth century to control populations through laws relating to miscegenation and compulsory sterilization of the 'unfit' (usually people with mental illnesses or with disabilities). Eugenics is regarded as very tainted because of its link to such coercive practices, and especially to the Nazi genocide. Nevertheless it shaped the science of genetics and its influence can be seen in common medical practices such as foetal screening, though this remains controversial.

Experience economy: The experience economy was described (and advocated) by business writers B. Joseph Pine II and James H. Gilmore in a 1999 book. Using the example of Walt Disney amongst others, they argued that businesses should create memorable experiences for their customers, and the memory is itself the product. In an experience economy, the value of goods and services are measured by the feelings they provoke, and the 'transformation' of visitors through experience is conceived of as added value. The experience economy implies the commodification of sensations and memories, and requires the development of techniques to measure transformation.

Fetishism: Initially an anthropological term associated with nineteenth-century religious practices on the west coast of Africa. The fetish is a material object used in religious ritual, attributed special powers or human qualities. European philosophers saw African cultures as representing an early stage of social evolution. This gave rise to the argument (put forward by Auguste Comte) that fetishism was a rudimentary form of religion – the primitive precursor of modern spiritualism and the belief in the soul. The term was later appropriated by Karl Marx (see **commodity fetishism**) and Sigmund Freud. Between 1905 and 1927 Freud developed his concept of fetishism to characterize the sexual desire for an object or body part. He theorized that pathological fetishism in men, where sexual desire can only be aroused by certain objects or materials, was a response to the castration anxiety provoked by the discovery that women do not have penises. The fetish object becomes a phallic substitute, and also a form of protection for the fetishist, who oscillates between acknowledgement and denial of sexual difference.

Fordism and Taylorism: New modes of production and work, but also social organization, which emerged out of the introduction of the assembly line by Henry Ford and the time-motion studies of Frederick Winslow Taylor. The standardization and rationalization associated with mechanization and automation proved attractive to capitalists and socialists alike, and shaped the Soviet Union just as much as it did the United States.

Heterotopia: In a lecture given in 1967, Michel Foucault used this word to describe places in which a society reflects itself back to itself, or which are both inside and set outside everyday social existence. Foucault included sacred spaces, psychiatric hospitals and retirement homes, cemeteries and theatres in this category. He described museums and libraries as 'heterotopias of indefinitely accumulating time', epitomizing the nineteenth-century idea of 'constituting a place of all times that is itself outside of time and inaccessible to its ravages' (Foucault 1986: 23).

Intermedia: This word, coined by the Fluxus artist Dick Higgins in the mid-1960s, described the way in which new art practices were overcoming the traditional separation between media. Higgins saw the hierarchy of artforms and media as paralleling social hierarchies and class distinctions. For him, intermedia was the appropriate response to an increasingly populist society. Intermedia practices occupied the ground between media usually considered as art and those considered outside its boundaries, and was about abolishing the separation between art (or performance) and audience. Intermedia could describe both Marcel Duchamp's 'ready-mades' as well as Higgin's own work with 'happenings' and event art.

Interpellation: This term is taken from the French Marxist philosopher, Louis Althusser. It is the process whereby ideology 'hails' an individual as its subject, constructing a 'subject–position' for him/her.

Mass culture: This is a controversial term associated with the negative view of popular culture espoused by Theodor Adorno and Max Horkheimer (sometimes called 'mass culture theorists') and also with a middle-class fear of the working-class 'masses'. It is sometimes seen as necessarily implying a derogatory view. However, 'mass culture' can also be a narrower and more precise term than 'popular culture', because it specifically refers to culture which is mass-produced and experienced *en masse*. In these respects it is distinguished from more traditional, craft-based or 'folk' forms of popular culture.

Museum effect: This term comes from André Malraux and refers to the way that just placing an object in a museum gives it importance and value. Svetlana Alpers has given it a specifically aesthetic inflection – the museum turns objects into things to be looked at attentively, and requires them to have a primarily 'visual interest'.

Museum set: This phrase is used by Michael Baxandall to refer to the cultural competences required and tacitly acquired which enable visitors to interpret museums. Visitors acquire the 'museum set' through frequent visits to a range of museums, and as Glenn Penny explains, they thus acquire 'a similar set of standards, a certain degree of shared subjectivity and, ideally the same goals of communication' as those who author the museums (2002: 119).

Mimesis: The term usually refers to imitations, or simulations, especially the mimicry of nature through artifice. However mimesis also refers to the entangled world of

nature and artifice, such as that found in curiosities such as the carved cherrystone, or the stone in the shape of a heart. Thus, not only illusionistic dioramas, panoramas and immersive exhibits can be understood as mimetic, but also the resemblances and 'sympathetic' correspondences of the curiosity cabinet. The anthropologist Michael Taussig argues that instead of seeing mimesis in terms of deception or in opposition to the real, mimesis connects people to the world of things, and to one another. To mimic or imitate is to sensuously connect with that which is different, to become 'Other'.

Taylorism: see Fordism

REFERENCES

Abelson, E. S. (1989) *When Ladies Go A-Thieving: Middle-Class Shoplifters in the Victorian Department Store*. New York: Oxford University Press.

Adorno, T. (1967) Valéry Proust Museum, in *Prisms*. London: Neville Spearman.

Adorno, T. and Horkheimer, M. (1986) *Dialectic of Enlightenment*. London: Verso.

Alpers, S. (1991) The museum as a way of seeing, in I. Karp and S. D. Lavine (eds) *Exhibiting Cultures: The Poetics and Politics of Museum Display*. Washington DC: Smithsonian Institution Press.

Ames, M. M. (1992) *Cannibal Tours and Glass Boxes: The Anthropology of Museums*. Vancouver: UBC Press.

Anderson, P. (2004) Union Sucrée, *London Review of Books*, 23 Sept. 26(18).

Angus, I. (1998) The materiality of expression: Harold Innis' communication theory and the discursive turn in the human sciences, *Canadian Journal of Communications*, 23(1).

Appadurai, A. (1986) Introduction: commodities and the politics of value, in A. Appadurai (ed.) *The Social Lives of Things*. Cambridge: Cambridge University Press.

Auslander, L. (1996) The gendering of consumer practices in nineteenth-century France, in V. de Grazia and E. Furlough (eds) *The Sex of Things*. Berkeley, CA: University of California Press.

Bal, M. (1996) *Double Exposures: The Subject of Cultural Analysis*. London: Routledge.

Bann, S. (2003) The return to curiosity: shifting paradigms in contemporary museum display, in A. McClellan (ed.) *Art and Its Publics: Museum Studies at the Millennium*. Oxford: Blackwell.

Barber, L. (1980) *The Heyday of Natural History: 1820–1870*. London: Jonathan Cape.

Barry, A. (2001) *Political Machines: Governing a Technological Society*. New York: Athlone Press.

Barry, J. (1996) Dissenting spaces, in R. Greenberg, B. W. Ferguson, and S. Nairne (eds) *Thinking About Exhibitions*. London: Routledge.

Barthes, R. (1989) The reality effect, in *The Rustle of Language*. New York: Hill and Wang.

Bazin, G. (1967) *The Museum Age*. New York: Universe Books.

Belting, H. (2001) *The Invisible Masterpiece*. London: Reaktion books.

Benedict, B. M. (2001) *Curiosity: A Cultural History of Early Modern Inquiry*. Chicago, IL: University of Chicago Press.

Benjamin, W. (1979) A small history of photography, in *One Way Street and Other Writings*. London: New Left Books.

Benjamin, W. (1983) *Charles Baudelaire: A Lyric Poet in the Era of High Capitalism*. London: Verso.

Benjamin, W. (1985) Central Park, *New German Critique*, (34): 32–58.

Benjamin, W. (1992a) The storyteller, in *Illuminations*. London: Fontana Press.

Benjamin, W. (1992b) On some motifs in Baudelaire, in *Illuminations*. London: Fontana Press.

Benjamin, W. (1996) On the program of the coming philosophy, in M. Bullock and M. W. Jennings (eds) *Selected Writings* (vol. 1, 1913–26). Pp. 100–110. Cambridge, MA: Harvard University Press.

Benjamin, W. (1999a) *The Arcades Project*. (Trans. H. Eiland and K. McLaughlin). Cambridge, MA: Belknap Press of Harvard University Press.

Benjamin, W. (1999b) On the image of Proust, in M. W. Jennings, H. Eiland, and G. Smith (eds) *Selected Writings* (vol. 2 1927–34). Cambridge, MA: Harvard University Press.

Benjamin, W. (2002) The work of art in the age of its technological reproducibility, in *Selected Writings* (vol. 3, 1935–38). Cambridge, MA: Harvard University Press.

Bennett, T. (1995) *The Birth of the Museum: History, Theory, Politics*. London: Routledge.

Bennett, T. (2002) Archaeological autopsy: objectifying time and cultural governance, *Cultural Values*, 6(1 &2): 29–47.

Bennett, T. (2003) Stored virtue: memory, the body and the evolutionary museum, in S. Radstone, and K. Hodgkin (eds) *Regimes of Memory*. London: Routledge.

Blazwick, I. and Wilson, S. (eds) (2000) *Tate Modern: The Handbook*. London: Tate Publishing.

Bourdieu, P. (1997) Three forms of capital, in A. H. Halsey *et al.* (eds) *Education: Culture, Economy and Society*. Oxford: Oxford University Press.

Bourdieu, P. (2003) *Distinction: A Social Critique of the Judgement of Taste*. London: Routledge.

Brechin, G. (1996) Conserving the race: natural aristocracies, eugenics, and the US conservation movement, *Antipode*, 28 (July): 229–45.

Bright, D. (2001) Shopping the leftovers: Warhol's collecting strategies in *Raid the Icebox I*, *Art History*, 24(2): 278–91.

British Museum (n.d.) Department of Ancient Egypt and Sudan, Collection's History. Published at www.thebritishmuseum.ac.uk, accessed July 2004.

Bronner, S. J. (1989) Object lessons: The work of ethnological museums and collections,

in S. J. Bronner (ed.) *Consuming Visions: Accumulation and Display of Goods in America, 1880–1920*. New York: W.W. Norton.

Brosterman, N. (1997) *Inventing Kindergarten*. New York: Harry N. Abrams.

Brown, B. (2001) Thing theory, *Critical Inquiry*, 23: 1–19.

Buchloh, B. (1988) From faktura to factography, in A. Michelson *et al.* (eds) *October, the First Decade 1976–1986*. Cambridge, MA: MIT Press.

Burke, E. (1958) *A Philosophical Enquiry into the Origin of Our Ideas of the Sublime and Beautiful*. (ed. by J. Boulton). Oxford: Basil Blackwell.

Burke, E. (1999) *Reflections On the Revolution in France, Volume 2 of the Select Works of Edmund Burke*. Indianapolis, IN: Liberty Fund.

Butler, S. (1992) *Science and Technology Museums*. Leicester: Leicester University Press.

Cartwright, N. and Uebel, T. E. (1996) Philosophy in the earthly plane, in E. Nemeth, and F. Stadler (eds) *Encyclopedia and Utopia: The Life and Work of Otto Neurath (1882–1945)*. London: Kluwer Academic Publishers.

de Certeau, M. (1986) The beauty of the dead, written in collaboration with D. Julia and J. Revel, in *Heterologies: Discourse on the Other*. Minneapolis, MN: University of Minnesota Press.

Clifford, J. (1985) Objects and selves – an afterword, in G. Stocking (ed.) *Objects and Others: Essays on Museums and Material Culture*. Madison, WI: University of Wisconsin Press.

Clifford, J. (1988) *The Predicament of Culture: Twentieth Century Ethnography, Literture and Art*. Cambridge, MA: Harvard University Press.

Clifford, J. (1997) *Routes: Travel and Translation in the Late Twentieth Century*. Cambridge, MA: Harvard University Press.

Cockcroft, E. (1985) Abstract Expressionism: Weapon of the Cold War, in F. Frascina (ed.) *Pollock and After: the Critical Debate*. London: Harper and Row.

Colomina, B. (1994) *Privacy and Publicity: Modern Architecture as Mass Media*. Cambridge, MA: MIT Press.

Conn, S. (1998) *Museums and American Intellectual Life 1876–1926*. Chicago, IL: University of Chicago Press.

Cook, J. W. (1996) Of men, missing links, and nondescripts: The strange career of P.T. Barnum's 'What is It?' exhibition, in R. G. Thomson (ed.) *Freakery: Cultural Spectacles of the Extraordinary Body*. New York: New York University Press.

Coombes, A. E. (1991) Ethnography and the formation of national and cultural identities, in S. Hiller (ed.) *The Myth of Primitivism: Perspectives on Art*. London: Routledge.

Crary, J. (1999) *Suspensions of Perception: Attention, Spectacle and Modern Culture*. Cambridge, MA: MIT Press.

Crary, J. (2002) Géricault, the panorama and sites of reality in the early nineteenth century, *Grey Room*, 09, Fall:5–25.

Culver, S. (1988) What manikins want: 'The Wonderful Wizard of Oz' and 'The Art of Decorating Dry Goods Windows', *Representations*, 21, Winter: 97–116.

Daston, L. (1995) Curiosity in early modern science, *Word and Image*, 11(4), October–December: 391–404.

Daston, L. (2004a) Are you having fun today? *London Review of Books*, 23 Sept. 26(18): 29–31.

Daston, L. (2004b) Type specimens and scientific memory, *Critical Inquiry*, 31, Autumn: 153–82.

Daston, L. and Park, K. (1998) *Wonders and the Order of Nature 1150–1750*. New York: Zone Books.

Design Museum (2005) Cedric Price – Doubt, Delight and Change (Exhibition text) online at www.designmuseum.org, accessed 12 Feb 2005.

Dewey, J. (1934) Art as experience, in J. A. Boydston (ed.) *The Later Works*, vol. 10. Carbondale, IL: Southern Illinois University Press.

Dias, N. (1994) Looking at objects: memory, knowledge in nineteenth-century ethnographic displays, in G. Robertson *et al.* (eds) *Travellers Tales: Narratives of Home and Displacement*. London: Routledge.

Dicks, B. (2003) *Culture on Display: The Production of Contemporary Visitability*. Buckingham: Open University Press.

Duncan, C. (1991) Art museums and the ritual of citizenship, in I. Karp and S. D. Lavine (eds) *Exhibiting Cultures: the Poetics and Politics of Museum Display*. Washington DC: Smithsonian Institution Press.

Duncan, C. (1995) *Civilizing Rituals: Inside Public Art Museums*. London: Routledge.

Duncan, C. and Wallach, A. (2004) The Museum of Modern Art as late capitalist ritual: an iconographic analysis, in D. Preziosi, and C. Farago (eds) *Grasping the World: The Idea of the Museum*. Aldershot: Ashgate Publishing.

Durham, J. (1993) *A Certain Lack of Coherence: Writings On Art and Cultural Politics*. London: Kala Press.

Eagleton, T. (1990) *The Ideology of the Aesthetic*. Oxford: Basil Blackwell Ltd.

Ernst, W. (2000a) Archi(ve)textures of museology, in S. A. Crane (ed.) *Museums and Memory*. Stanford, CA: Stanford University Press.

Ernst, W. (2000b) Archival phantasms: between imaginary museum and archive: cyberspace, posted to *Nettime*, 21 Dec 2000 at www.nettime.org

Fisher, P. (1991) *Making and Effacing Art: Modern American Art in a Culture of Museums*. Cambridge: Harvard University Press.

Foster, H. (1996) *The Return of the Real*. Cambridge, MA: MIT Press.

Foucault, M. (1970) *The Order of Things: An Archeology of the Human Sciences*. London: Tavistock.

Foucault, M. (1978) *The History of Sexuality: An Introduction*. Harmondsworth: Penguin.

Foucault, M. (1979) *Discipline and Punish: The Birth of the Prison*. Harmondsworth: Peregrine Books (Penguin).

Foucault, M. (1986) Of Other Spaces, *Diacritics* 16(1): 22–7.

Foucault, M. (1988) The masked philosopher, in L. D. Kritzman (ed.) *Michel Foucault: Politics, Philosophy, Culture, Interviews and Other Writings 1977–1984*. London: Routledge.

Freud, S. (1953) *Three Essays On Sexuality and Other Writings (1901–1905).* (standard ed.) London: Hogarth Press.

Freud, S. (1961) *Fetishism.* vol. 21. (standard ed.) London: Hogarth Press.

Freud, S. (1984) Beyond the Pleasure Principle, in *On Metapsychology: the Theory of Psychoanalysis.* The Pelican Freud Library, vol. 11. Harmondsworth: Penguin.

Freud, S. (1991) A note upon the mystic writing pad, in *On Metapsychology: The Theory of Psychoanalysis,* The Pelican Freud Library, vol. 11, Harmondsworth: Penguin.

Fyfe, G. (2004) Reproductions, cultural capital and museums: aspects of the culture of copies, *Museum and Society,* 2(1) March: 47–67.

Fukuda, T. (2003) Does a museum represent a storehouse or a medium? Recent trends in Japanese museums, in S. Nakagawa, R. M. Soedarsono, and I. M. Bandem (eds) *Urban Culture Research,* vol. 1. Yogyakarta: Urban Culture Research Centre.

Geertz, C. (1993) *The Interpretation of Cultures.* London: Fontana.

Gere, C. (1997) Museums, contact zones and the internet, in D. Bearman and J. Trant (eds) *Museum Interactive Multimedia 1997: Cultural Heritage Systems Design and Interface.* Pittsburgh, PA: Archives & Museum Informatics.

Gere, C. (1999) Hypermedia and Emblematics, in T. Szraijber (ed.) *Computing and Visual Culture: Representation and Interpretation. Fourteenth Annual CHArt Conference.* London: CHArt.

Gómez, M. V. and González, S. (2001) A reply to Beatriz Plaza's 'the Guggenheim-Bilbao museum effect', *International Journal of Urban and Regional Research,* 25(4): 898–900.

Goodman, D. (1990) Fear of circuses: founding the National Museum of Victoria, *Continuum: The Australian Journal of Media and Culture,* 3(1).

Gourevitch, P. (1993) Behold now Behemoth – The Holocaust Memorial Museum: one more American theme park, *Harper's Magazine* (NY), May: 55–62.

Greenblatt, S. (1991a) *Marvelous Possessions: The Wonders of the New World.* Oxford: Clarendon Press.

Greenblatt, S. (1991b) Resonance and Wonder, in I. Karp and S. D. Lavine (eds) *Exhibiting Cultures: the Politics and Poetics of Museum Display.* Washington DC: Smithsonian Institution Press.

Greer, G. (1979) *The Obstacle Race: The Fortunes of Women Painters and Their Work.* London: Secker and Warburg.

Gregory, R. (1990) *Eye and Brain: The Psychology of Seeing.* London: Weidenfield and Nicholson.

Griffin, D. (2002) Museums for the 21st Century: entertainments or big challenging ideas? *Artlink,* 22(4): 16–22.

Griffiths, A. (1996) 'Journey for those who can not travel': promenade cinema and the Museum Life Group, *Wide Angle,* 18(3).

Griffiths, A. (2002) *Wondrous Difference: Cinema, Anthropology and Turn of the Century Visual Culture.* New York: Columbia University Press.

Groys, B. (1994) The struggle against the museum; or, the display of art in totalitarian space, in D. J. Sherman, and I. Rogoff (eds) *Museum Culture: Histories, Discourses, Spectacles.* Minneapolis, MN: University of Minnesota Press.

Guilbaut, S. (1983) *How New York Stole the Idea of Modern Art: Abstract Expressionism, Freedom and the Cold War.* Chicago, IL: University of Chicago Press.

Gunning, T. (1989) 'An aesthetic of astonishment', *Art and Text*, Spring: 31–45.

Gunning, T. (1990) The Cinema of Attractions: early film, its spectator and the avant-garde, in T. Elsaesser (ed.) *Early Cinema: Space, Frame, Narrative.* London: BFI.

Gunning, T. (1997) From the kaleidoscope to the x-ray: urban spectatorship, Poe, Benjamin, and traffic in souls (1913), *Wide Angle*, 19(4), October: 25–63.

Habermas, J. (1989) *The Structural Transformation of the Public Sphere: An Inquiry into a Category of Bourgeois Society.* Cambridge, MA: MIT Press.

Hall, S. (1991) Old and new identities, old and new ethnicities, in A. King (ed.) *Culture, Globalization and the World-System. Contemporary Conditions for the Representation of Identity.* Binghamton, NY: Department of Art and Art History, SUNY-Binghamton.

Hanssen, B. (2000) *Walter Benjamin's Other History: Of Stones, Animals, Human Beings and Angels.* Berkeley, CA: University of California Press.

Haraway, D. (1989) *Primate Visions: Gender, Race and Nature in the World of Modern Science.* London: Routledge.

Harris, N. (1978) Museums, merchandising, and popular taste: the struggle for influence, in I. M. G. Quimby (ed.) *Material Culture and the Study of American Life.* New York: Norton.

Harris, N. (1990) *Cultural Excursions: Marketing Appetites and Cultural Tastes in Modern America.* Chicago, IL: University of Chicago Press.

Harrison, M. (1967) *Changing Museums: Their Use and Misuse.* London: Longmans.

Harvey, D. (1989) *The Condition of Postmodernity: An Enquiry into the Origins of Cultural Change.* Oxford: Blackwell.

Haug, W. (1986) *Critique of Commodity Aesthetics: Appearance, Sexuality and Advertising in Capitalist Society.* Cambridge: Polity Press.

Hein, H. (1986) *The Exploratorium: The Museum as Laboratory.* Washington DC: Smithsonian Institution Press.

Hein, H. (2000) *The Museum in Transition: A Philosophical Perspective.* Washington DC: Smithsonian Institution Press.

Henning, M. (1999) Don't touch me (I'm electric): on sense and sensation in modernity, in J. Arthurs, and J. Grimshaw (eds) *Women's Bodies: Discipline and Transgression.* London: Cassell.

Higgins, H. (2002) *Fluxus Experience.* Berkeley, CA: University of California Press.

Highmore, B. (2002) *Everyday Life and Cultural Theory: An Introduction.* London: Routledge.

Highmore, B. (2003) Machinic magic: IBM at the 1964–1965 New York World's Fair, *New Formations*, 51(1):128–48.

Hooper-Greenhill, E. (1990) The space of the museum, *Continuum: The Australian Journal of Media & Culture*, Space * Meaning * Politics 3(1).

Hooper-Greenhill, E. (1992) *Museums and the Shaping of Knowledge.* London: Routledge.

Hooper-Greenhill, E. (ed) (1995) *Museum, Media, Message.* London: Routledge.

Hornsey, R. (2004) 'Homosexuality and Everyday Life in Postwar London'. PhD Dissertation, University of Sussex.

Hoskins, A. (2003) Signs of the Holocaust: exhibiting memory in a mediated age, *Media, Culture and Society*, 25: 7–22.

Hudson, K. (1975) *A Social History of Museums*. London: Macmillan Press.

Huhtamo, E. (2002) On the origins of the virtual museum. Paper presented at the Nobel Symposium *Virtual Museums and Public Understanding of Science And Culture*, Stockholm, Sweden.

Huyssen, A. (2000) Present pasts: Media, politics, amnesia, *Public Culture*, 12(1): 21–38.

Imai, Y. (2003) Walter Benjamin and John Dewey: the structure of difference between their thoughts on education, *Journal of Philosophy of Education*, 37(1): 109–25.

Jenkins, T. (2005) The museum of political correctness, *The Independent*, Independent Review section 25 Jan.: 15.

Kachur, L. (2001) *Displaying the Marvellous. Marcel Duchamp, Salvador Dali and Surrealist Exhibition Installations*. Cambridge, MA: MIT Press.

Kaplan, F. E. S. (ed.) (1994) *Museums and the Making of 'Ourselves': The Role of Objects in National Identity*. London: Leicester University Press.

Karp, I. and Wilson, F. (1996) Constructing the spectacle of culture in museums, in R. Greenberg, B. W. Ferguson, and S. Nairne (eds) *Thinking about Exhibitions*. London: Routledge.

Kattago, S. (1999) Gravediggers of the present: the information age and cultural memory; online at www.theblowup.com, first published in November 1999 at www.popmatters.com, accessed December 2004.

Kavanagh, G. (2000) *Dream Spaces: Memory and the Museum*. London: Leicester University Press.

Kiesler, F. (1930) *Contemporary Art Applied to the Store and Its Display*. New York: Brentano's Publishers.

King, T. A. (1994) Performing akimbo: queer pride and epistemological prejudice, in M. Meyer (ed.) *The Politics and Poetics of Camp*. London: Routledge.

Kirshenblatt-Gimblett, B. (1998) *Destination Culture: Tourism, Museums and Heritage*. Berkeley, CA: University of California Press.

Kittler, F. (1999) *Gramophone, Film, Typewriter*. (Trans by G. Winthrop-Young) and M. Wutz. Stanford, CA: Stanford University Press.

Kracauer, S. (1987) The little shopgirls go to the movies, *New German Critique*, 40(14).

Krauss, R. E. (1996) Postmodernism's museum without walls, in R. Greenberg, B. W. Furguson, and S. Nairne (eds) *Thinking About Exhibitions*. London: Routledge.

Kutcha, D. (1996) The making of the self-made man: class, clothing and English masculinity, 1688–1832, in V. de Grazia (ed.) *The Sex of Things: Gender and Consumption in Historical Perspective*. Berkeley, CA: University of California.

Kwass, M. (2003) Ordering the world of goods: consumer revolution and the classification of objects in eighteenth-century France, *Representations*, 82, Spring: 87–116.

Latour, B. (1992) Where are the missing masses? The sociology of a few mundane artifacts, in W. E. Bijker, and J. Law (eds) *Shaping Technology / Building Society: Studies in Sociotechnical Change*. Cambridge, MA: MIT Press.

Leach, W. (1989) Strategists of display and the production of desire, in S. J. Bronner (ed.) *Consuming Visions: Accumulation and Display of Goods in America, 1880–1920*. New York: W. W. Norton.

Lennon, J. J. and Foley, M. (1999) Interpretation of the unimaginable: the US Holocaust Memorial Museum, Washington, DC, and 'dark tourism', *Journal of Travel Research*, 38, August: 46–50.

Leslie, E. (2003) Absent-minded professors: Etch-a-sketching academic forgetting, in S. Radstone, and K. Hodgkin (eds) *Regimes of Memory*. London: Routledge.

Lissitzky, E. (1984) *Russia: An Architecture for World Revolution*. Cambridge, MA: MIT Press.

Luke, T. W. (2002) *Museum Politics: Power Plays at the Exhibition*. Minneapolis, MN: University of Minnesota Press.

Macdonald, S. (ed.) (1998) *The Politics of Display: Museums, Science, Culture*. London: Routledge.

Macdonald, S. (2004) Exhibitions and the public understanding of science paradox, *Pantaneto Forum*, 13, January: 1–14.

MacGregor, B. (2002) Cybernetic serendipity revisited. Paper presented at Creativity and Cognition 4, Processes and Artefacts: Art, Technology and Science, An ACM SIGCHI International Conference, Loughborough, Leics., UK.

McLuhan, M. (2002) *Understanding Media*. London: Routledge.

Maleuvre, D. (1999) *Museum Memories: History, Technology, Art*. Stanford, CA: Stanford University Press.

Malraux, A. (1967) *Museum Without Walls*. New York: Doubleday and Company.

Manovich, L. (2001) *The Language of New Media*. Cambridge, MA: MIT Press.

Marinetti, F. T. (1973) The Founding and Manifesto of Futurism, in U. Apollonio (ed.) *Futurist Manifestos: An Anthology of the Writings of Futurist Artists*. London: Thames and Hudson.

Marx, K. (1968) The Eighteenth Brumaire, in *Karl Marx and Frederick Engels: Selected Works*. London: Lawrence and Wishart.

Marx, K. (1976) *Capital*, vol 1. Harmondsworth: Penguin.

Marx, K. (1977) *The Economic and Philosophical Manuscripts of 1844*. London: Lawrence and Wishart.

Mauries, P. (2002) *Cabinets of Curiosities*. London: Thames and Hudson.

Metz, C. (1982) *The Imaginary Signifier: Psychoanalysis and Cinema*. Bloomington, IN: Indiana University Press.

Miles, R. (1996) Otto Neurath and the modern public museum: the case of the Natural History Museum (London), in E. Nemeth, and F. Stadler (eds) *Encyclopedia and Utopia: The Life and Work of Otto Neurath (1882–1945)*. London: Kluwer Academic Publishers.

Mitman, G. (1999) *Reel Nature: America's Romance With Wildlife Films*. Cambridge, MA: Harvard University Press.

Morris, J. (2004) The root of the problem, *Museums Journal*, September:10–11.

Mullen, C. (1994) The people's show, in S. M. Pearce (ed.) *Interpreting Objects and Collections*. London: Routledge.

Neurath, O. (1973) *Empiricism and Sociology*. Dordrecht: Reidel.

Nietzsche, F. W. (1997) On the uses and disadvantages of history for life, in D. Breazale (ed.) *Untimely Meditations*. (Trans. R. J. Hollingdale) Cambridge: Cambridge University Press.

Nochlin, L. (1991) Why have there been no great women artists? in *Women, Art and Power and Other Essays*. London: Thames and Hudson.

Noordegraaf, J. (2004) *Strategies of Display: Museum Presentation in Nineteenth- and Twentieth-Century Visual Culture*. Rotterdam: Museum Boijmans van Beuningen, NAi Publishers.

Nora, P. (ed.) (1996) *Realms of Memory: The Construction of the French Past, vol. I: Conflicts and Divisions*. New York: Columbia University Press.

O'Doherty, B. (1999) *Inside the White Cube: The Ideology of the Gallery Space*. Berkeley, CA: University of California Press.

Oettermann, S. (1997) *The Panorama: History of A Mass Medium*. Cambridge, MA: Zone Books.

O'Neill, M. (2004) Enlightenment museums: universal or merely global? *Museum and Society*, 2(3), November:190–202.

Otis, L. (1994) *Organic Memory: History and the Body in the Late Nineteenth and Early Twentieth Centuries*. Lincoln, NB: University of Nebraska Press.

Otwell, A. (1997) Fredrick Kiesler as a commercial designer, published online at www.heyotwell.com, accessed July 2004.

Parker, R. and Pollock, G. (1981) *Old Mistresses: Women, Art and Ideology*. London: Pandora.

Pearce, S. (1995) Collecting as medium and message, in E. Hooper-Greenhill (ed.) *Museum, Media, Message*. New York: Routledge.

Penny, H. G. (2002) *Objects of Culture: Ethnology and Ethnographic Museums in Imperial Germany*. Chapel Hill, NC: The University of North Carolina Press.

Pensky, M. (1996) Tactics of remembrance: Proust, surrealism and the origins of the Passagenwerk, in M. P. Steinberg (ed.) *Walter Benjamin and the Demands of History*. Ithaca, NY: Cornell University Press.

Phillips, C. (1988) The judgement seat of photography, in A. Michelson *et al.* (eds) *October: the First Decade 1976–1986*. Cambridge, MA: MIT Press.

Pickering, A. (2002) Cybernetics and the mangle: Ashby, Beer and Pask, *Social Studies of Science*, 32(3):413–37.

Plaza, B. (2000) Evaluating the influence of a large cultural artifact in the attraction of tourism:the Guggenheim Museum Bilbao case, *Urban Affairs Review*, 36(2): 264–74.

Pollock, G. (1988) *Vision and Difference*. London: Routledge.

Poole, J. (2000) The Fund for Arts and Culture in Central and Eastern Europe: Final Report on Museum Assessment and Design Seminar, St. Petersburg Russia, December 7–11, 2000. Retrieved 31 January 2005 from www.fundforartsandculture.org

Pratt, M. L. (1992) *Imperial Eyes: Travel Writing and Transculturation*. London: Routledge.

Preziosi, D. and Farago, C. (eds) (2004) *Grasping the World: The Idea of the Museum*. Aldershot: Ashgate Publishing.

Prior, N. (2003) Having one's Tate and eating it: transformations of the museum in a hypermodern era, in A. McClellan (ed.) *Art and Its Publics: Museum Studies at the Millennium*. Oxford: Blackwell.

Putnam, J. (2001) *Art and Artifact: The Museum As Medium*. New York: Thames and Hudson.

Rectanus, M. W. (2002) *Culture Incorporated: Museums, Artists and Corporate Sponsorships*. Minneapolis, MN: University of Minnesota.

Rectanus, M. W. (2005) Globalisation, in Sharon Macdonald (ed) *The Blackwell Guide to Museum Studies*. Oxford: Blackwell. (forthcoming)

Reichardt, J. (ed.) (1968) *Cybernetic Serendipity: The Computer and the Arts*. A Studio International Special Issue. London: Studio International.

Ritvo, H. (1997) *The Platypus and the Mermaid and Other Figments of the Classifying Imagination*. Cambridge, MA.: Harvard University Press.

Rosen, C. and Zerner, H. (1984) *Romanticism and Realism: The Mythology of Nineteenth Century Art*. London: Faber and Faber.

Rosoff, N. B. (2003) Integrating native views into museum procedures: hope and practice at the National Museum of the American Indian, in L. Peers, and A. K. Brown (eds) *Museums and Souce Communities: A Routledge Reader*. London: Routledge.

Ross, K. (1988) *The Emergence of Social Space: Rimbaud and the Paris Commune*. Minneapolis, MN: University of Minnesota Press.

Rugoff, R. (1995) *Circus Americanus*. London: Verso.

Saisselin, R. G. (1992) *The Enlightenment Against the Baroque: Economics and Aesthetics in the Eighteenth Century*. Berkeley, CA: University of California Press.

Samuel, R. (1994) *Theatres of Memory*. London: Verso.

Sandberg, M. B. (1995) Effigy and narrative: looking into the nineteenth-century folk museum, in L. Charney, and V. R. Schwartz (eds) *Cinema and the Invention of Modern Life*. Berkeley, CA: University of California Press.

Sandberg, M. B. (2003) *Living Pictures, Missing Persons: Mannequins, Museums and Modernity*. Princeton, NJ: Princeton University Press.

Schapiro, D. and Schapiro, C. (1985) Abstract Expressionism: the politics of apolitical painting (edited version), in F. Frascina (ed.) *Pollock and After: The Critical Debate*. London: Harper and Row.

Schivelbusch, W. (1986) *The Railway Journey: The Industrialization of Time and Space in the Nineteenth Century*. Berkeley, CA: University of California Press.

Schor, N. (1987) *Reading in Detail: Aesthetics and the Feminine*. New York: Methuen.

Schwartz, V. R. (1998) *Spectacular Realities: Early Mass Culture in Fin-de-Siècle Paris*. Berkeley, CA: University of California Press.

Sekula, A. (1993) The body and the archive, in R. Bolton (ed.) *The Contest of Meaning: Critical Histories of Photography*. Cambridge, MA: MIT Press.

Sennett, R. (1993) *The Fall of Public Man*. London: Faber & Faber.

Shaffer, M. S. (2001) Scenery as an asset: assessing the 1930 Los Angeles regional park plan, *Planning Perspectives*, 16: 357–82.

Sherman, D. J. (1994) Quatremère/Benjamin/Marx: art museums, aura, and commodity fetishism, in D. J. Sherman, and I. Rogoff (eds) *Museum Culture: Histories, Discourses, Spectacles*. New York: Routledge.

Silverstone, R. (1992) The medium is the museum: on objects and logics in times and spaces, in J. Durant (ed.) *Museums and the Public Understanding of Science*. London: The Science Museum.

Simmel, G. (2002) The Berlin Trade Exhibition [1896], in B. Highmore (ed.) *The Every-day Life Reader*. London: Routledge.

Simpson, M. G. (1996) *Making Representations: Museums in the Postcolonial Era*. London: Routledge.

Smith, G. M. (2002) Streisand shops the museum store: consuming art on television, *Journal of Popular Film and Television*, Spring.

Solomon-Godeau, A. (1996) The other side of Venus: the visual economy of feminine display, in V. de Grazia, and E. Furlough (eds) *The Sex of Things: Gender and Consumption in Historical Perspective*. Los Angeles, CA: University of California Press.

Sontag, S. (1966) Notes on Camp, in *Against Interpretation*. London: Vintage.

Spencer, L. (1985) Allegory in the world of the commodity: the importance of 'Central Park', *New German Critique*, (34):59–77.

Staal, G. and de Rijk, M. (2003) *In Side Out, On Site In: Redesigning the National Museum of Ethnology, Leiden, the Netherlands*. Amsterdam: BIS Publishers.

Staniszewski, M. A. (1998) *The Power of Display: A History of Exhibition Installations at the Museum of Modern Art*. Cambridge, MA: MIT Press.

Stearn, W. T. (1998) *The Natural History Museum at South Kensington: A History of the Museum 1753–1980*. London: The Natural History Museum.

Steel, P. (2004) Close to the bone, *Museums Journal*, August:22–25.

Stocking, G. (1985) *Objects and Others; Essays On Museums and Material Culture*. Madison, WI: University of Wisconsin Press.

Survey Graphic (1936) Social showman, *Survey Graphic: Magazine of Social Interpret-ation*; 25(11)Nov, published online by the *New Deal Network*, newdeal.feri.org, accessed 17 June 2004.

Swanson, G. (2000) Regimes of truth and the fashioning of the self, in J. Crisp, K. Ferres, and G. Swanson *Deciphering Culture: Ordinary Curiosities and Subjective Narratives*. London: Routledge.

Tagg, John (1988) *The Burden of Representation*. London: Macmillan.

Taussig, M. (1993) *Mimesis and Alterity: A Particular History of the Senses*. New York: Routledge.

Tega, Walter (1996) Atlases, cities, mosaics: Neurath and the Encylopédie, in E. Nemeth and F. Stadler (eds) *Encyclopedia and Utopia: The Life and Work of Otto Neurath (1882–1945)*. London: Kluwer Academic Publishers.

Tenner, E. (2005) Keeping Tabs, *Technology Review*, published online by MIT at www.techreview.com, accessed 20 Feb 2005.

Terdiman, R. (1993) *Present Past: Modernity and the Memory Crisis*. Ithaca, NY: Cornell University Press.

Thomas, N. (1991) *Entangled Objects: Exchange, Material Culture and Colonialism in the Pacific*. Cambridge, MA: Harvard University Press.

Torgovnick, M. (1990) *Gone Primitive: Savage Intellects, Modern Lives*. Chicago, IL: University of Chicago Press.

Trodd, C. (2003) The discipline of pleasure; or, how art history looks at the art museum, *Museum and Society*, 1(1): 17–29.

Usselmann, R. (2003) The dilemma of media art: Cybernetic Serendipity at the ICA London, *Leonardo*, 36(5): 389–96.

Valéry, P. (1956) The problem of museums, in *Degas, Manet, Morisot*. New York: Pantheon Books.

Vidler, A. (2001) The space of history: modern museums from Patrick Geddes to Le Corbusier, in M. Giebelhausen (ed.) *The Architecture of the Museum: Symbolic Structures, Urban Contexts*. Manchester: Manchester University Press.

Vossoughian, N. (2003) The language of the World Museum: Otto Neurath, Paul Otlet, Le Corbusier, *Transnational Associations*, 1–2: 82–93.

Watkins, E. (1993) *Throwaways: Work Culture and Consumer Education*. Stanford, CA: Stanford University Press.

Watson, J. (1999) *Literature and Material Culture from Balzac to Proust: The Collection and Consumption of Curiosities*. Cambridge: Cambridge University Press.

Webb, F. (2004) Current affairs, *Museums Journal*, October: 22–5.

Wigley, M. (1995) *White Walls, Designer Dresses*. Cambridge, MA: MIT Press.

Williams, R. (1977) *Marxism and Literature*. Oxford: Oxford University Press.

Wilson, E. (1992) The invisible flaneur, *New Left Review*, 191: 90–110.

Wilson, F. (1994) *Mining the Museum: An Installation By Fred Wilson*. (Ed. L. G. Corrin.) Baltimore, MD: Contemporary Press.

Wolff, J. (1990) The invisible flaneuse: women and the literature of modernity, in *Feminine Sentences*. Cambridge: Polity.

Wollen, P. (1993) *Raiding the Icebox*. London: Verso.

Wonders, Karen (1993) *Habitat Dioramas; Illusions of Wilderness in Museums of Natural History*. Uppsala: Acta Universitatis Upsaliensis.

INDEX

RETHINKING CULTURAL POLICY
Jim McGuigan

- What are the possibilities and limitations of public policy in the cultural field under late-modern conditions?

Issues of cultural policy are of central importance now because forms of media are growing at an astonishing rate – new media like video games and chat rooms as well as modified older forms such as virtual access to museums, libraries and art galleries on the Internet. The digital revolution gives rise potentially to a culture of 'real virtuality' in which all the cultural artefacts of the world, past and present, may become instantly available at any time.

This innovative book charts the decline and renewal of public cultural policy. It examines a wide range of contemporary issues and blends a close reading of key theoretical points with examples to illustrate their practical import.

This is the perfect introduction to the area for undergraduate students in culture and media studies, sociology of culture, arts administration and cultural management courses, as well as postgraduates and researchers.

Contents
Introduction – Cultural Analysis, Technology and Power – Discourses of Cultural Policy – Cultural Policy 'Proper' and as Display – Rhetorics of Development, Diversity and Tourism – Culture, Capitalism and Critique – Glossary – References – Index.

192pp 0335 20701 4 (Paperback) 0 335 20702 2 (Hardback)

CULTURE ON DISPLAY
THE PRODUCTION OF CONTEMPORARY VISITABILITY

Bella Dicks

a welcome addition to a growing body of scholarly writing . . . a comprehensive critical survey of the literature on cultural heritage and tourism and associated issues in the fields of cultural and media studies over the previous decade. These concepts and issues are clearly presented and exemplified in the case studies of numerous sites of cultural display . . .

Southern Review

- Why is culture so widely on display?
- What are the major characteristics of contemporary cultural display?
- What is the relationship between cultural display and key features of contemporary society: the rise of consumerism; tourism; 'identity-speak'; globalization?
- What can cultural display tell us about current relations of self and other, here and there, now and then?

Culture on Display invites the reader to visit culture. Reflecting on the contemporary proliferation of sites displaying culture in visitable form, it offers fresh ways of thinking about tourism, leisure and heritage.

Bella Dicks locates diverse exhibitionary locations within wider social, economic and cultural transformations, including contemporary practices of tourism and travel, strategies of economic development, the staging of identities, globalization, interactivity and relations of consumerism. In particular, she critically examines how culture becomes transformed when it is put on display within these contexts. In each chapter, key theoretical issues of debate, such as authenticity, commodification and representation, are discussed in a lively and accessible manner.

This is an important book for undergraduate and postgraduate students of cultural policy, cultural and media studies and sociology, as well as academic researchers in this field. It will also be of considerable value to students of sociology of culture, cultural politics, arts administration and cultural management.

248pp 0 335 20657 3 (Paperback) 0 335 20658 1 (Hardback)